Arts and Crafts of Thailand

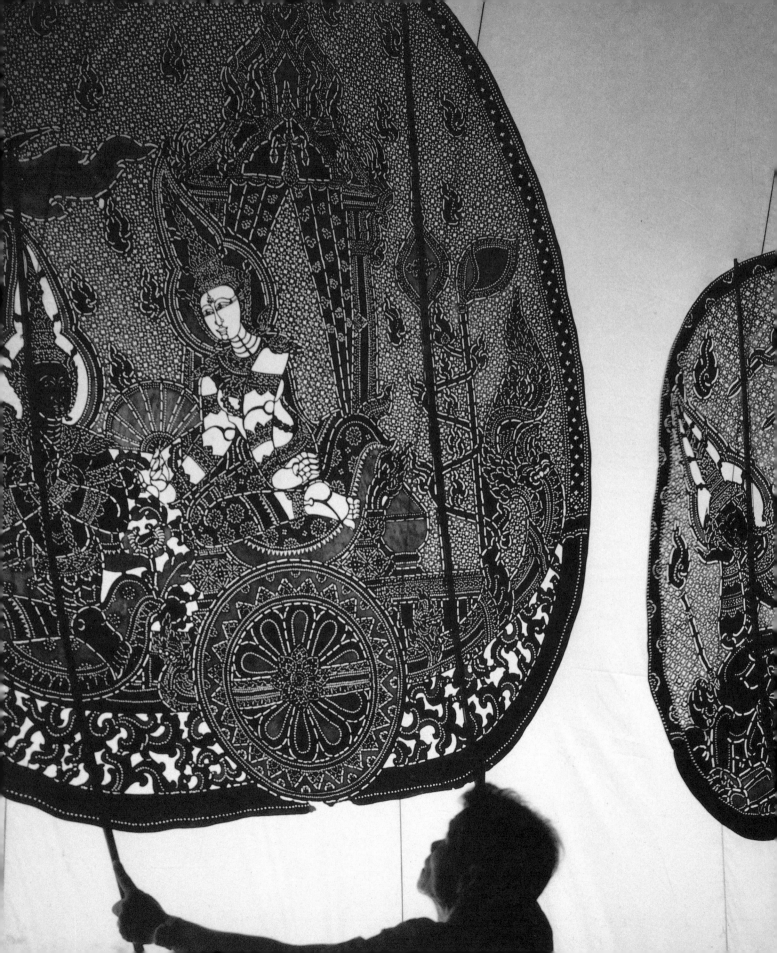

ARTS AND CRAFTS
OF
THAILAND

WILLIAM WARREN LUCA INVERNIZZI TETTONI

CONSULTANT: CHAIWUT TULAYADHAN

CHRONICLE BOOKS·

SAN FRANCISCO

FRONTISPIECE:

Nang yai, or large shadow-play figures, made of cowhide and manipulated against an illuminated screen.

Acknowledgments

The author and photographer are indebted to a number of people without whose generous assistance this book would not have been possible.

Our friend and consultant, Khun Chaiwut Tulayadhan of Neold Collection, was most helpful of all, providing not only objects to be photographed, but also devoting much of his time to the project. To him we are deeply grateful.

For lending crafts and giving information, we would also like to thank Khun Anongnart Ulapathorn of Rama Antiques, Mr. William Booth and Mr. Gerald Pierce of the Jim Thompson Silk Company, Khun Chanchai and Khun Orawan Supanichvoraparch of the Tao-Hong-Tai Ceramics Factory, Mr. Eberhard Horn, Mr. Robert McCarthy, Khun Pornroj Angsanakul of The Legend, Khun Surakit Leeruangsri of The August 9, Khun Vichai Thongvanit of The Old Time, Khun Waiyawuth and Khun Issrang Panich, Professor Chakrabhand Posayakrit of Silpakorn University, M. Alain Duchauffour, the Beaufort Sukothai Hotel in Bangkok, the National Museum in Bangkok, and the National Museum in Ayutthaya.

First published in the United States
in 1996 by Chronicle Books.

First published in Great Britain in 1995
by Thames and Hudson Ltd., London.

Copyright © 1994 by
Thames and Hudson Ltd., London.

Printed in Singapore.

Library of Congress
Cataloging-in-Publication Data:

Warren, William, 1930-
 Arts and crafts of Thailand / William
 Warren, Luca Invernizzi Tettoni; consultant,
 Chaiwut Tulayadhan.
 p. cm.
 Includes bibliographical references and
index.
 ISBN 0-8118-1026-7
 ISBN 0-8118-1001-1 (pbk.)
 1. Decorative Arts --Thailand.
 2. Folk art --Thailand.
 I. Invernizzi, Luca. II. Title.
NK 1055.A1W37 1996
745'.09593 –dc20 94-31817
 CIP

Book design by Lawrence Edwards.
Cover design by Sarah Bolles.

Distributed in Canada by
Raincoast Books
8680 Cambie Street
Vancouver, B.C. V6P 6M9

10 9 8 7 6 5 4 3 2 1

Chronicle Books
275 Fifth Street
San Francisco, California 94103

CONTENTS

INTRODUCTION

TOWARDS THE END of the 19th century, a passion for the outward trappings of a Western culture manifested itself in Thailand, then known to the outside world as Siam. The phenomenon arose from at least two sources. One, perhaps the most important, was a simple fascination with the new and different, particularly among the upper classes. European commodities flooded the markets of Bangkok after trade treaties were signed with various countries, the first being with Britain in 1855; and increasing numbers of Westerners – merchants and missionaries, diplomats and specialists employed by the government – took up residence in the capital and set a highly visible example in everything from dress and food to architecture and interior decoration.

Another factor was political. Both King Mongkut (r. 1851–88) and his son King Chulalongkorn (r. 1888–1910) were shrewd rulers who watched with alarm as neighbouring countries were colonized by the British, Dutch and French, often on the pretext that they were 'uncivilized' and that internal confusion demanded a European sense of order. To avoid such a fate, they deliberately set out to Westernize Siam, not only through fundamental reforms in foreign trade and government administration but also in other ways that affected traditional Thai culture, including its crafts.

Not all the resident Europeans were happy about these apparently sweeping changes. Malcolm Smith, an English doctor who served the court of King Chulalongkorn and later that of his widowed queen, expressed such sentiments when he commented with evident dismay: 'In the days of King Mongkut it was the custom of many of the wealthy families to maintain craftsmen in their own houses. Some were employed as gold and silver smiths, some as jewellers; others were painters and woodcarvers, or workers in lacquer or in mother-of-pearl; ... the artists belonged to the household, they took pride in their work, they vied with each other in performance, and their children when they grew up entered the occupation and learnt it from their parents.'

In this way, he pointed out, the master of the house was 'a patron of the Arts'. Every town in those days had its own 'potters, its metal workers, its carpenters and boat builders, its weavers and basket-makers. . . . The country was self supporting.'

That enviable state had virtually vanished, or so it seemed to Dr Smith, when he came to write his memoirs many years later in 1946, and the rulers had done nothing to arrest the process of Europeanization, no matter how unsuited they might be to the country. Today one can see that Dr Smith's pessimism was not entirely warranted. Undoubtedly, the changes must have seemed drastic in the Bangkok circles he frequented, and in the bazaars where he saw such a profusion of cheap,

mass-produced Western goods instead of the elegant, hand-crafted items of the past. Undoubtedly, too, the impact of the West really was considerable, and many of the old skills suffered as a result.

But they had not been extinguished, certainly not in many provincial areas which remained remote from the fads of Bangkok. The northernmost part of the country, for example, had been an independent kingdom known as Lanna, with traditions and a royal family of its own. Even after it came under the nominal control of the central government, it continued to be effectively sealed off from easy contact by a formidable mountain range; not until completion of the northern railway line in 1921 did travel to the region become relatively common, and as late as the 1960s, various artisans were still concentrated in their old communities around the city of Chiang Mai, each specializing in a particular craft.

A similar situation prevailed on the northeastern plateau that stretched along the Mekong river. Though railways were opened to some provincial capitals in the 1920s, roads were poor or non-existent, and many villages were totally isolated. In countless homes, craftsmen continued to produce the items needed in their daily life – the lengths of shimmering silk and supple cotton, the intricately woven baskets and mats – using the same techniques and designs as their ancestors had done. To a considerable extent, the same was true in the far south and in the villages that stood like islands amid the endless rice fields of the central plains, where political and social changes caused barely a ripple.

Even the more refined Thai arts and crafts, those elegant accessories and ceremonial objects created for use in royal palaces, aristocratic homes and Buddhist temples, were not entirely suppressed by the new-found taste for Western goods. Such items, displaying the highest levels of skill, had been produced in the first independent Thai capital of Sukhothai and continued through the 400-year rule of Ayutthaya and into the Rattanakosin, or Bangkok, period. They and their creators were known as *chang*, which roughly means 'craft' or 'craftsmen', some called *chang luang* ('royal craftsmen') attached directly to the court, others independent masters who worked on commissioned objects for wealthy outsiders.

These were the artisans most directly affected by the changes in taste during King Chulalongkorn's reign, but they, like their village counterparts, managed to survive and to hand down their skills. Such survival is clearly evident to anyone who visits modern Thailand, where on the surface – especially in urban centres – the triumph of Westernization seems almost total. But a closer examination reveals the strength of tradition, in crafts as in social mores. Not only have many of those at the village level been preserved; there has also been a resurgence of interest in classic *chang* generally associated with the past and a new generation of artisans to produce them.

The native crafts of Thailand remain a significant part of its daily life, reflecting a culture that has displayed a remarkable capacity for absorbing outside influences without losing its unique identity.

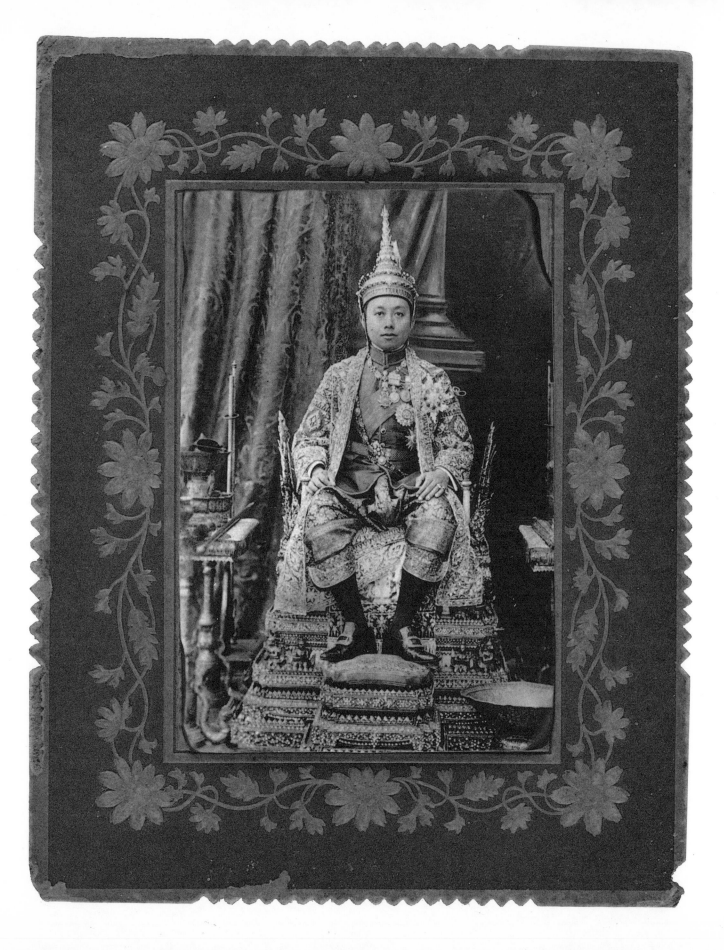

CRAFTS AS SYMBOLS
OF STATUS

IN 1957, following reports of items being sold by antique dealers, officials of the Thai Fine Arts Department began excavations near the base of the central *prang*, or tower, of Wat Ratchaburana in the former capital of Ayutthaya. The temple dates from the early 15th century and its remains are among the most imposing in the old city, which was almost totally destroyed following defeat by the Burmese in 1767. In a secret crypt near the base of the rounded, Khmer-style structure – a symbolic representation of the sacred Mount Meru – the diggers came upon an extraordinary trove of some 2,000 rare objects, mostly gold, that had somehow eluded nearly two centuries of determined treasure hunters.

Research revealed that the objects had been placed in the tower after the death of an Ayutthayan ruler named King Intharacha in 1424. The king had three surviving sons, two of whom were determined to seize the throne and decided to settle their dispute in a battle on elephant-back. Both were killed and the crown went to the youngest son, not involved in the dispute, who went on to rule until 1448.

To make merit for his brothers in the time-honoured tradition, the new king built two *chedi*s in which their ashes were enshrined on the spot where they met their death. Later he also constructed Wat Ratchaburana, not far from his royal palace, and in the central *prang* placed some of their personal belongings as well as Buddhist votive offerings.

The Buddhist items included a large number of images in gold and silver, often decorated with precious stones, as well as votive plaques valued by present-day Thais because of their supposed powers, miniature *chedi*s and Bodhi trees, and thin sheets of gold inscribed with verses from scriptures, all displaying a high degree of refined craftsmanship. Most fascinating of all, however, were the personal objects, which offered rare evidence of the skills of early Ayutthayan artisans and also of the period's aristocratic tastes.

There were several model items of royal regalia, among them a spectacular 115-cm. sword with a double-edged iron blade and a scabbard of gold adorned with coloured gems set in classic floral and flame-like vegetal motifs, a fly-whisk fashioned from gold threads and a tiny gold shoe embedded with precious stones. There were two headdresses, one a small open-sided crown for a man to wear on his top-knot and the other for a woman, a fragile mesh of gold threads woven in a bonnet-like shape, with an opening at the rear to accommodate a bun of royal hair. Hundreds of pieces of jewelry were found, from rings to ornate pendants, as well as numerous accessories of royal life: vessels for perfumes and medicinal herbs,

LEFT *King Rama VI (r. 1910–25) in traditional royal dress during his coronation ceremony.*

9

betel-nut boxes with elegant designs, a ceremonial water flask on a gold stand, a cluster of gold areca palm-nuts and, perhaps the loveliest of all, a miniature gold elephant encrusted with gems, holding a garland in its raised trunk.

The Wat Ratchaburana treasures, being mostly in gold or silver, reflect only one part of a tradition of craftsmanship that can be traced to the earliest days of Thai culture. Crafts used in the daily life of ordinary people in the ancient past have nearly all vanished and can be imagined only through the few surviving examples or through the modern ones that presumably evolved from them; but of those created for royal and religious use, serving either a practical or a symbolic purpose, as well as some made primarily for export in the first capital of Sukhothai, there is an ample selection on which to draw.

A degree of controversy surrounds the origin of the Thai (or T'ai) race, but the most generally accepted theory, based largely on linguistic evidence, maintains that they migrated in a series of waves down from the southern Chinese provinces of Wangtung, Kwansi and Yunnan, probably beginning around the 1st century AD. The earliest groups settled in the far northern part of the present country, centred around such cities as Chiang Rai and Chiang Mai in a loose federation known as Lanna, which in time developed a culture and monarchy of its own. Others later ventured farther south, to the upper extremities of the fertile central plains.

Between the 6th and 9th centuries, known as the Dvaravati period, Buddhist Mon people established cities in the Chao Phraya river valley, one of the world's greatest rice-growing regions, and also opened trade routes to Cambodia, Burma and northern Laos. The Mons in turn gave way to the more warlike Khmers, who expanded their empire from Cambodia until it encompassed large areas of modern Thailand, particularly the north-east.

As they moved southwards, the Thais added a new ingredient to this mixture of races and cultures – from each of which they would borrow and adapt certain features. Their first recorded appearance on the stage of history comes in a Cham inscription of the mid-11th century, which refers to 'Syam' prisoners-of-war. A century afterwards they can be found among a procession of Khmer warriors on a bas-relief in the gallery of Angkor Wat. And still later we find a reference to them in an account by a Chinese named Chou Ta-Kuan, who spent a year in Cambodia from 1296 to 1297 as part of a diplomatic mission sent by Timur Khan, successor of Kublai Khan. Significantly, the relevant passage concerns a craft for which the Thais are still noted.

'The Cambodians are not given to raising silkworms or to cultivating the mulberry tree,' wrote Chou Ta-Kuan, 'and their women are entirely ignorant of sewing, dressmaking and mending. . . . Recently much attention has been given by Siamese settlers in this country to raising silkworms and cultivating mulberries; their mulberry seed and silkworm stock all come from Siam. . . . The Siamese use silk to weave the dark damask-like textiles with which they clothe themselves.'

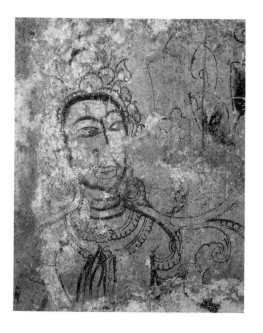

Detail of a mural painting from the 15th-century crypt of Wat Ratchaburana in which the treasure was found. It shows figures adorned with royal ornaments.

When this was written, the Thais had already shown themselves to be a significant force in the regional power balance. Indeed, in 1238, by which time they outnumbered their titular Khmer overlords, they had overthrown them and established a kingdom of their own called Sukhothai, which in Pali means 'Dawn of Happiness'.

Sukhothai's independence lasted less than two centuries, but it looms large in Thai cultural history for several reasons. Here an accessible, paternalistic system of monarchy was established – in striking contrast to the formidable god-kings of Angkor – the Thai alphabet was devised, and the first truly Thai elements made an appearance in Buddhist art and architecture.

The capital is also remembered for the fine ceramics produced in kilns located first outside its walls and later near the satellite city of Si Satchanalai, where the clay was superior. Thai ceramics became a thriving export during the 14th century. They were carried by Indian, Arab and Chinese traders to neighbouring countries; some idea of the quantities can be gained from the fact that a sunken ship found in the Gulf of Thailand in the 1970s contained a cargo of almost 4,000 pieces, and thousands of others have been found in Indonesia, Borneo and the Philippines, the main customers of this early Thai craft.

The next major Thai capital was Ayutthaya, founded in 1350 in the heart of the rich Chao Phraya river valley. It began as a small fortified island city but eventually grew into one of the major powers in Southeast Asia, absorbing both Sukhothai and the northern kingdom of Lanna and ruling a vast territory for more than four centuries. Highly cosmopolitan, Ayutthaya attracted numerous outsiders and new cultural ideas. Of the Europeans, the Portuguese were the first to arrive, in 1512, and they were soon followed by the Dutch, the Spanish, the English and the French.

Embassies were exchanged between the court of King Narai (1658–88) and that of Louis XIV, the Thai delegation bringing a vast assortment of presents for the French king and his family when they sailed to distant Europe on their mission. Many of these were of foreign manufacture, particularly Chinese and Japanese, reflecting an early Thai fondness for imported goods; but a substantial number had been produced by Ayutthayan artisans and ranged from gold and silver tableware to brocaded silks. The Thai delegates created a sensation with their exotic clothes, which were made of a kind of weft *ikat* silk in subtle patterns that was then, as it is still today, a speciality of northeastern weavers and an indication in Thai society of the rank of the wearer. These textiles were soon being copied by local silk manufacturers, and by 1873 had become so familiar that a French dictionary defined 'Siamoise' as 'a material of silk and cotton mixture in imitation of the silks worn by the Siamese Ambassadors sent to the court of Louis XIV.'

In both Sukhothai and Ayutthaya, as well as in the northern Lanna kingdom, a substantial part of the creative energy was expended on the creation of Buddha images and on construction and decoration of the temples that enshrined them. At

Glazed figurine made in kilns at Sukhothai, the first independent Thai kingdom, established in the early 13th century.

the same time, however, there was a need for other items, often requiring the same skills, to be used by the king and other royalty in both their personal and ceremonial lives: regalia, for example, that symbolized the monarchy and defined status, jewelry of superior quality, countless beautiful bowls, cups, urns, trays and other receptacles that were not only part of palace furnishings but also presented as gifts to foreign rulers.

Production of such refined crafts increased enormously in the Ayutthaya period. Royal palaces, which at Sukhothai had been relatively simple wooden structures, became magnificent affairs symbolizing the celestial abode of Hindu gods and decorated accordingly.

To supply these needs, a large body of *chang*s evolved, passing their specialized skills down from master to apprentice and eventually forming a hierarchy of their own. They were never regarded as artists in the Western sense but rather as superior manual labourers; even in early Bangkok, the names of only a handful of gifted mural painters, goldsmiths and woodcarvers were preserved for posterity; but they formed a significant segment of Ayutthayan society and played a major role in its cultural development. A similar development took place in Chiang Mai, where a collection of artisan villages grew up outside the walls to produce local versions of lacquer, woodcarving, silver and other crafts for which the region is still noted.

Most of Ayutthaya's historical records, as well as its more perishable crafts, were lost when the city fell to the Burmese in 1767, but it seems probable that artisans

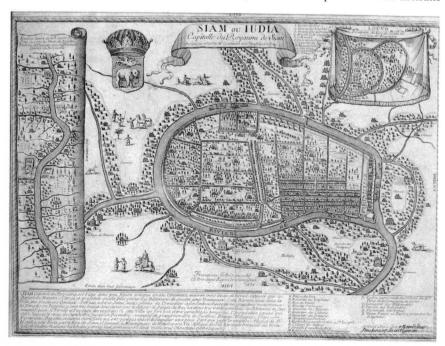

LEFT *17th-century map of Ayutthaya, the Thai capital for more than four centuries, which was centered on an artificial island in the fertile Chao Phraya river valley.*

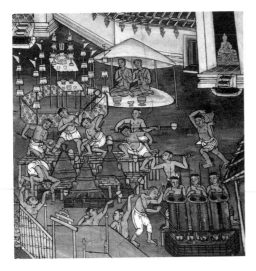

Detail from a mural painting at Wat Bovornivej in Bangkok, showing bronze casting, one of the classic Thai changs, or crafts.

who worked on royal commissions were grouped by category as they were in the early Bangkok period. Some of these categories overlapped, and some of the Thai terms for them that have been passed down through historical chronicles are obscure; for the sake of convenience, however, they are usually divided into ten classic crafts:

(1) Drawing (which includes lacquer painters, muralists, manuscript illustrators, engravers and draughtsman);

(2) Engraving (which includes ornamental, architectural and sculptural wood-carvers, precious metal inlayers, jewelers and seal-engravers);

(3) Turning (lathe workers, carpenters and joiners, ivory carvers and cabinet workers, often working together with other specialists);

(4) Sculpting (not in stone, as for Buddha images, but rather decorative fruit and vegetable carvers and makers of banana-leaf items used for ceremonies);

(5) Modelling (bronze casters, dance mask-and-puppet-makers, stucco and clay figure modellers);

(6) Figuring (makers of animal and mythological figures, dummies, possibly also puppets and masks);

(7) Moulding (makers of clay and beeswax moulds; part of the work of bronze and metal casting);

(8) Plastering (plaster craftsmen, bricklayers, makers of Buddha images out of brick, plaster and stucco);

(9) Lacquering (involves the finishing of a variety of crafts, including lacquer-work, glass mosaic, mother-of-pearl inlay, and gilding);

(10) Beating (metal beaters, closely related to, but distinct from, makers of monks' bowls, jewelry and small Buddha images).

All these artisans were called on to continue their work with the establishment of a new capital at Bangkok. After the near-total destruction of Ayutthaya, Thai forces rallied with remarkable speed, expelled the enemy and moved the seat of government to Thonburi, on the west bank of the Chao Phraya river. A military leader, who ascended the throne in 1782 as King Rama I and founded the present Chakri dynasty, decided that the site was vulnerable to attack and proposed a move to the opposite side of the river, where he began construction of his palace that same year.

For much of the 19th century, the ruler, his court and various high officials lived amid settings of great traditional splendour. The centre, both spiritual and temporal, was of course the mile-square Grand Palace compound, which also included the temple that enshrined the sacred Emerald Buddha, regarded as the kingdom's palladium. In audience halls lavishly decorated with gilded glass mosaics, gold and black lacquer painting, ornate woodcarvings and mother-of-pearl inlay, the king, seated on a magnificent raised throne sheltered by a nine-tiered white canopy, received petitions and visiting dignitaries. His attendants, clad in

special clothes to denote rank, approached him on their hands and knees and kept their heads as low as possible.

Richness of detail was a characteristic of the period, with classic motifs covering much of the surface on everything from woodcarving to goldwork, calling for both technical skill and immense patience. These motifs included natural elements such as flowers, leaves and vines, as well as various divinities from Hindu mythology associated with royalty. During the reign of King Rama III, Chinese design elements became more popular, often blended with older Thai ones in distinctive ways.

Outside the palace, princes, court officials and an increasingly large number of wealthy commoners enjoyed luxuries only slightly less impressive. They, too, required numerous items that reflected their status in society, and many assembled a substantial staff of artisans to produce them.

An extraordinary renaissance of Thai art resulted from the needs of these various classes, not to mention the adornment of countless new temples built at the time, using and in some cases refining skills that had developed over past centuries.

Craftsman making a bowl decorated with gold and black lacquer designs, a process known as lai rod nam, *literally 'ornaments washed with water'.*

Lacquer

The earliest known pieces of Thai lacquerware date from the Ayutthaya period, but it almost certainly goes back much farther and may have been brought from China with the first migrant groups. The craft is regarded as traditional in Chiang Mai, where it has long been made by a Thai tribal group known as the Khoen, who originally settled in one of the artisan communities around the city.

The resin used is obtained by tapping a tree (*Melanorrhoea usitata; rak* or *hak* in Thai) which once grew widely in the north and still does in neighbouring Burma; the milky sap that results turns yellow-brown and then black on exposure to air. This is applied in layers to wood, pottery or shaped objects made of stripped woven bamboo, allowing each layer to dry and polishing it with a rough leaf or sandpaper – a process that can take weeks or even months. A red dye is often used in northern lacquerware, and distinctive regional designs are applied to the surface in black.

One of the most elegant arts of Ayutthaya, continued in Bangkok, was that of gold and black lacquer painting, or in Thai *lai rod nam* (literally 'ornaments washed with water'). Though the technique was developed in China and many Chinese ornamental elements can be found, it acquired distinctively Thai features and, in the best examples, resembles the complex mural paintings that cover almost the entire surface of temple walls.

Requiring immense skill on the part of craftsmen, the art was brought to a peak of perfection in the early Bangkok period and used to adorn temple and palace doors, window panels, ceremonial bowls, screens, boxes and cabinets to hold Buddhist scriptures and the personal belongings of wealthy patrons. The subject-matter of such paintings was often drawn from Buddhist legends, but secular themes were also used, particularly the epic *Ramakian*, the Thai version of the Indian

Ramayana, or the surface was covered with flowing designs of flowers, trees and other landscape features. Objects decorated in *lai rod nam* for aristocratic houses – particularly square storage boxes with flat or tiered lids – were frequently donated to monasteries following the death of their owner as a form of merit-making.

Mother-of-pearl inlay

Another probable legacy from China which was included in the general craft of lacquering, mother-of-pearl decoration can be traced back as far as the 6th century AD, when it was used in the stucco embellishments of a Dvaravati temple. It flowered fully, however, during the late Ayutthaya and early Bangkok periods, when it attained high levels of beauty and refinement. The shell used is called *muk fai*, meaning 'mother-of-pearl with flame', which has a particularly rich opalescent lustre and is said to come only from the Gulf of Thailand.

Like gold and black lacquer painting, mother-of-pearl inlay was used extensively during the early Bangkok period to adorn royal food containers, boxes with sloping sides in which clothing presented by the king to nobles was kept, furniture, musical instruments and Buddhist objects of worship; among the most famous examples are the designs on the soles of the feet of the enormous Reclining Buddha at Bangkok's Wat Phra Chettuphon, made during the reign of King Rama II, which depict the 108 auspicious Buddhist symbols.

Closely allied to mother-of-pearl inlay were glass mosaics set in lacquer, which required similar skills. The most spectacular examples are those on Buddhist temples, covering extensive areas such as walls and columns, but the craft was employed as well on a variety of objects, among them finely detailed trays on which to present offerings to Buddhist monks.

Goldwork

As vividly shown by the treasures found in Wat Ratchaburana, the goldsmiths of early Ayutthaya were skilled to a high degree. Though surviving evidence is scant, the same was undoubtedly true in Sukhothai; engraved line drawings at a Sukhothai temple called Wat Si Chum, dating from around 1350, show figures wearing elaborate crowns, necklaces and other adornments that very likely reflected royal fashions of the time, and a famous stone inscription of 1292, attributed to King Ramkhamhaeng, specifically notes that people were free to trade in silver and gold. In addition to jewelry, such artisans were also responsible for the production of countless other items used by the royal family and high-ranking officials – cosmetic jars, betel-nut containers, tableware, decorations for elephant howdahs and palanquins, and an enormous number of ceremonial and everyday vessels. Though their work was closely related to the classic craft of beating, goldsmiths in Ayutthaya and early Bangkok were elevated to a special category sometimes called Suwannakit, denoting that they worked on royal commissions.

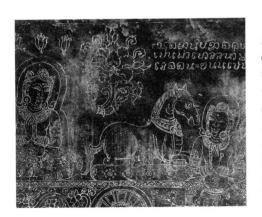

Stone engraving at Wat Si Chum in Sukhothai, showing royal figures wearing 14th-century adornments.

From the examples that remain, as well as from accounts by early travellers, it is clear that these finely wrought gold creations were not intended merely – or perhaps even primarily – to satisfy a desire for personal adornment and luxurious household accessories. Instead, they symbolized rank and authority, sometimes accompanied by supernatural powers.

Certain gemstone combinations were reserved exclusively for the highest figures. The most famous of these was the Brahman-derived belief in the Nine Gems – Nopparat in Thai – which symbolized various components of the universe and also brought individual powers to those allowed to wear them. In Thailand, the stones concerned were the diamond, the ruby, the emerald, the yellow sapphire, the blue sapphire, the garnet, the moonstone (sometimes the pearl), the zircon and the cat's eye. In combination, these were believed to have special powers; military leaders wore gold sashes embedded with jewels when they rode into battle on their war elephants, and some rulers of Ayutthaya wore not only a solid gold Nopparat ring but also nine others, each set with a separate stone and a chain with a similar pattern.

'Siamese goldsmiths are scarcely less skilled than ours,' wrote a French Jesuit missionary named Nicholas Gervais in the late 17th century. 'They make thousands of little gold and silver ornaments, that are the most elegant objects in the world. Nobody can damascene more delicately than they nor do filigree work better. They use very little solder, for they are so skilled at binding together and setting the pieces of metal that it is difficult to see the joints.'

Goldwork was among the crafts that emerged with renewed vigour in King Rama I's Bangkok, one of the most valued because splendour was a key element in plans for the new capital. This can be clearly seen in the all-important Royal Regalia made at the time, most of which is still used in the coronation of each Chakri ruler.

Another important task of the early goldsmiths was making seasonal costumes for the Emerald Buddha, most sacred of all the kingdom's innumerable Buddha images. By tradition, these are changed by the king at the beginning of each session in a solemn ceremony. Two were made during the reign of Rama I, a crown and jewelry of gold and precious stones for the summer months and a gilded monastic robe flecked with enamel for the rainy season; cool season robes, consisting of a shawl of enamel-coated solid gold with gems that covers the image from head to toe, were presented by Rama III.

Nearly every foreign visitor to the Thai capital in the 19th century, especially those with entree to royal circles, has something to say about the profusion of ornaments worn by both men and women. The French Marquis de Beauvoir, who was granted an audience by Rama IV, was particularly struck by those of the children: 'Their small heads are shaved except for the crown, whence rises a little plait surrounded by a wreath of white flowers, fastened by sapphire pins; their bare chests are ornamented with various chains of precious stones, and their waists with

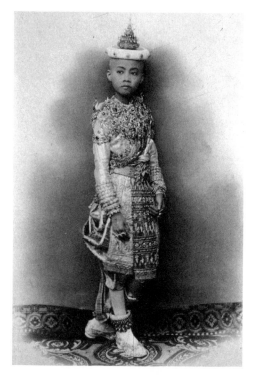

A Thai prince during the reign of King Rama V, dressed for the top-knot cutting ceremony which marked the official coming of age for both boys and girls.

a belt of some silvered material, from which hangs a scarf of pink and blue China silk; finally, seven or eight large rings, to which are attached pendants of sapphires and rubies, are attached above the ankle.'

Carl Bock, a Norwegian traveller who visited an exhibition held in 1882 to commemorate Bangkok's centennial, was impressed by 'a large glass case, in the centre of the room, containing a raised stand, in four tiers, the whole of which from top to bottom, glittered with gems, mounted and unmounted, some of large size – especially diamonds and rubies – set in snuff-boxes, bracelets, vases and rings, of all shapes and sizes.'

Rama V was the first Thai ruler to travel abroad, and among the many new ideas he brought back were novel jewelry designs. A large number were produced by famous European craftsmen, including Fabergé, sometimes incorporating traditional Thai motifs but often wholly Western; several foreign jewelers were encouraged by this interest to set up shop in Bangkok, where they were patronized by aristocratic clients who formerly used local artisans. The decline of Thai goldsmiths is suggested by Carl Bock's observation that 'The manufacture of gold and silver jewelry, which is carried on to a large extent in Bangkok, is entirely in the hands of the Chinese.'

Bock was probably overstating the case, as were those who claimed Thailand produced no silk at the time. Certainly, traditional Thai goldsmiths were at work in Petchaburi, southwest of Bangkok, and were receiving royal commissions; some of their descendants are still practising the craft today, creating typical 19th-century designs.

Nielloware

Production of nielloware, which some authorities believe was acquired from the Portuguese and others think arrived from Persia by way of India, became a speciality in the area around the far southern city of Nakhon Si Thammarat, known as Ligor to ancient travellers. It became so identified with fine Thai craftsmanship, especially in the late Ayutthaya period, that it was presented as gifts to foreign dignitaries, a tradition started in the reign of King Narai and still continued by the present royal family.

Nielloware has been used to decorate royal thrones (most notably the one in the hall where the present king receives the credentials of foreign ambassadors), manuscript covers and a wide variety of trays, boxes, bowls, urns, vases, teapots and similar containers found in wealthy homes.

Silverware

While silver was produced in both Ayutthaya and early Bangkok, the traditional centre of Thai silverware is Chiang Mai in the north. According to legend, some 500 silversmith families fled to the Chiang Mai area from Burma in 1284 as refugees

from Mongol invasions, and established the craft there; whether this is true or not, the rhythmic sound of silver being meticulously tapped is still common in the old city, and in many instances the art has been a family concern for generations. Moreover, Burmese influences have remained strong in both the shapes and patterns, and with certain old pieces it is difficult to tell exactly where they were produced.

Until fairly recently, the silver required came from old Indian, Indochinese and Chinese coins collected in the extensive trading that took place in the region. The coins, some of which yielded 92 per cent silver, were melted down, sometimes alloyed with small amounts of copper, and then pounded into thin sheets for production. This practice is still followed by some of the hill tribes who live in the mountains along the border, but in Chiang Mai itself the metal is more likely today to be imported from abroad and the average content is around 80 per cent for most objects.

A characteristic of northern silver is repoussé, more pronounced than the relatively flat patterns of Bangkok but shallower than those of Burmese bowls, on which figures can be raised as much as an inch from the background design. Connoisseurs of the ware look particularly for sharp, fine detail in the design; these usually indicate a high grade of silver, since intricate patterns and high repoussé designs can be successfully produced only by hammering silver that approaches sterling in alloy composition.

Typically northern patterns generally cover most of the surface, while a bowl that shows any expanse of smoothly polished surface is probably of Bangkok origin. Most traditional on Chiang Mai bowls and containers is a floral pattern; human or animal figures are more often found on Burmese-style silver, and lotus designs are commonly used on items presented to monks.

Woodcarving

Because of the climate, very few examples of pre-Ayutthaya woodcarving survive but this most visible – and some would say most characteristic – of Thai crafts was certainly a prominent feature of Sukhothai and also of the northern Lanna kingdom. Hardwood trees were plentiful in ancient Thailand and they supplied the material not only for homes and palaces – which before Ayutthaya were never made of stone – but also for the spectacular adornments of Buddhist temples.

In both Ayutthaya and early Bangkok, where there were few proper roads outside the immediate palace area, transportation was primarily by elephant, boat and, for royalty, carriage or palanquin. The palanquins, especially those used by the king, were lavishly carved and gilded, and some required as many as 60 men to carry them. The largest and most elaborate – many consisting of a throne-like seat sheltered by a wooden pavilion – were limited to ceremonial occasions and covered relatively short distances; others were carried by only eight men but were often

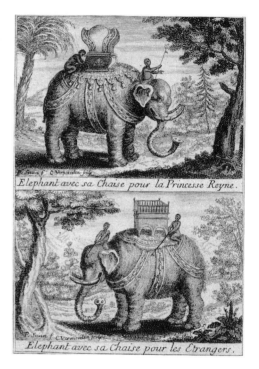

Elephant avec sa Chaise pour la Princesse Reyne.

Elephant avec sa Chaise pour les Etrangers.

French impressions of Thai royal elephants during the reign of King Narai of Ayutthaya in the late 17th century.

RIGHT *French engravings of royal barges in 17th-century Ayutthaya, from an account of his visit by Simon de La Loubère.*

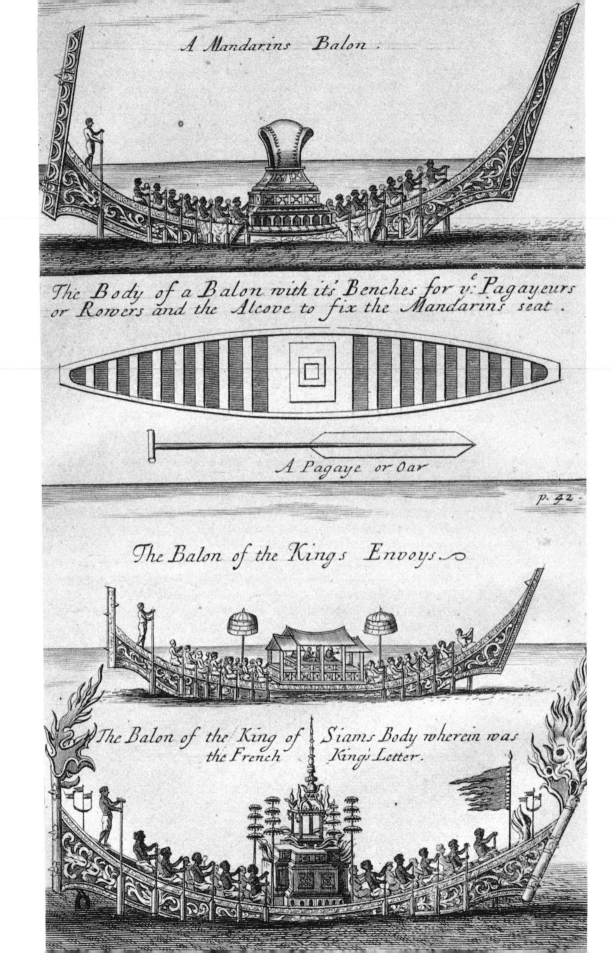

A Mandarins Balon.

The Body of a Balon with it's Benches for y.ͤ Pagayeurs
or Rowers and the Alcove to fix the Mandarin's seat.

A Pagaye or Oar

p. 42.

The Balon of the Kings Envoys.

The Balon of the King of Siams Body wherein was
the French Kings Letter.

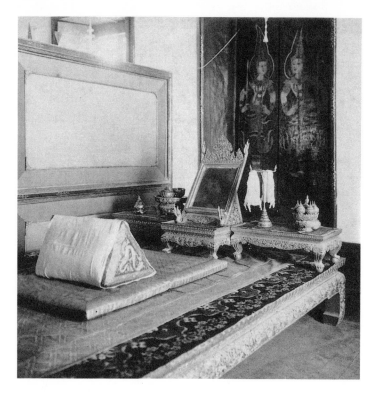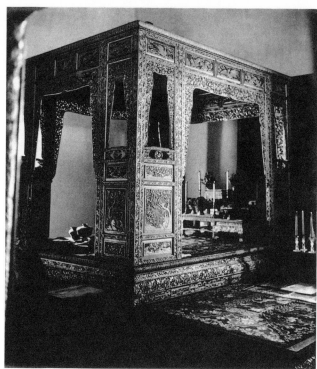

equally ornate, decorated with intricate carvings or silver-and-gilded nielloware. One kind used by ladies of the inner palace had walls on three sides and an elegant roof adorned with gilded lacquer and inlaid glass mosaic.

Elephant howdahs, too, reflected status. The general design was similar in various parts of the country, though the type of wood and the adornments differed according to who was using it. The simplest, for commoners, are called *sapakhab* and are merely seats with raised sides and back and splayed legs designed to fit over the animal's back near the head, while royal howdahs – called *phra thinang praphasthong* or *phra thinang lakho* (*phra thinang* being a general term for halls or seats used by royalty) – were made of more valuable wood and decorated with carvings or inlaid ivory designs. Some had roofs of lacquered bamboo with cloth or paper lining on the interior.

Boats were a part of every household, ranging from simple canoes hewn from a log to spectacular craft used in war and royal processions along the waterways that formed the principal means of communications. It was on the latter that the art of woodcarving was displayed in the most memorable forms.

The missionary Nicholas Gervais observed that 'Those belonging to the great mandarins are usually for fifty to sixty oars. There is a kind of small throne in the middle ... on which they sit. It is only made of wood and mats, but is of elegant appearance and very comfortable to sit on.'

Sir John Bowring, the English diplomat who came to negotiate with Rama IV in 1855, was assigned six state boats and six accompanying ones to carry him from the mouth of the Chao Phraya to Bangkok. 'Mine was magnificent,' he wrote in his journal. 'It had the gilded and emblazoned image of an idol at its prow, with two flags like vanes grandly ornamented. Near the stern was a raised carpeted divan, with scarlet and gold cushions....'

ABOVE LEFT *Bedchamber of a royal lady, with carved bed, dressing table and various accessories.* ABOVE RIGHT *A carved and canopied royal bed from early Bangkok, showing Chinese influence.*

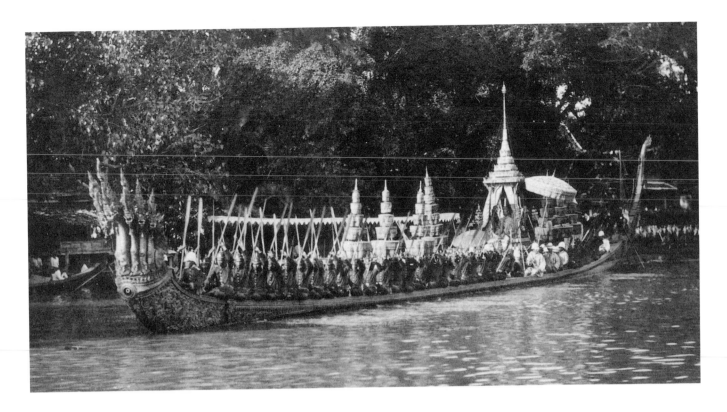

Royal barge from late 19th-century Bangkok with the prow in the shape of a multi-headed naga.

The grandest of the royal barges, of course, was that used by the king himself in processions that might consist of more than a hundred craft of varying sizes. The one at present on display in Bangkok, known as the Subhanahongsa, dates from only 1911, but was a close replica of the original made at the start of the Bangkok period. Over 46 meters long, it is made from a single piece of teakwood and has a prow carved in the shape of a Hamsa, a mythological swan-like steed of Brahma, with protruding eyes and flared nostrils; feathery carvings, gilded and studded with glass mosaics, cover the sides of the barge and rise to a flame-like tail at the stern.

Carriages also served as royal transport, extensively carved with figures from Hindu mythology to protect the occupant from harm and symbolize his semi-divine status. These were more often seen at cremations, when they conveyed royal remains in a sandalwood urn to the funeral pyre; but Rama I had a number constructed for his own use. The most famous of existing funeral chariots, dating from the first reign and now at the National Museum, is known as the Vejayant Rajarot, or great Chariot of Victory; symbolizing Mount Meru, the heavenly abode the deceased is about to enter, it is made of teak carved, gilded and inlaid with glass mosaic, and weighs 40 tons.

The furniture commissioned for palaces and aristocratic homes, at least until the mid-19th century, was nearly all inspired by Chinese models, particularly beds with carved canopies, couches with lion-paw feet, and long benches decorated with bas-relief floral patterns. Also adapted from China, though given certain local features, were one-piece screens on bases to provide privacy and mirrors mounted on low dressing tables to accommodate the Thai custom of sitting on the floor. More distinctively Thai were tall rectangular cabinets, tapering inwards at the top, with legs that curved outwards or inwards and door panels adorned with gold and black lacquer or carved wood; after their owner's death, such cabinets were often donated

to monasteries, where they were used to keep religious scriptures and other items.

Western influences appeared during the reign of Rama IV, leading to the introduction of cabinets with glass panels for printed books rather than Buddhist manuscripts, as well as chairs and tables. At first limited to the palace – when Sir John Bowring visited the king's private quarters, he noted life-sized statues of Queen Victoria and Prince Albert and 'all the instruments and appliances which might be found in the study or library of an opulent philosopher in Europe' – such features soon spread to the homes of outside aristocrats and wealthy traders, and spelled the virtual end of traditional furniture except that made solely for religious and ceremonial use.

Bencharong

Florence Caddy, who visited Bangkok in 1889 as a guest aboard the Duke of Sutherland's yacht, was disappointed when she went to a local market and found no Bencharong, which she had possibly seen in the royal palace where the Duke's party was accommodated by King Rama V. This she described as 'old enamelled terracotta ware, with floral decorations, or figures of Buddha and lotus leaves … not quite like Persian nor Chinese [but] just Siamese.'

The ware was in fact Chinese-made at the time, which raises the question of whether it deserves inclusion as a Thai craft. On the other hand, since so many of its features – both shapes and design motifs – were unmistakably Thai and since it was a prized possession of royal palaces and upper-class Thai homes, some mention seems inevitable for the benefit of those who come across the numerous examples being produced today in Thailand.

The art of ceramic production had declined with Sukhothai, but during the early Ayutthaya period potters made a somewhat crude multi-coloured earthenware known as Bencharong – a term based on the Sanskrit words *panch*, meaning five, and *rang*, meaning colours, thus literally 'five-coloured'. Increasingly, though, rulers and high nobility turned to China for the finest items to adorn their residences. Starting in the 17th century, the Chinese began to produce high-quality Bencharong with unique Thai designs, exclusively for export to Thailand. These were over-glazed enamel wares, first developed in the reign of the Emperor Ch'eng-hua (1465–87) but not made for export until the reign of Wan-li.

Bencharong received several firings, the coloured enamels added over the glaze in a descending scale of temperatures to fuse them to the surface. The earliest, decorated with swirling flame-like motifs and Thai-style *thepanom*s, or celestial beings, usually against a black background, were made for the royal household, mainly such utilitarian items as rice bowls, stem plates and covered waterjars.

The greatest period of Bencharong production took place in early Bangkok, when some of the most beautiful pieces arrived aboard the junks that traded with the new capital. Ayutthaya-style wares with *thepanom*s, *rajasingha*s (royal lions)

and *kinaree*s (mythological half-bird half-woman creatures) continued to be made, but new designs and colours were also introduced. The Garuda – the half-bird half-man mount of the god Vishnu and a symbol of Thai royalty – became popular, along with a twisting stem motif known in Thai as *lai kan kod* (adapted from India). Characters from the *Ramayana* appeared in the reign of Rama II, a noted artist who is believed to have designed personally a set of tableware for the palace.

A related art was Lai Nam Thong, in which gold was applied to the ceramics, enhancing their rich appearance. One of Rama II's queens ordered a set of this ware, which had Chinese as well as Thai motifs. Lai Nam Thong was always reserved for royalty, and Thai craftsmen were sometimes sent to China to supervise its production.

Bencharong imports declined during the reign of Rama III, when a decision by the Chinese Emperor Tao-kuang to reduce orders for Imperial porcelains led to a drastic drop in the numbers of kilns at Ching-te-chuan. They resumed under Rama V, who ordered some of the finest Lai Nam Thong wares for his dinner table, where Florence Caddy may have first admired their gleaming gold backgrounds and intricately detailed decorations.

Production ceased upon the overthrow of the Manchu dynasty, and for many years thereafter the only Bencharong available were old pieces that came on the markets when their owners were in need of money. In the past few decades, however, several Thai companies have started making the ware locally, for the most part following traditional patterns and shapes, and this has resulted in renewed interest among a younger generation.

Basketry

The utilitarian baskets that play a vital role in every Thai village appear also in more reformed forms for aristocratic use. In these the difference can be found not only in an obviously higher quality of workmanship, but also sometimes in the basic material.

Perhaps the outstanding examples of such basketry are those woven from the thin, polished stems of a durable, fern-like vine called *yan lipao*, which grows abundantly in southern Thailand. The craft developed in Nakhon Si Thammarat province and by the early Bangkok period was being used to produce elegant trays, containers, betel-nut boxes and other household items, some of which are still being used today.

Yan lipao production suffered from competition with Western imports and might have disappeared altogether had the present Thai Queen not been impressed by the beauty of specimens she came across in the palace collection and decided to include the craft among those in her Foundation for the Promotion of Supplementary Occupations and Related Techniques, popularly known as SUPPORT, which encourages the revival of traditional skills as a means of increasing rural income. A

yan lipao project was started in 1974 in the southern province of Narathiwat, where the royal family has a residence, using craftsmen from Nakhon Si Thammarat to train students; today the basketry is produced in a number of places and many aristocratic ladies are following the Queen's example and using it for distinctive handbags.

Another project supported by the Queen is basketry made by a supplementary weft technique known in Thai as *khit*, similar to that used in weaving cloth. Once common in the northeast, this employs tiny, almost thread-like strips of dried bamboo, some dyed and others left their natural colour. Large strips are used to weave the frame of the desired object, while smaller strips are interwoven to create patterns, usually geometric; the rim and handle are reinforced with rattan.

These crafts, produced primarily for an upper-class clientele, suffered far more than those at the village level as a result of the Westernized tastes that swept Bangkok in the latter half of the 19th century. 'One of the first to go', wrote Dr Malcolm Smith, 'was the weaving of brocades and embroideries in silk and gold thread. Its disappearance was brought about, not by the introduction of cheaper and better products from Europe, but by the change of fashion in dress, particularly that of the men. In the two chief towns of the north . . . where the industry had been in existence for hundreds of years, it had attained a very high degree of perfection. For intricacy of design and richness of colouring the fabrics made there compared well with any of their kind made in other countries. They provided the materials for the dress, the robes of office, worn by nobles and officials at Court functions.

'With the introduction of the uniform, which began as soon as Chulalongkorn came to the throne, those garments were discarded.'

Such rich textiles did not, in fact, vanish – the skills to produce them were still available to meet the demands of a notable revival of interest just after the Second World War – but certainly they, along with other status-oriented crafts, were seriously affected. Royal polygamy ended during the reign of Rama VI, and the teeming women's world of the Inside Palace slowly emptied; during the following reign the absolute monarchy itself came to an end and, along with it, most of the great princely establishments which had provided both haven and patronage for many artisans. The economic travails of the Depression years, followed by the war, were hardly conducive to wide-scale production of elegant betel-nut boxes in gold niello or superbly decorated cabinets.

One of the major factors that kept such skills alive, however, was a continuing demand for numerous objects used in traditional ceremonies. Throughout social and political change, these have remained a vital part of the culture; with the rise of a new leisure class, they have also come to represent something uniquely Thai and therefore worth preserving.

1 RIGHT *On a low table carved with a floral pattern are displayed an assortment of finely crafted silver trays and containers used for betel-nut; the raised designs are characteristic of northern silver. Such accessories were a mark of status and were highly prized by their aristocratic owners.*

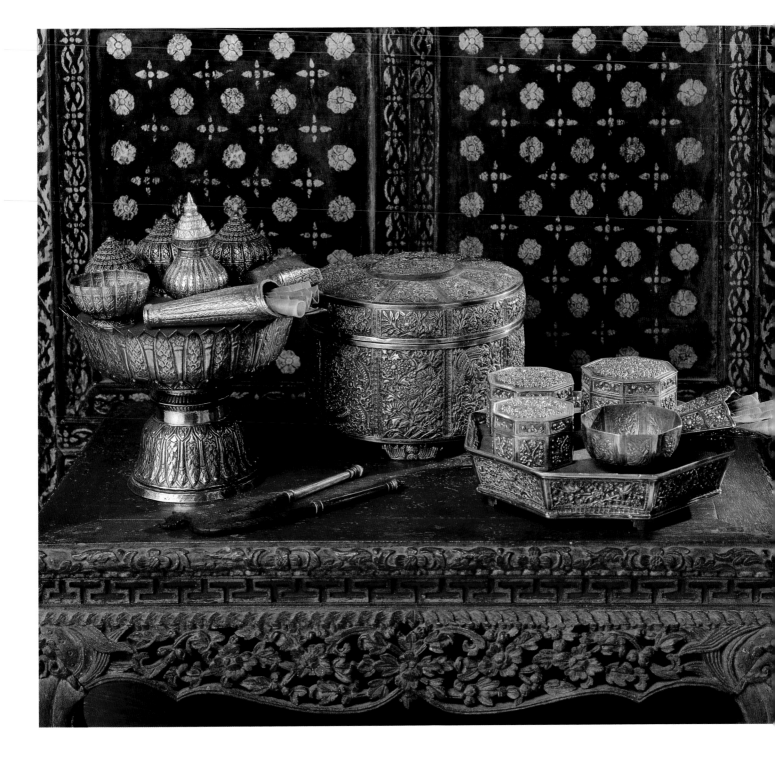

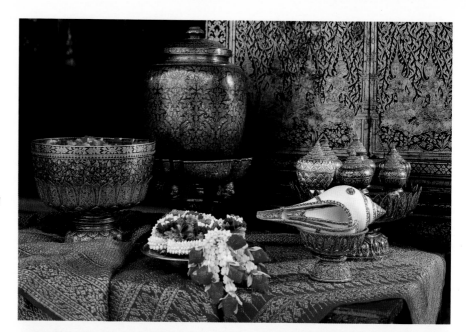

2–5 BELOW AND BOTTOM *Gold neilloware, among the finest of Thai crafts, once reserved for the exclusive use of royalty.* RIGHT *Gold nielloware bowls and covered containers; the gold trimmed conch shell is used to pour lustral water in a variety of Brahman-inspired ceremonies.* BELOW RIGHT *Teapot, box and betel-nut accessories in gold nielloware.*

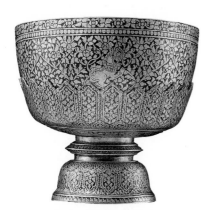

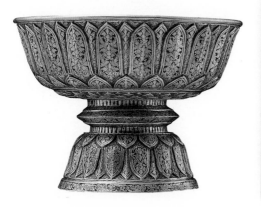

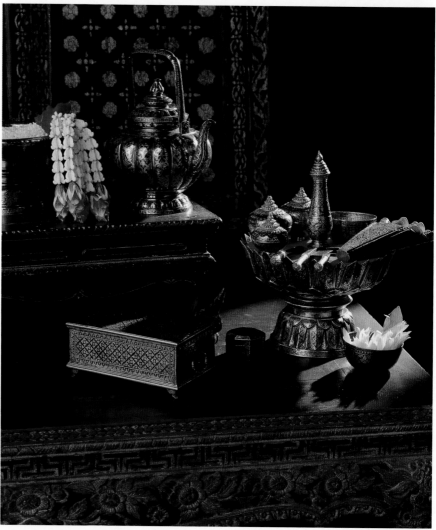

6 BELOW *Gold nielloware, some further embellished with enamel, used in aristocratic households of the past to hold cosmetics, medicines and betel-nut ingredients. Nielloware was a famous craft of the southern city of Nakhon Si Thammarat.*

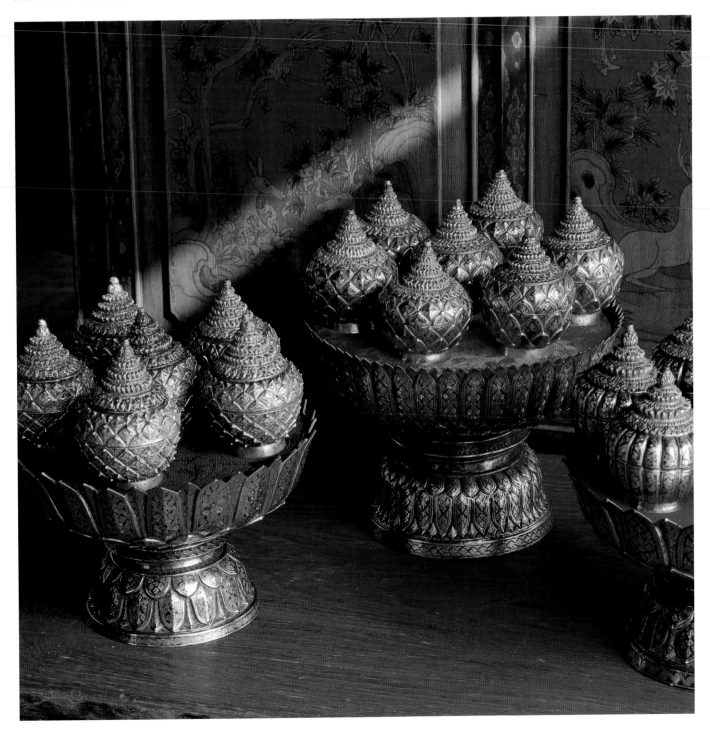

7–10 *Gold items made for royal use in early Ayutthaya, part of a remarkable collection discovered in a crypt at Wat Ratchaburana in the former capital. They were placed in the monument around 1424 in memory of two royal princes killed during a battle over the throne.*

11 RIGHT *Printed textile with traditional Thai designs, most of them using the classic* kanok *motif, and jewelry fashioned by goldsmiths in early Bangkok. The quality of the gemstones in such ornaments was considered less important than the beauty of the elaborate settings.*

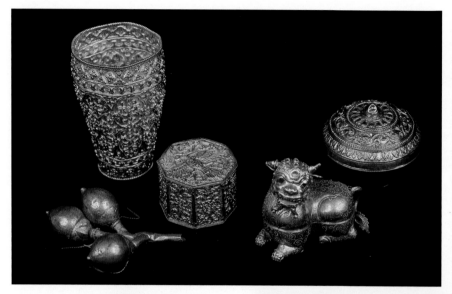

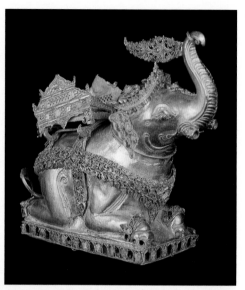

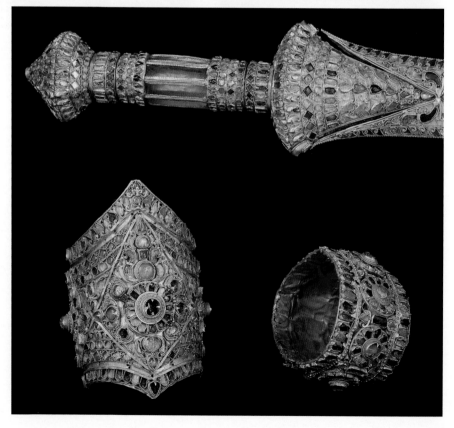

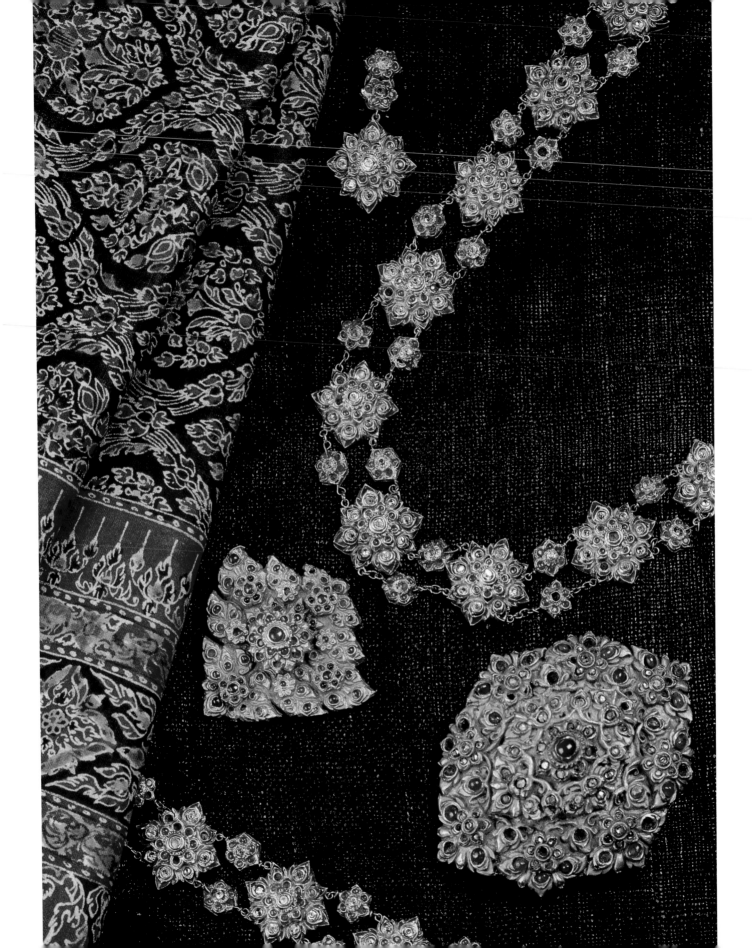

12–14 BELOW LEFT *Silver containers for leaves used in betel-nut chewing.* BELOW RIGHT *A group of silver boxes, in shapes typical of northern Thailand.* BOTTOM *Footed silver vessels used in royal ceremonies for the presentation of food and other offerings; the ones on the right are gold plated.*

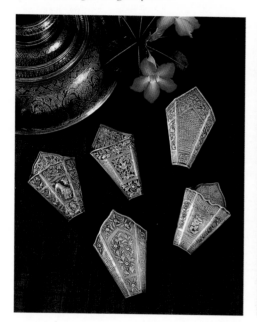

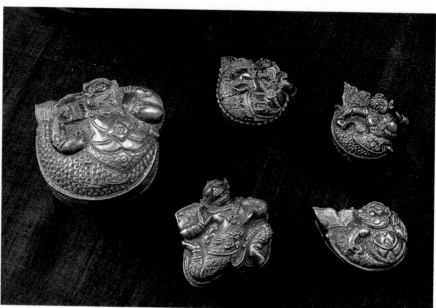

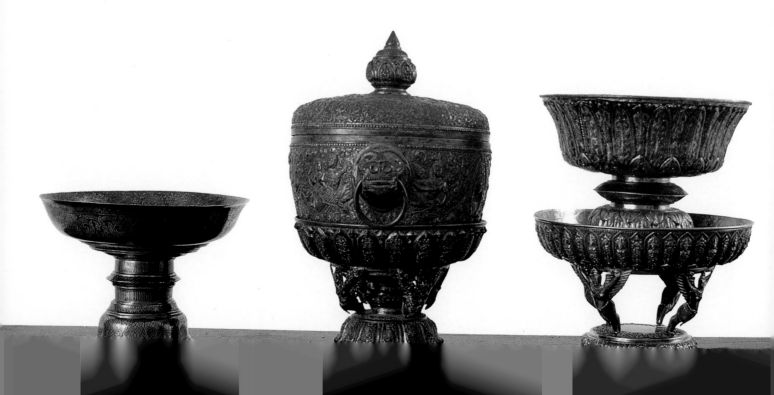

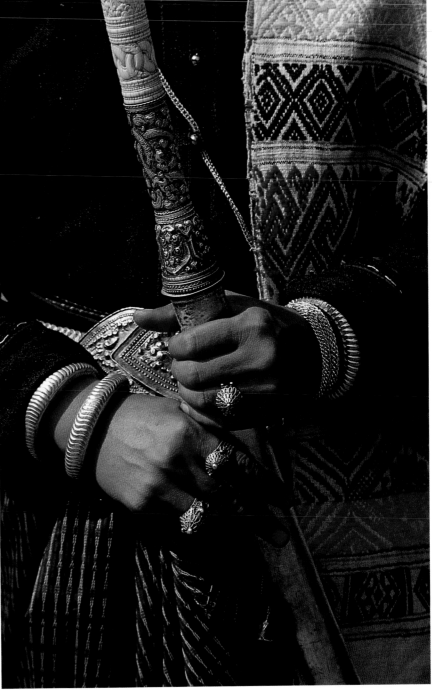

15–18 TOP *Carved deer-horn handles for knives and swords, indicating the rank of the owner; from northern Thailand.* ABOVE *Silver pendant of Lanna Thai workmanship.* BELOW *Silver belt buckle.* RIGHT *Silver ornaments and sword used during a ceremony in the northern province of Lampang.*

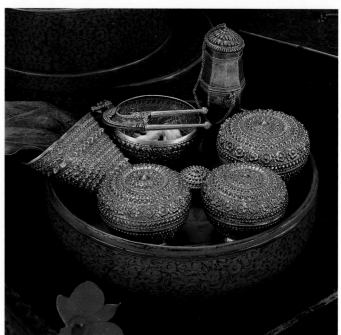

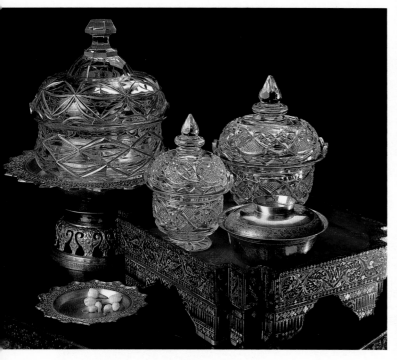

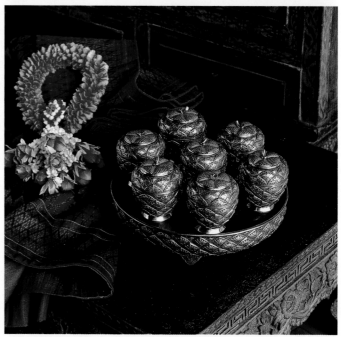

19–21 ABOVE *Crystal and silver items, crafted in Europe in characteristic Thai shapes; the footed stand is decorated in mother-of-pearl inlay, a popular form of adornment in both Ayutthaya and early Bangkok.* ABOVE RIGHT *Silver betel-nut accessories from Chiang Mai in a lacquer container.* RIGHT *Silver boxes with a fruit design, trimmed with gold; the footed tray displays the same motif.*

22–24 OPPOSITE *Examples of Bencharong, a multi-coloured overglaze enamel ware made in China for export to Thailand, starting in the late Ayutthaya period. Earlier pieces like those shown* ABOVE LEFT *and* BELOW *had traditional Thai motifs and figures from Thai mythology. The covered bowls shown* ABOVE RIGHT *are a later form called Lai Nam Thong, in which gold was applied to the ceramics and the designs were often Chinese.*

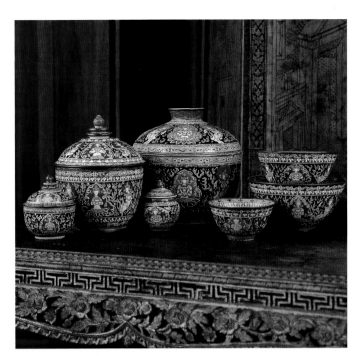

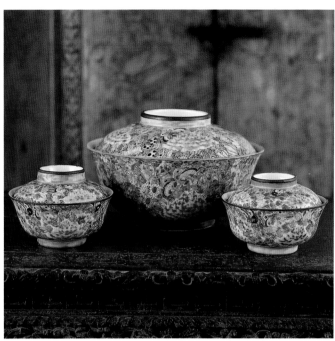

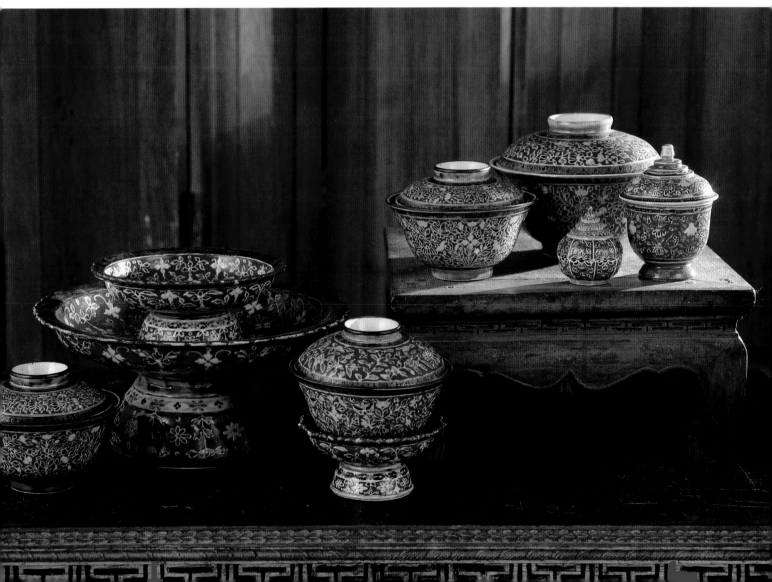

25 Mother-of-pearl inlay was used to decorate a wide assortment of items, including ceremonial trays, bowls, and furniture. The art, which probably came to Thailand from China, reached a high level of refinement in the late Ayutthaya and early Bangkok periods.

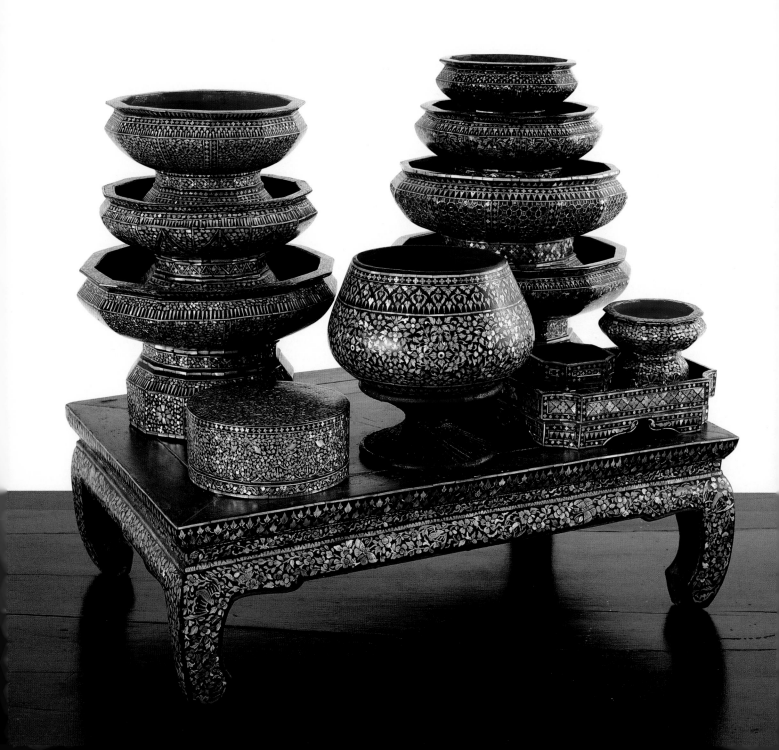

26–27 BELOW *Mother-of-pearl inlay design showing a* singha, *or royal lion; this covered box is from the Suan Pakkad Palace collection and was made for the son of a king.* BOTTOM *Design of a* kinaree, *a half-bird, half-human figure from Hindu mythology popular in classic Thai decoration; from a door at Wat Po in Bangkok.*

28–29 BELOW AND BOTTOM *Covered boxes, a footed presentation tray and a low table, all decorated with mother-of-pearl inlay. Such items were made for high-ranking households, sometimes by artisans who lived in the family compound, and reflected the status of their owners through refinement of workmanship and unusual shapes.*

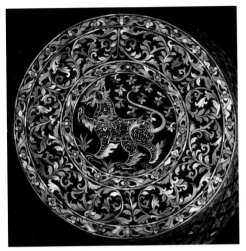

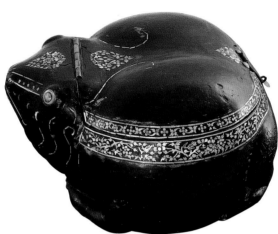

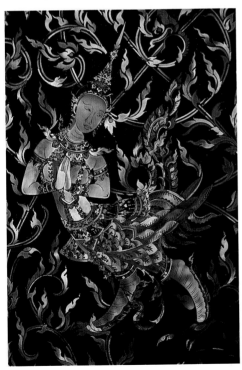

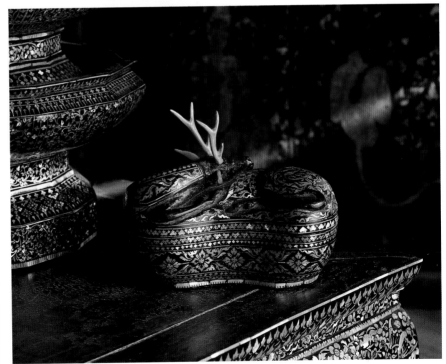

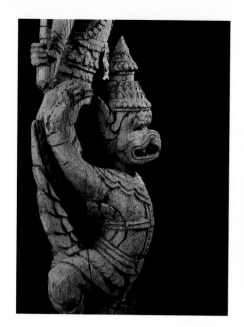 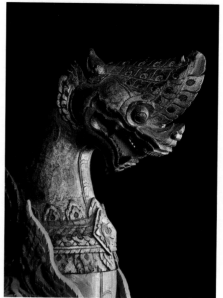 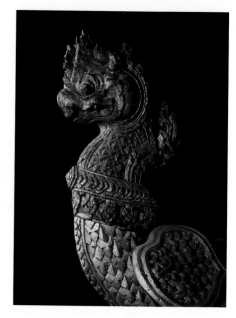

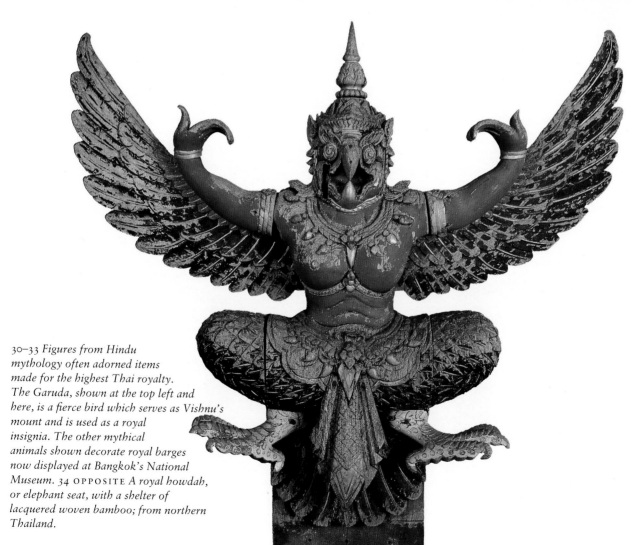

30–33 *Figures from Hindu mythology often adorned items made for the highest Thai royalty. The Garuda, shown at the top left and here, is a fierce bird which serves as Vishnu's mount and is used as a royal insignia. The other mythical animals shown decorate royal barges now displayed at Bangkok's National Museum.* 34 OPPOSITE *A royal howdah, or elephant seat, with a shelter of lacquered woven bamboo; from northern Thailand.*

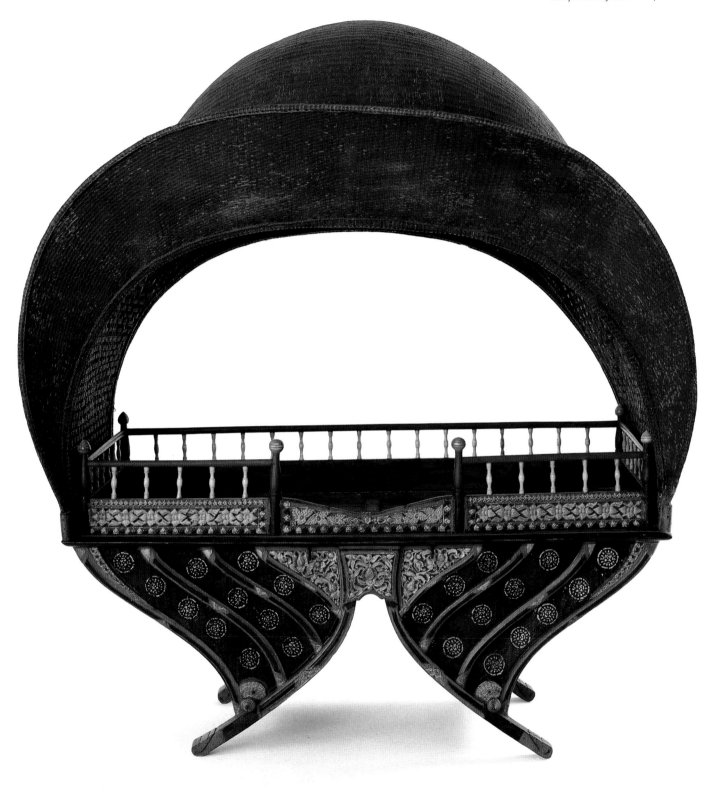

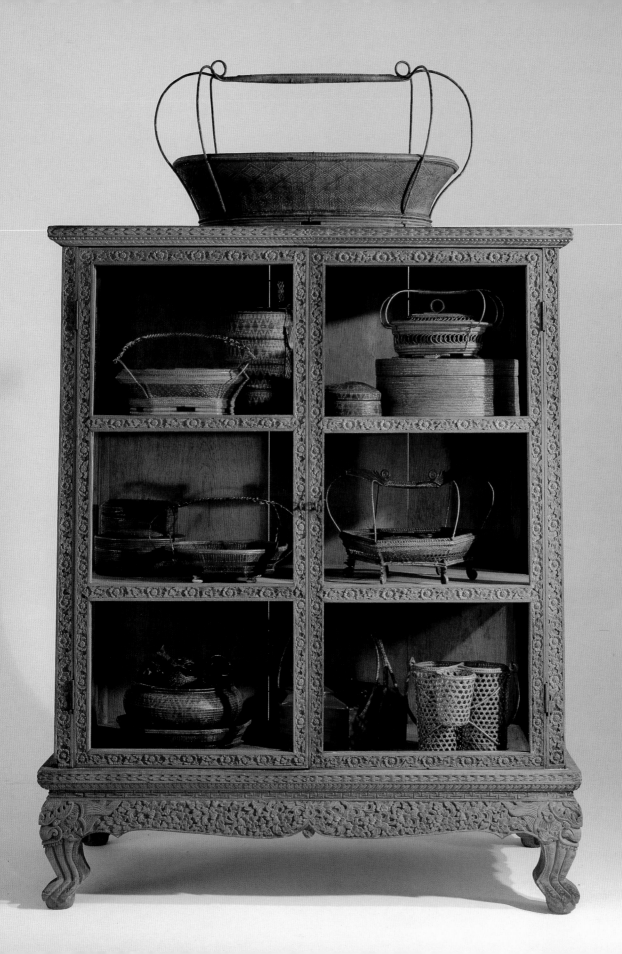

35 LEFT *Refined basketry in a cabinet of the early Bangkok period. All but the basket on the bottom right are made of* yan lipao, *a tough, fern-like vine which grows in the south, particularly popular among members of the court in the 19th century and revived in recent years as one of the Queen of Thailand's handicraft projects.*

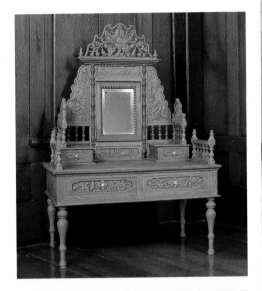

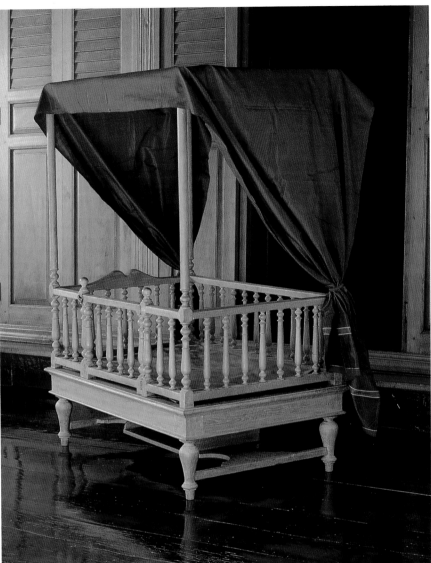

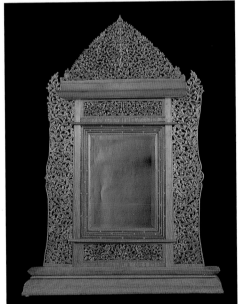

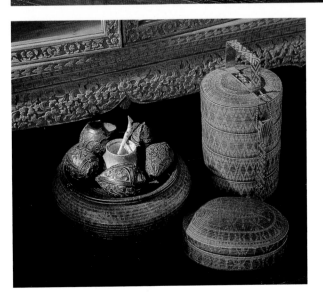

36–39 TOP *Carved wooden dressing table and* ABOVE *an ornate mirror, in a later 19th century blend of Western and traditional styles.* ABOVE RIGHT *A child's bed of the same period.* RIGHT *A* yan lipao *container with boxes of carved coconut shell and two examples of patterned basketry called* khit.

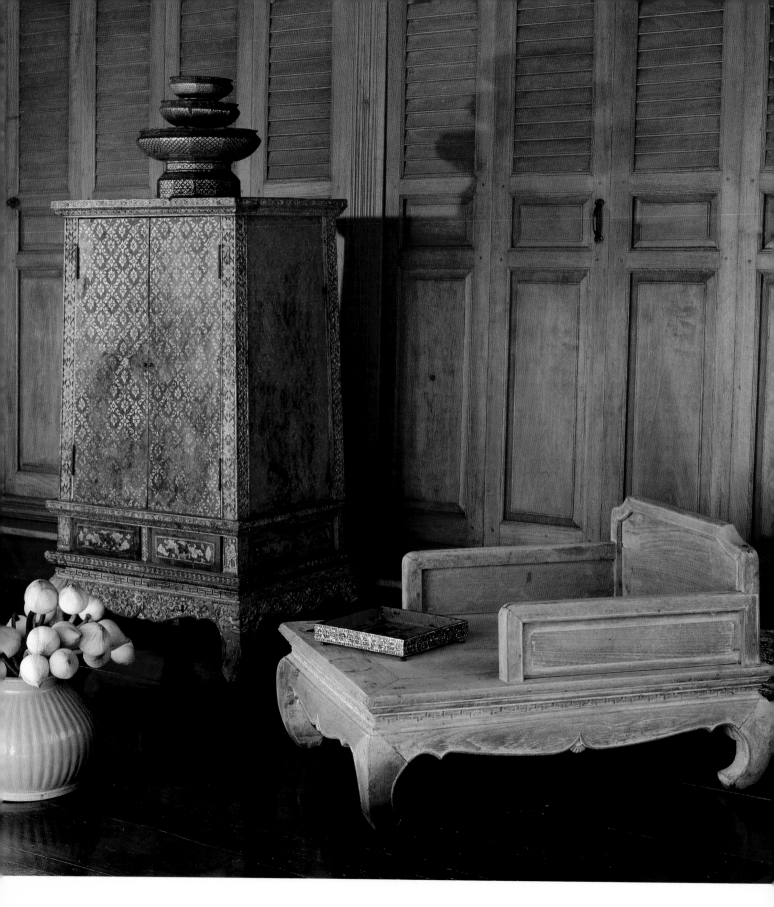

CEREMONIAL CRAFTS

TODAY, AS IT HAS FOR OVER 700 YEARS, ceremony lies close to the heart of Thailand's distinctive culture, assuming a variety of forms: the solemn rites of Buddhism and those of other beliefs as well, the splendour of royal occasions and the high-spirited *sanuk*, or fun, of village festivals. Each follows long established patterns, and nearly all involve crafts that range from artistic achievements of lasting beauty to highly ephemeral creations.

Buddhism first appeared in what is today Thailand around the 3rd century BC, when missionaries of the Theravada sect were sent by the Indian Emperor Asoka to preach the faith in a semi-legendary kingdom called Suvannabhumi near the present provincial capital of Nakhon Pathom, southwest of Bangkok. Much later Mahayana, the other major Buddhist sect, was also introduced but found adherents in only a few places.

Theravada Buddhism proved so popular that it was adopted as the state religion by Mons, who migrated into the area during the Dvaravati period and built an impressive number of temples adorned with fine works in stone, stucco and, to a lesser extent, bronze. It also prevailed among the Thais as they moved southwards into the fertile central plains. In Sukhothai it inspired a magnificent flourishing of art of all kinds; King Li Thai (1347–68), who built some of Sukhothai's most important monuments, also rewrote 30 volumes of Buddhist scriptures into a single volume called the *Tribhumikatha*, the first Thai Buddhist treatise, which has had a lasting impact on such religious arts as mural painting.

But Buddhism is not the only Thai belief celebrated through ceremonies. Far older, and equally powerful at the village level, is the conviction that a host of supernatural beings control such vital matters as bountiful rainfall, adequate crops and the fortunes (or misfortunes) of individuals. Faith in such beings was not replaced by Buddhism but effortlessly absorbed by it, often in ways perplexing to outsiders more anxious to categorize than the tolerant Thais are.

Yet another force is Brahmanism, against which in India Buddhism had originally been a reaction. But Brahmanism also answered deep-felt needs in ancient hierarchies and continues to play a significant role, particularly in rituals concerning royalty, but also in others at the more popular level, such as weddings. Similarly, Hinduism and its gods – potent forces in the Khmer kingdom which once embraced much of Thailand – can be found co-existing with the newer faith without causing any apparent conflict.

The blend of various beliefs found in many Thai ceremonies can be seen in this description by A. B. Griswold of the 1851 coronation of King Mongut, fourth ruler of Bangkok's Chakri dynasty, a remarkably modern man for his time who had spent

40 LEFT *A* thammat, *or preaching chair, and a cabinet for storing religious manuscripts, decorated with gold and black lacquer designs; on top of the cabinet are trays called* talums, *used for presenting offerings in many different ceremonies.*

41

his early life as a monk and was an avowed opponent of superstition. With only slight variations, it applies to the rites that still accompany the crowning of a new king:

'On May 15, at 7:30 A.M. – the auspicious moment calculated by the astrologers – a ritual lustration of his person was performed in the presence of an image of the elephant-headed Hindu god Ganesha. . . . Having ascended an octagonal throne, he sat successively facing towards each of the eight cardinal points, promising in Pali to protect the Buddhist religion in his kingdom. He sat on another throne while a Brahman read a stanza praising the sacred mountain of the Hindu gods, offered a blessing, and delivered up the kingdom of Siam to him. Officers presented him with various insignias of royalty which had been charged with exalted power by means of prayer to Shiva. . . .'

A similar mixture was present in the top-knot cutting ceremony which marked a child's coming of age. Though observed in all upper-class families, it was celebrated with special splendour in the palace, where an artificial hill representing Mount Krailat (home of the Brahman divinities) was constructed, complete with a waterfall, and the rituals went on for a number of days.

It is difficult to separate Thai ceremonial crafts into clearly defined groups, since many are used for multiple purposes. For the sake of convenience, we might divide them into those primarily associated with Buddhism (with the exception of the higher art forms of image-making and painting), those of royalty and a miscellaneous group that includes animistic rites and offerings.

Selectively assimilating elements from such cultures as Khmer and Singhalese, and adding others of their own, the Thais created Buddhist temples of increasing complexity and fantasy: dazzling structures with multi-layered roofs and gilded spires, adorned with profuse decorations. Nearly all the country's classic crafts – stucco, woodcarving, gold and black lacquer painting, mother-of-pearl inlay, glass mosaics and stonework – were primarily employed for such ornamentation.

Though great skill was valued and appreciated, the principal aim of both artisans (nearly always anonymous) and patrons was not the creation of art for the sake of mere beauty. Instead it was to acquire merit and thus to ascend to a higher plane in the next reincarnation. The construction and decoration of a temple were two of the major means of achieving this goal, and it mattered to a relatively small degree whether the temple was in fact a major work of architecture or an unimportant one in a village, whether the adornment was of the highest quality or merely an approximation of it; the act was what counted in the ultimate summing-up.

Many Buddhist crafts are associated in one way or another with the fervent desire to earn merit through the presentation of items to a temple or to individual monks. There is, for instance, the *phra batra*, or monk's bowl, which he carries on his morning rounds to receive food from the faithful. Some early Western writers,

possibly out of ignorance, referred to this as a 'begging-bowl'; in fact, the donor of the food could more accurately be called the supplicant since it is he, rather than the monk, who receives the most benefit from the act.

The commonest *phra batra* is a plain metal bowl with a rounded bottom, sometimes with a simple painted design around the rim, the shape supposedly modelled after that of the simple clay bowl carried by the Buddha before he attained enlightenment.

Far more elaborate *phra batra*s have evolved, for use by royalty and other high-ranking people when offering food to monks on various special occasions. Some have exquisite designs in mother-of-pearl inlay, while others are made of niello, lacquer or precious metals. One in the National Museum has mother-of-pearl designs that depict the insignia of Rama V as well as a triple-headed elephant, or Erawan, flanked by two other mythological animals.

In addition to food bowls, a wide assortment of similarly adorned trays, covered containers and other receptacles are used in ceremonies at which offerings such as robes are presented to monasteries. One of the best known is the *talum*, a shallow tray or wide-mouthed container of possibly Khmer origin which is set on a high, flaring pedestal; it may be round, hexagonal, octagonal or twelve-sided and comes in various sizes, sometimes placed one atop another to resemble a *stupa*. A *talum* may also be used to support a round bowl with sloping sides called a *khan nam*, in which lustral water is kept.

Aside from architectural features, the craft of woodcarving is prominent in the ceremonial furnishings of a Buddhist temple. Among the most important of these is the *thammat*, or pulpit, on which monks sit when delivering sermons or chanting. The oldest form, known as a *thaen* or *tieng*, is also the simplest, merely a rectangular seat without a back panel and legs that are either straight or carved in a lion's-foot (*kha singh*) shape. These are still found in village monasteries, sometimes painted and gilded.

More ornate is the *thammat tang*, which is larger, has arm-rests as well as a back support, and is often decorated with inlaid mother-of-pearl designs or carvings. Most splendid of all is the *thammat yot*, which comes in two styles, a smaller version that seats only one monk and a larger one that can hold up to five. Both consist of an elevated seat sheltered by a multi-tiered, spired roof, the whole almost covered with decorative carvings and mosaics. The seat of the *thammat yot* is raised so high that equally ornate stairs, sometimes a sculpted animal figure, is required for the user to reach it from the back side.

Altars for the display of Buddha images are now found in both homes and temples, but were once limited to either the latter or a separate, private chapel, because of an old belief that images should not be kept in a place where they would be exposed to worldly activities; today they are often placed in a special 'Buddha room' in a house. The most basic, the *ma-ki*, consists of a small table atop a larger

LEFT *An altar with Buddha images and offerings in the living-quarters of an Abbot. The most important image is always at the highest level. Manuscripts can be seen on the right, spread out for study.*

one; the image is placed on the higher and offerings on the lower, and a white canopy is hung from the ceiling above the set. Another style, the *benja*, popular among nobility and high officials, is a low, rectangular table with four posts for the canopy; on the table are placed three progressively smaller ones, with the Buddha image on the top one, vases for flowers on the middle, and an incense-stick pot flanked by two candlesticks on the bottom. A third form, the *attachan*, developed from the *benja*, is made entirely of wood with the table replaced by three steps.

Devotional tables, introduced in the reign of Rama III, were a Thai adaptation of those in Chinese temples. Of varying heights, they generally come in sets of five, seven, or nine, sometimes three or six, and are used not only for worshipping Buddha images but also for holy relics or paying respect to royalty. The image or a picture of royalty is always placed on the highest table, and the others arranged below it.

Traditionally the religious manuscripts studied by monks and used in various ceremonies were written on strips processed from the leaves of the corypha palm; approximately 18 x 3 inches in size, these were pressed in bundles, trimmed and sanded for a smooth surface. The texts were inscribed with a sharp stylus and soot was rubbed over the page to make the letters visible; the pages were then tied

together through holes in the middle of each, placed between two hard covers and, when not in use, wrapped in a piece of cloth and tied with a cord, through which a knife-shaped object inscribed with the title was fixed.

Within these conventions, however, there was considerable scope for craftsmanship. While the majority of manuscripts were plain, those presented by royalty were often beautifully illustrated. Moreover, the hard covers were sometimes made of gold or silver niello, carved ivory or lacquer inlaid with mother-of pearl, while the label displayed equally fine artistry and the cloth wrapping might come from a richly brocaded garment donated to the temple after the owner's death.

At a much humbler craft level are the *toong*s, or flags, that adorn rural temples, especially in the north and northeast, during Buddhist festivals. These are made of loosely woven cotton yarn, often mixed with other materials such as split bamboo and palm leaf, and display a great variety of patterns, shapes and colours. Some may be a meter or more in length and hung at the entrance of the temple. Another kind, the *toong sor*, is triangular and attached to a stalk of bamboo in the monastery compound, while the *toong yai moom* is a square, web-like flag tied together in strings in the belief that these will lead the soul to heaven.

Illustrated manuscript; while most deal with religious subjects, others cover a wide variety of topics from astrology to warfare.

According to a somewhat controversial stone inscription of 1292, attributed to King Ramkhamhaeng, an accessible, paternalistic system of monarchy was established in the first Thai capital at Sukhothai. A bell was hung outside the palace and 'if any commoner in the land has a grievance which sickens his belly and grips his heart, and which he wants to make known to his ruler and lord, it is easy; he goes and strikes the bell which the King has hung there; the King hears the call; he goes and questions the man, examines the case, and decides it justly for him.'

This relative openness disappeared in Ayutthaya, when the Khmer concept of divine kingship was adopted and the ruler became an aloof, seldom-seen figure, surrounded by arcane ritual. Engelbert Kaempfer, a German who worked for the Dutch East India Company, was ordered to remain indoors on the day after his arrival at the capital in 1690 since the king was emerging from the palace. 'When the King of Siam goes abroad', he wrote, 'everybody must keep out of the way . . .'

This sense of royal ceremony was carried over into early Bangkok. When John Crawfurd, who came on an unsuccessful trade mission in 1822, was received by Rama II, he found himself in a resplendent audience hall filled with prostrate officials. A curtain at one end was dramatically drawn and 'raised about twelve feet from the floor . . . there was an arcaded niche, on which an obscure light was cast, of sufficient size to display the human body to effect, in the sitting posture. In this niche was placed the throne, projecting from the wall a few feet. Here, on our entrance, the King sat immovable as a statue, his eyes directed forwards. He resembled, in every respect, an image of Buddha placed upon his throne.'

Many of the most important ceremonial items now associated with the monarchy

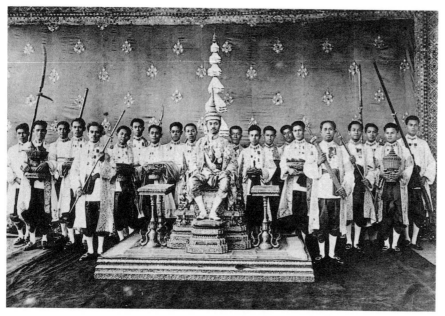

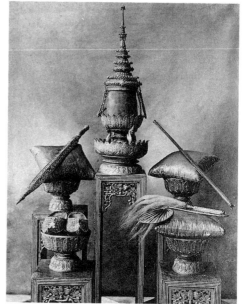

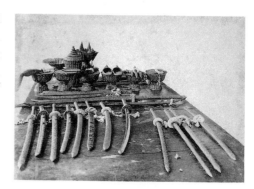

date from the establishment of Bangkok as the capital, among them the Royal Regalia used in every coronation. The centrepiece is the Crown of Victory, a magnificent pyramidal creation of diamond-studded gold, 51 cm. tall and weighing 7.3 kg; the large diamond embedded at the pinnacle, known as Phra Maha Vichien Mani, was acquired from India and added by Rama IV. The Royal Sword is of Khmer origin, found in the Tonle Sap lake near Angkor and presented to Rama I by the governor of Siemreap and Battambang provinces, both then under Thai rule; but its ornate fold hilt and scabbard were crafted by Bangkok artisans. Other items of the original regalia include the Valvijani, a one-sided fan of gilded palmyra palm leaf with a long gold handle, and the Royal Slippers, gold with diamonds and floral designs in coloured enamel. A walking stick used at the coronation of Rama I, made of Cassia wood sheathed in gold, was replaced by Rama IV with one modelled after an antique sword.

The Grand Palace also contains a number of historic thrones. The most spectacular – the one on which Rama II received John Crawfurd – is called the Phra Thinang Busbok Mala. This is constructed in the form of a *busbok*, a pavilion-like structure of wood with a multi-tiered roof, used only for kings and objects of veneration; gently rising on each side of the base of the *busbok* are lateral extensions called *kroen*, decorative features which make the throne appear to be floating in the air; and the whole is mounted on a richly carved, gilded masonry dais.

In the same hall is another imposing throne of carved and gilded wood with glass inlay, above which a second throne (where the king actually sits) is placed; over that

TOP LEFT *King Rama VII, in full ceremonial dress, and members of his court on the occasion of his coronation.* TOP RIGHT *Items of the Royal Regalia.* ABOVE *Royal swords and other items of the Regalia.*

is the nine-tiered Great White Umbrella of State. This is used both at coronations and at annual Birthday Audiences when high-ranking officials are received. One of the earliest thrones in the palace is a tiered affair in black wood, decorated with mother-of-pearl; when the original throne hall was struck by lightning and burned five years after its completion, Rama I himself is said to have helped carry this precious item to safety.

Items associated with Brahmanism figure significantly in most royal rituals, even predominantly Buddhist ones, as well as in others outside such exalted circles. Thus conch shells, often beautifully chased with gold, are blown at functions like the Plowing Ceremony, held each year in a field outside the Grand Palace to mark the start of the annual planting season; and replicas are used to pour lustral water over the hands of the bride and groom at weddings.

White-robed Brahman priests – who participate in royal ceremonies are also called upon to determine astrologically auspicious dates and times – have their own temple in one of the older parts of Bangkok. One of their most spectacular past performances, attended by the king and also vaguely associated with agriculture, was the Giant Swing Ceremony in a nearby square. The swing was suspended between pillars some 90 feet high, and the objective was for one of three men to seize with his teeth a bag of money attached to the top of a tall bamboo pole, the highest arc of the swing being nearly 180 degrees. The ceremony was discontinued in 1935, but the lofty apparatus still stands in the square.

Hindu deities and symbols are also prevalent. The Garuda, half-bird half-human mount of the god Vishnu, is regarded as a symbol of royalty in Thailand and appears in countless decorative motifs. The trident of Shiva rises from the top of the Royal Pantheon in the Temple of the Emerald Buddha, and scattered about the compound are memorials to sacred white elephants as well as gilded bronze and stucco statues of fabulous creatures from the Hindu heavens.

Somewhere in the compound of every Thai house or business company, raised atop a post, stands an elegant little structure – traditionally a wooden replica of a classic Thai house but sometimes, especially in cities, an ornate cement affair modelled after a temple building. This is the symbolic residence of the Phra Phum (Lord of the Land or Place), who watches over the compound and, if properly honoured, protects both buildings and human inhabitants.

Similar spirits guard larger areas: an orchard or rice field, a village, even a major city. The one that oversees the fortunes of Bangkok resides in an ornate structure across from the Grand Palace known as Lak Muang, originally established by Rama I in 1782, but enlarged and refurbished many times since.

In addition, there are numerous other shrines to other sorts of non-Buddhist gods and goddesses, each of whom is believed to have some special power. Outside a major hotel, for example, a famous one is dedicated to Brahma, whose four-faced,

eight-armed image sits inside; this is credited with being able to grant all kinds of wishes, from a winning lottery number to the cure of a fatal disease. Still others are located near venerable *Ficus* trees, whose twisting aerial roots are associated with spiritual residence in many cultures; one in Bangkok, housing a female spirit known as Chao Mae Tuptim, is honoured with hundreds of realistically carved phalluses piled around the base of the tree.

Such shrines, as well as the countless Buddha images in temples, require an almost daily supply of ceremonial offerings. Some of these are semi-permanent, like carved wooden elephants symbolizing longevity and small clay figures that represent attendants. Others, however, belong to the more ephemeral art of floral decoration, in which the Thais have excelled for centuries.

These are not 'arrangements', in the Western sense of the word, but rather meticulously crafted creations based on manual skills and traditional designs. The most commonly seen are the *malai*, or garlands, which are presented to both temples and shrines, hung on the prows of boats and the dashboards of taxi cabs, given to respected guests and elders on various occasions.

Another classic type is the *jad paan*, or bowl arrangement, sometimes called *poom* in a reference to their traditional rounded pyramidal shape which is supposed to resemble a budding lotus. A core, usually 6 to 8 inches high but sometimes much larger for royal ceremonies, is made of moistened earth, clay or sawdust, and the whole is embedded with flowers so that it resembles a multi-coloured piece of porcelain.

A third category of perishable crafts for offerings is made from banana leaves, deftly folded into numerous shapes. One group known collectively as *bai-sri* is essential to many ceremonies of Brahman origin, such as the installation of a spirit house or paying homage to a respected teacher. One of this group, the *bai-sri pak cham*, consists of a central banana-leaf cone filled with cooked rice and surmounted by a boiled egg, sometimes adorned with a jasmine crown; surrounding the base are other elongated cones decorated with flowers.

As far as visitors are concerned, perhaps the most memorable banana-leaf and flower construction is the *krathong*, which Thai legend claims originated at the royal court of Sukhothai. Modern synthetic materials are often used today, but the classic *krathong* is still made of fresh leaves folded into the shape of an open lotus blossom and mounted on a slice of porous banana stalk. Flowers, burning incense-sticks and a lighted candle are placed in the middle, and the *krathong* is set adrift in rivers and streams under the full moon of the eleventh lunar month as a gift to the water spirits who play such a vital role in Thai life.

Unlike many others, Thailand's ceremonial crafts are surrounded by both ancient beliefs and tradition and have remained relatively unchanged over the years. This seems likely to be true as long as the institutions that inspire them continue to exert such a potent appeal.

41 RIGHT *The Niello Throne, also called the Phra Thinang Phuttan Thom, in the Central Audience Hall of the Chakri Maha Prasat in Bangkok's Grand Palace, sheltered by a nine-tiered royal umbrella and flanked by seven-tiered umbrellas. Behind the throne is the emblem of the Chakri dynasty and figures from mythology also adorn the platform. The throne was made during the reign of King Rama V in the latter part of the 19th century, when the Western-style building was also constructed. Traditionally, foreign ambassadors are received by the king in this audience hall when they present their credentials.*

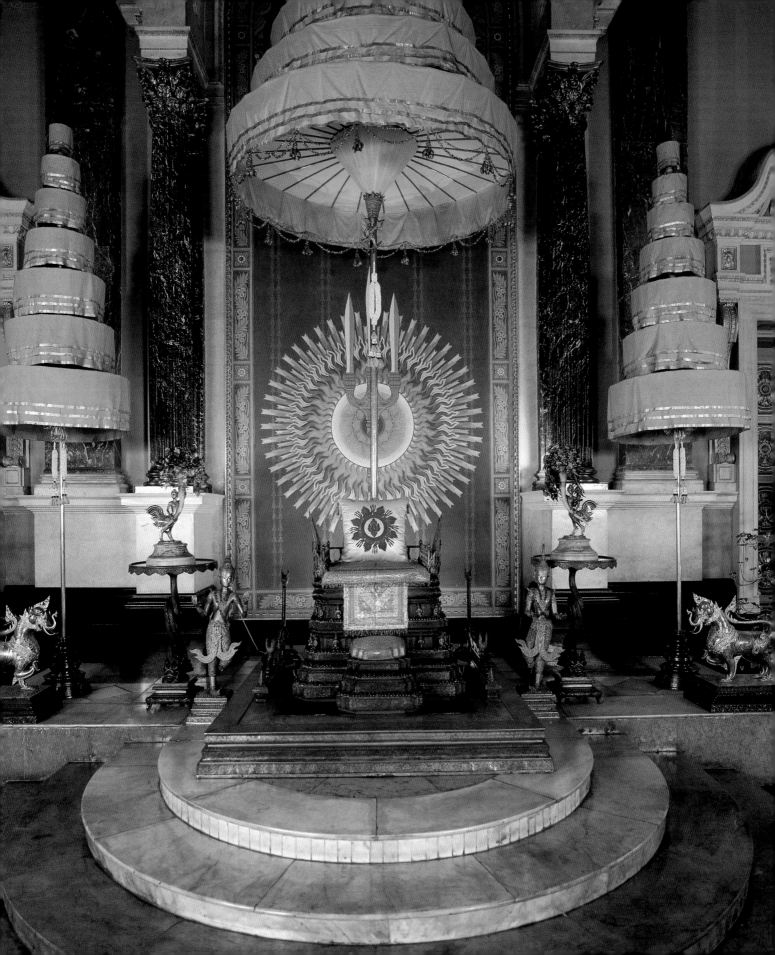

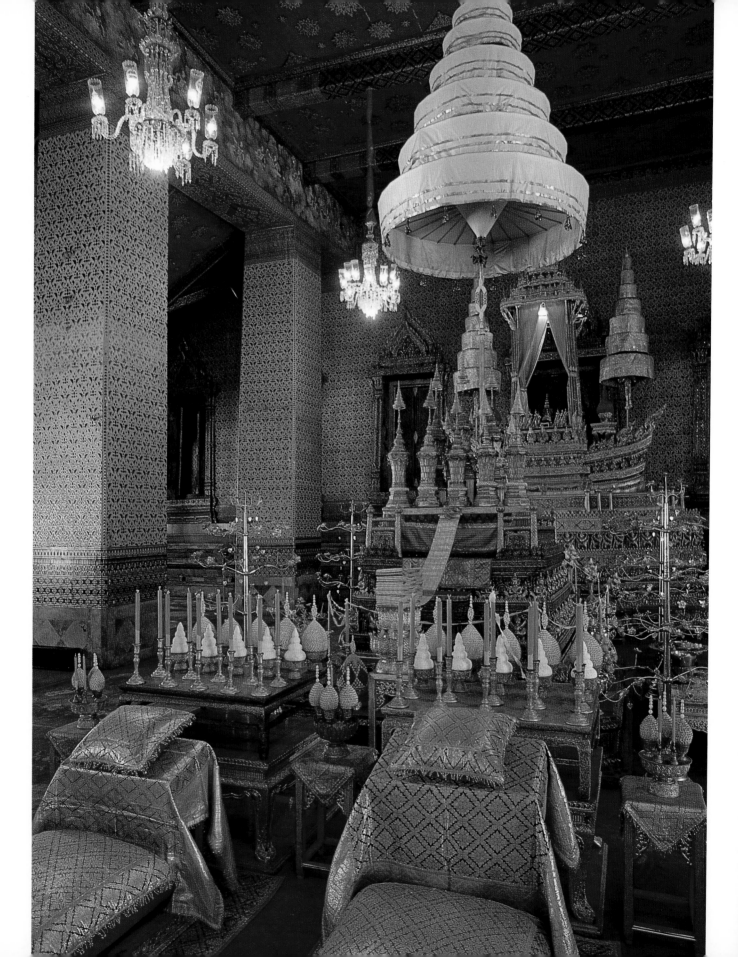

42–44 LEFT *The Phra Thinang Busbok Mala, most spectacular of the several thrones in the Grand Palace; urns containing the remains of past Chakri kings are placed in front, along with numerous offerings to them.* BELOW AND BOTTOM *Items of the Royal Regalia, some of which date from the reign of the first Chakri king and were made towards the end of the 18th century.*

45–46 BELOW AND BOTTOM *Ceremonial offerings to past Chakri kings in the Grand Palace, including betel-nut accessories, a spittoon, tiered receptacles, candlesticks and traditional floral arrangements, all of highly refined workmanship. These are in the Phaisan Taksin hall of the Grand Palace, where former rulers held audiences.*

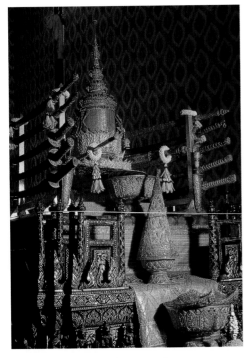

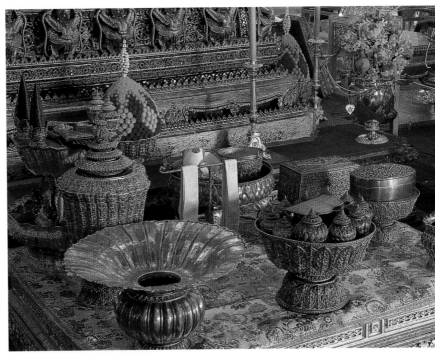

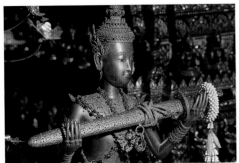

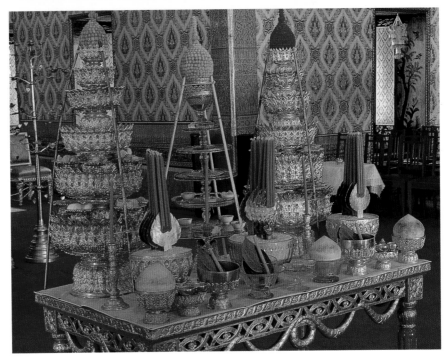

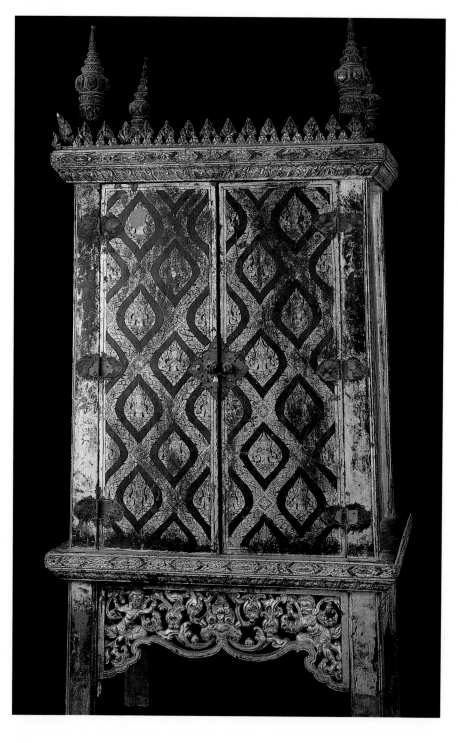

47–51 LEFT AND OPPOSITE *Gold and black lacquer painting, called* lai rod nam *in Thai, was one of the most notable arts of Ayutthaya and early Bangkok, applied to scripture cabinets as well as to doors, boxes and other surfaces. The designs ranged from classical motifs to scenes from the life of the Buddha and the* Ramakian *epic. The cabinet on the left dates from the reign of King Narai, in the latter part of the 17th century, and is in the collection of the National Museum at Lopburi. The other designs are on cabinets in Bangkok's National Library.*

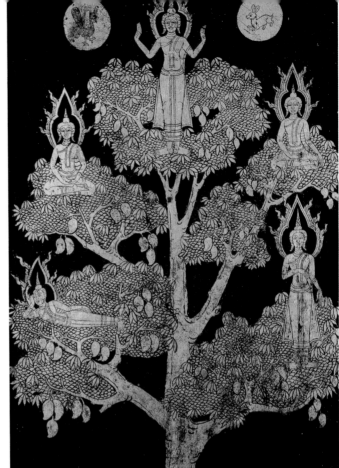
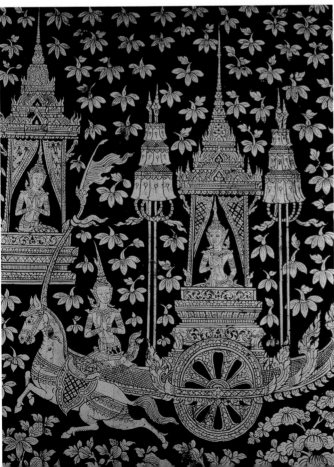

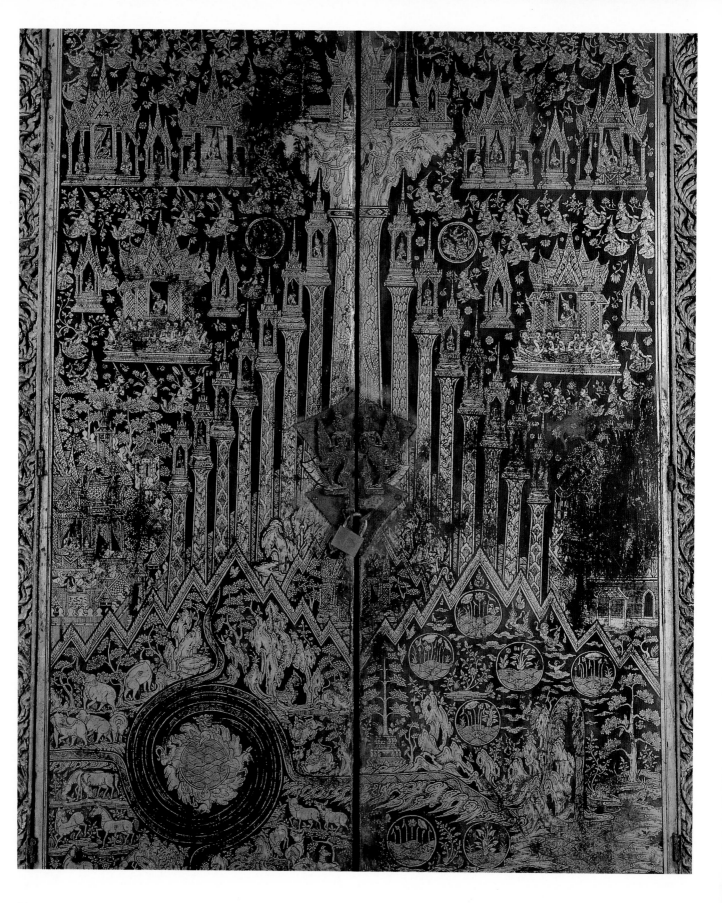

52 LEFT *Famous gold and black manuscript cabinet from 18th-century Ayutthaya, known as 'the cabinet of the three worlds'. The design shows the Himalayas with a sacred lake and four rivers in the lower part, as well as Mount Meru surmounted by the abode of the god Indra and various planetary symbols. The cabinet is at present in the Ayutthaya National Museum.*

55–56 BELOW *Illustrated manuscript book on* khoi *paper, made from the bark of a native tree, folded accordion-style for use during prayers.* BOTTOM *Boxes for storing religious manuscripts, decorated with gold and black designs.*

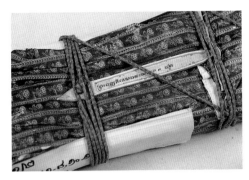

53–54 TOP *Religious manuscript wrapped in cloth and tied; the carved ivory label is inscribed with the title.* ABOVE *Page of an illustrated manuscript on Thai military arts, showing a Garuda; dated 1815, the manuscript is in Bangkok's National Museum.*

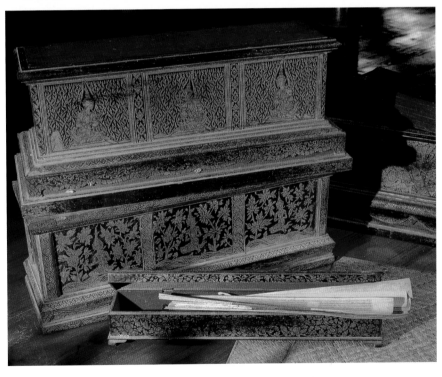

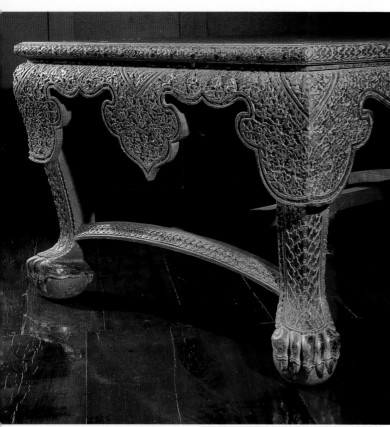

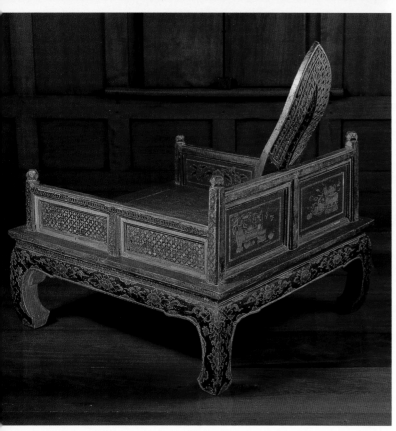

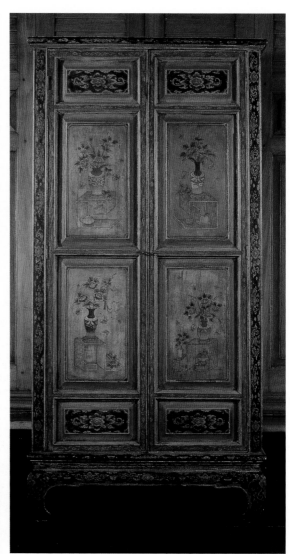

57–58 LEFT *Gilded carving and legs in the shape of a lion's foot on a pulpit; early Bangkok period.* BELOW LEFT *Form of pulpit known as a* thammat tang, *on which a monk sits while delivering a sermon.*

59 ABOVE *Painted wooden cabinet for religious manuscripts or other items. The decorations on this example are Chinese, suggesting that it dates from the early 19th century when such motifs became popular in Bangkok.*

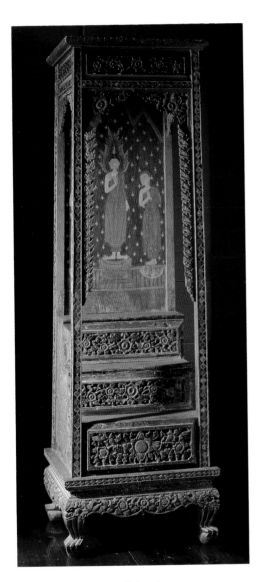

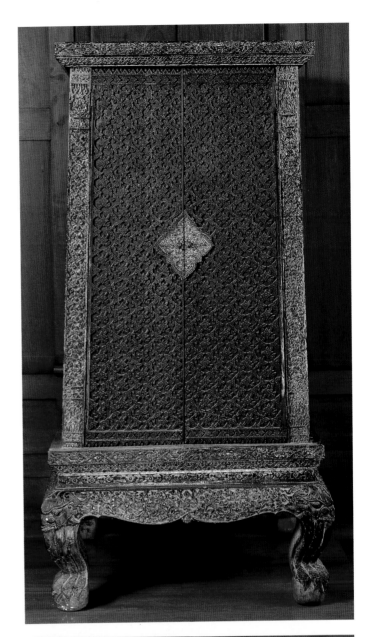

60–62 ABOVE *Form of altar known as an attachan for displaying Buddha images and offerings; the image is always placed on the highest of the three steps.* ABOVE RIGHT *Manuscript cabinet decorated with carved designs, further inlaid with glass mosaic.* RIGHT *Ornately carved altar tables with lion's-foot legs.*

63 BELOW *A splendid* thammat yot, *a pulpit consisting of an elevated seat with a multi-tiered roof and steps to reach the seat. This example, in the National Museum at Lopburi, bears an inscription dating it to 1682 during the reign of King Narai.*

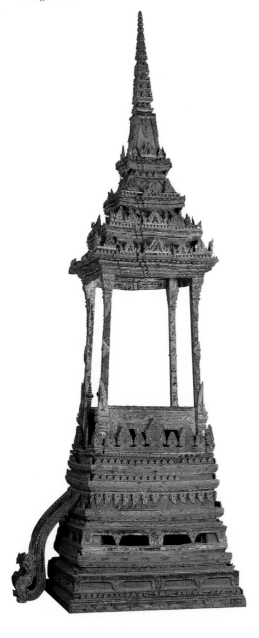

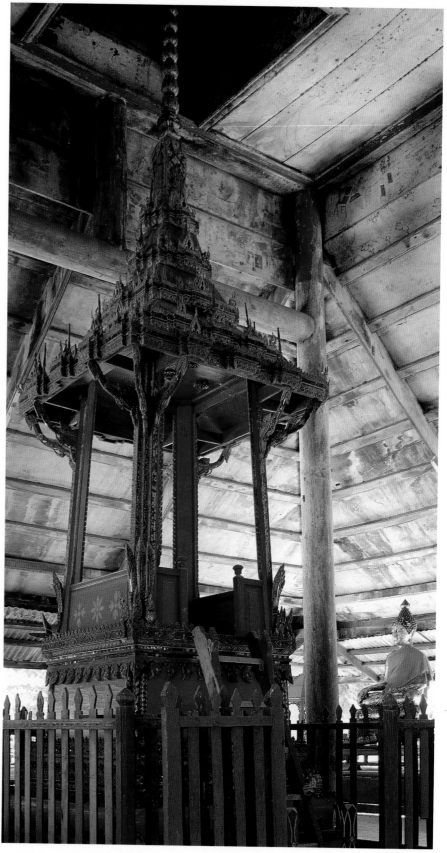

64–69 LEFT *A thammat yot, most ornate of the various forms of Buddhist pulpit even when found in a rural temple like this one.* BELOW *Steps used to ascend a high pulpit.* RIGHT *Single steps are often carved like these in the form of kneeling animals.*

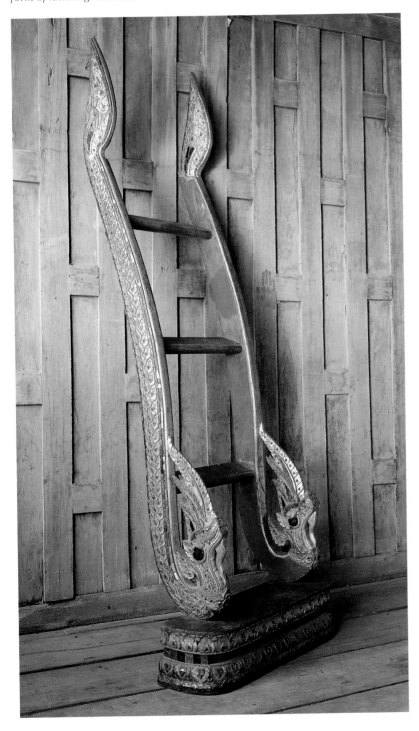

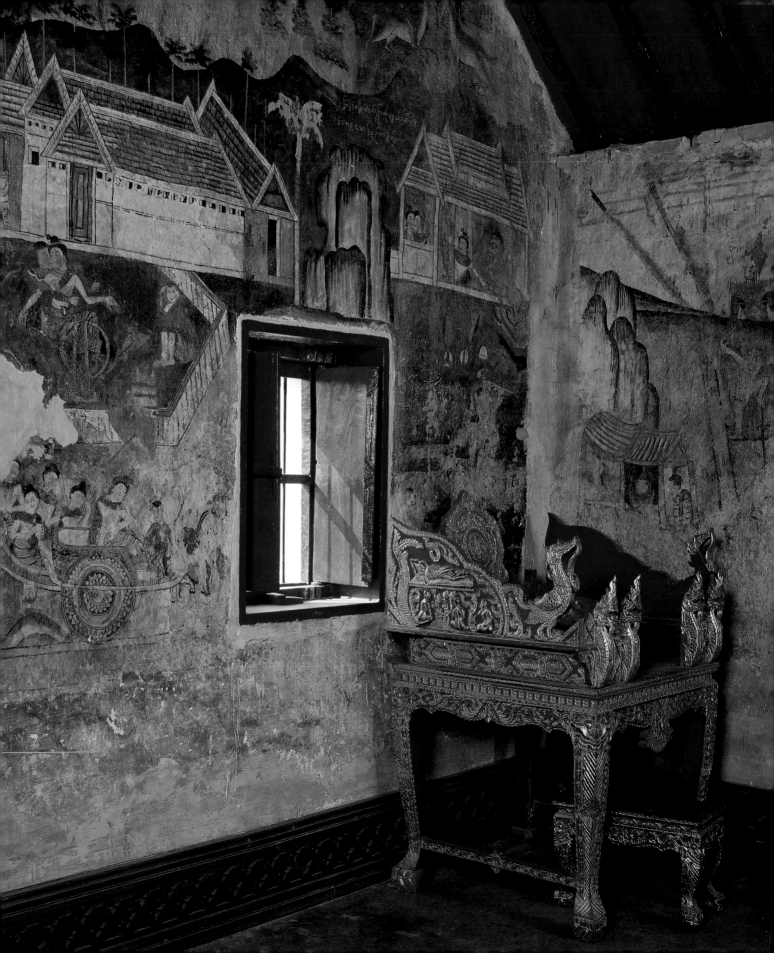

70–71 LEFT *A contemporary carved and gilded* thammat tang *pulpit at Wat Phumin in the northern province of Nan.* BELOW *Ceremonial vessels in the shape of lotus buds, a popular Buddhist motif.*

72, 73 BELOW *Ceremonial trays known as* talums, *used for the presentation of offerings such as robes to monasteries; decorated with glass mosaic inlay.* BOTTOM *A traditional floral creation covers an offering.*

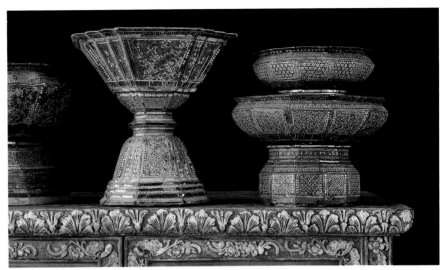

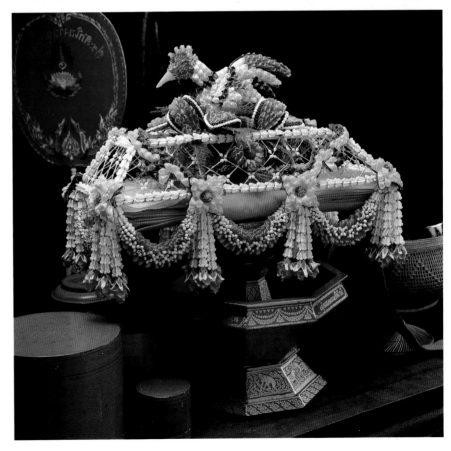

74 BELOW *A traditional Thai garland, known as a* malai. *The most common of all the country's floral creations, these range from simple to highly complex and are placed as offerings on shrines, presented to honoured guests, and used on many other special occasions.*

75–76 BELOW AND BOTTOM *Thai garlands, made by stringing together various flower combinations that depend on seasonal blooms and the creator's imagination. The mixture will always include one or more fragrant flowers, usually jasmine buds and roses.*

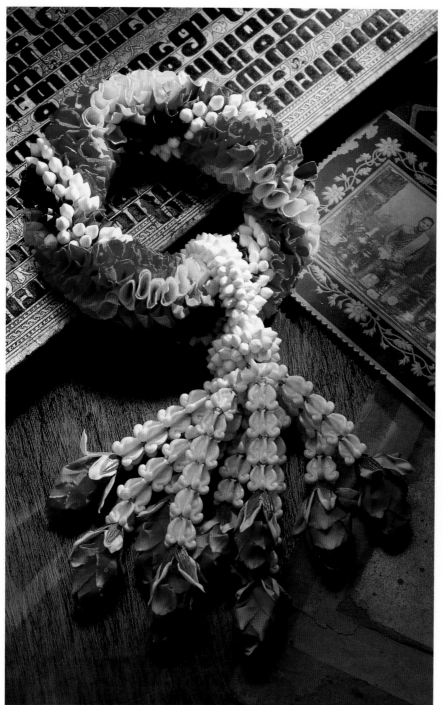

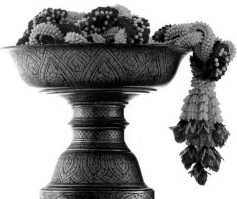

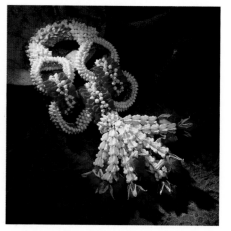

77–78 BELOW *A type of offering known as a* bai sri, *consisting of banana leaves folded into various shapes and further adorned with fragrant flowers and sometimes a boiled egg.* BOTTOM *A bowl-type floral offering called* poom, *made by embedding flowers in a core of moist earth or sawdust.*

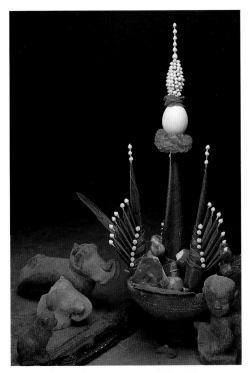

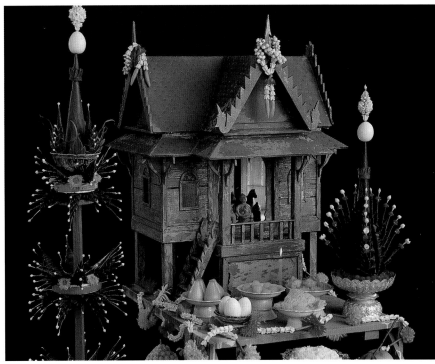

79 ABOVE *A spirit house with offerings. Such structures, which may be plain or elaborate, are found in the compound of nearly every home or business and are the symbolic residences of the guardian spirits; offerings include food, incense-sticks, candles and floral arrangements.*

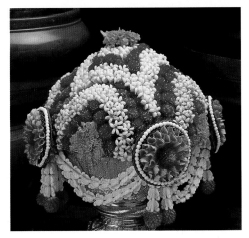

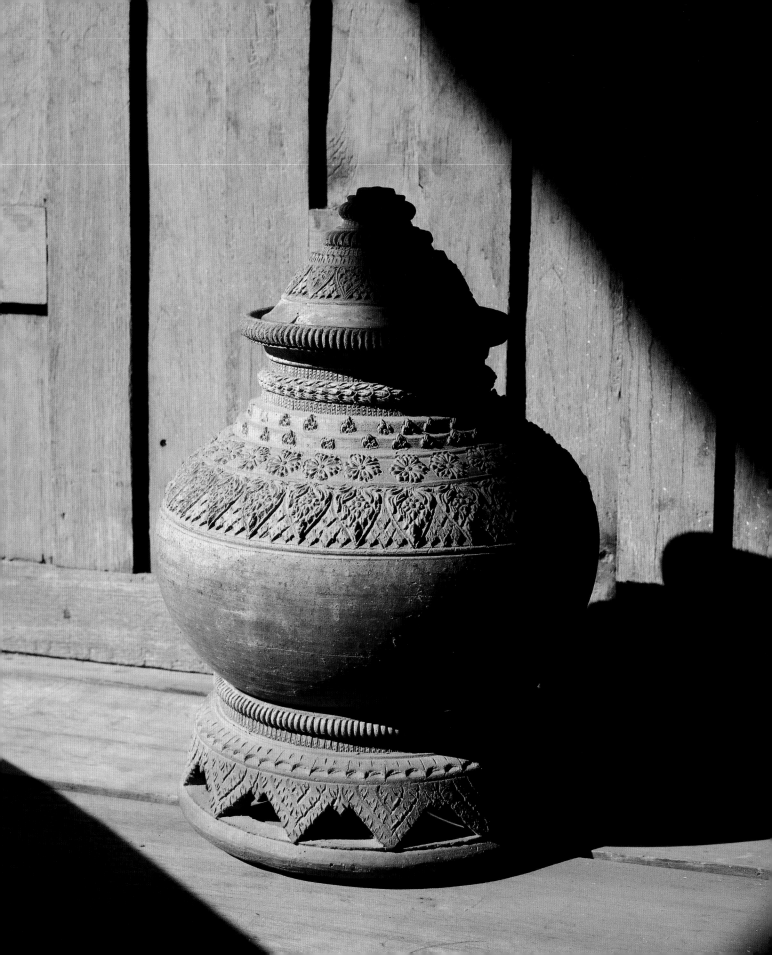

THE CRAFTS OF VILLAGE LIFE

DESPITE THE IMMENSITY and magnetism of Bangkok, despite the phenomenal growth of provincial capitals in recent years, modern Thailand remains predominantly a country of rural villages, where the great majority of its 60 million people derive a living from some form of agriculture. There are regional differences, of course, some of them significant, but it is at this level that one discovers the essential Thai social values and also its most enduring crafts.

Village life

Each craft, past and present, evolved to serve an immediate, useful function in the home or at work, and to appreciate them more fully one should have some knowledge of a typical village and its life patterns. These patterns are not static; to a greater or lesser degree, they are continually being affected by outside forces; but they have remained far more constant than their urban equivalents.

In most areas, such a community will consist of around 100 to 150 households, which, since rural families tend to be large and often include several generations, means some 500 to 700 inhabitants. The houses are nearly always simple wooden structures, elevated on posts off the ground as protection against floods and unwelcome animal intruders and also to provide extra storage space. Poorer families may live in a single room; others have several separate ones. (In either case, there is generally an open verandah on which most activities take place, from eating to convivial gatherings with neighbours. A small granary, also elevated, may be found beside the more prosperous homes, and all have a number of large earthenware jars to keep rainwater for drinking.

The traditional Thai house is a superb piece of craftsmanship in itself, calling for highly specialized skills on the part of local carpenters who were once valued members of every community of any size. It is made in prefabricated parts, which are then hung and fitted together with wooden pegs on a frame of hand-hewn pillars. In ancient times, ostentation was regarded as a royal prerogative, and simplicity was the keynote both of domestic architecture and of the people it housed. Accordingly, decorative effects are sparse, but the overall effect is nevertheless one of memorable grace and elegance, ideally suited to climate and customs.

On the village outskirts or not very far away stands the local *wat*, or Buddhist monastery, as ornate as the houses are plain. This serves not only as a spiritual centre – for regular sermons, ordinations, cremations and the observance of special religious holy days – but for most temporal gatherings as well, from village fairs to meetings on communal concerns, such as the digging of a new well or the allocation

80 LEFT *Earthenware waterjar of the Ayutthaya period. Such jars, though often less ornately decorated today, are still used to keep rainwater cool in households throughout much of rural Thailand.*

of agricultural chores. The *wat* has often been built by the villagers and is maintained by them through donations of money or labour as a means of earning merit.

The basic unit of rural life is, of course, the family, followed by that of village society. Within the house there is little privacy, which the average Thai neither seeks nor admires; social harmony, characterized by tact, compromise and tolerance, is the ideal of family life and, indeed, of existence in the village as a whole.

Children assume a steadily increasing workload from an early age – boys helping the older men in the fields, girls learning such domestic skills as cooking and weaving cloth – and are regarded as fully mature adults by the age of 15 or 16. The principal events of an individual's life – birth, marriage and death – are each accompanied by appropriate traditional ceremonies which may be Buddhist, Brahmanical or animistic, often a mixture of all three; an additional rite of passage for boys is a period spent in the Buddhist monkhood, believed to prepare him for having a family of his own.

In the larger unit of the village, sudden change is viewed with suspicion, as are unseemly displays of individuality; and these conservative tendencies have undoubtedly been responsible for the continuation of many customs and crafts that have disappeared or been diluted in cities. Decisions that affect all are generally reached by consensus, often with advice from a respected local monk and under the leadership of the *phu-yai-ban*, or elected headman. The old concept of a fully self-sustaining society which produced all its material needs is no longer viable; most villages, even remote ones, now have electricity, and roads connect them with provincial centres, bringing new products and ideas. But tradition still plays a strong role in both the large area of accepted behaviour and such smaller ones as household chores and farming.

The most important cycle of village activity is determined by the demands of the surrounding fields, which usually means the planting, tending and harvesting of rice. It would be almost impossible to overestimate the importance of this staple grain in Thai life; *kin khao*, the expression for 'to eat', literally means 'to eat rice', and countless crafts have been devised over the centuries for use in one stage or another of its cultivation and preparation as food.

Fields are generally ploughed for planting in April or May, a communal undertaking in most villages, and then flooded with water from surrounding streams and canals, followed by transplanting of the young seedlings. By the time this has been completed, the seasonal monsoon has arrived, bringing three months of regular rain in most parts of the country to nourish the rice as it grows to maturity.

When the rain ends, the daily rhythm of field work intensifies. There are birds and other pests to be kept away from the ripening rice, and brimful rivers and canals to be fished with a large assortment of ingenious devices. By late November or early

December, rice in the north and central plains is ready for harvesting, another all-out effort involving cooperative work groups who stay in the fields from dawn to dusk, breaking only for lunch sent out by the host family. The cut rice is spread to dry in the sunlight, then taken to the family compound to be threshed, winnowed and measured for use in the home or eventual sale. Another few months can then be devoted to growing secondary crops, repairing buildings and tools, perhaps making handicrafts for sale or personal use, before the cycle begins again.

Home crafts

Thai village crafts, like those of other cultures, have developed through the classic principle of form following function, using for the most part readily available materials and traditional skills. The design is secondary to practical application, and few if any villagers would look upon such items as being artistic creations, even when parts of them are decoratively carved or woven. As one writer has expressed the process, 'Once the need is established (i.e., a container – basket; a weapon – crossbow) generally the designs originate from the properties and limitations of locally available materials. For instance, the flexible and linear qualities of the grass-family materials (rattan, bamboo, sisal, etc.) suggest a woven end product. Through trial and error, experimentation, personal quirks, and copying, a satisfactory product emerges which is likely to remain unchanged until an exterior force, such as competition or cost, comes into play.'

Wood, clay, reeds, bamboo, rattan, coconuts and various leaves are used for the great majority of rural crafts, since these are the easiest materials to obtain; stone and metals are also employed, but often for objects made outside the village and sold or bartered by itinerant merchants.

The bamboo that grows so plentifully throughout the country is perhaps the commonest craft material, cut into long, thin slivers and deftly woven into shapes that serve innumerable needs. Carl Bock, when shown an exhibition of Thai bamboo products, was moved to comment, 'What bamboo is NOT used for, it is difficult to say, and the array of mats, baskets, water-buckets, paddy-bins, etc., used by the Siamese, large as it was, might have been indefinitely enlarged had it been open to foreign nations, and if the value of the bamboo were everywhere as fully appreciated as it is in Siam.'

The typical village house, as already noted, is generally a simple affair, almost spartan in its amenities. While some located closer to cities, and therefore subject to their influences, may display such novelties as chairs and beds, in most the inhabitants prefer to live on the floor. For that reason there is little in the way of traditional furniture – a kitchen cabinet, perhaps, to hold cooking utensils, sometimes a low table or two and a mirror, either hung on the wall or mounted on a stand, nearly always a few woven bamboo containers in which the best clothes are kept for festivals and other such occasions. Some better-off houses might have a

Preparing split bamboo for basket-weaving, still a common village craft in many regions of the country.

cradle for babies, above which is often hung a mobile of fish made of plaited strips of palm leaf, providing a rare touch of frivolity; other items reflecting a somewhat higher status might include ornamental boxes or, in the past, superior betel-nut accessories.

Important items in the living and sleeping areas are soft mats woven from reeds, straw or similar materials. These were once predominantly plain but now often have intricately interwoven geometric designs, sometimes brightly coloured. In the central plains area some of the most popular mats are made in Chanthaburi province on the Gulf of Thailand, where the reeds grow in profusion, but other regions have their own types. In the far southern provinces of Krabi, Narathiwat and Pattani, for instance, mats are woven from pandanus leaves, while in Phattalung they are made of a tough water-plant known botanically as *Lepironia arpiculata* (in Thai, *kachud*), which is first soaked in mud to soften the leaves, then pounded into flat strips for plaiting.

Many Thai household crafts have evolved from the various requirements of the kitchen. One of the oldest stoves, no longer seen except in the most remote villages, was called a *cherng kran*, an all-in-one device made of baked clay in the form of a tray, with one side raised and shaped to hold cooking pots of different sizes; fuel, either wood or charcoal, was placed in the tray below. This stove and many variations based on it had the advantage of taking up little space in small rooms and was also easy to move.

Another portable cooking device found in some houses is a multi-piece unit used for making a rice-flour and coconut milk pastry called *khanom krok*. Also made of clay, this consists of a drum-like stove with a flared upper portion and an opening at the bottom for charcoal and a flat top with seven or more scooped-out depressions, each of which has a separate clay lid. The batter is poured into the depressions, then covered and baked for several minutes.

While the actual cooking of most Thai food is rapid – usually by stir-frying, boiling or steaming – preparation of the various ingredients is more time-consuming. Spices and herbs must be ground and blended, vegetables and fruits must be chopped or grated; for some dishes, particularly those served at special events such as weddings and religious festivals, the process can take many hours or even days.

Essential for these tasks is a sturdy mortar (*krok*) and pestle (*saak*) which may be made of stone, wood or baked clay, and come in a number of shapes and sizes. Equally necessary is a selection of sharp knives, often bought today from itinerant pedlars who travel about the countryside with their wares.

The need for coconut milk, an essential component of countless dishes, led to the development of an ingenious implement called a *khood maprow*, or coconut-grater. This probably began as a simple seat with a sharp iron grater protruding at one end, the whole unit often carved from a single piece of wood. The user straddled the seat

Carved coconut graters known as kratai khood maprow, *or 'grating rabbits', once common in village households.*

and, leaning slightly forwards, deftly rotated a half coconut around the grater to extract the interior flesh, from which the 'milk' was subsequently pressed.

Over the years, the *khood maprow* became much more elaborate, with the body carved into a wide variety of elegant shapes. The most typical, called a *kratai khood maprow* ('grating rabbit'), was that of a rabbit, perhaps because of the prominent 'teeth', but other animals and even crouching humans were used as the models for some, and the carving often displayed a high level of artistry.

Another device, also of carved wood, was used in slicing lengths of sugar cane. For some unknown reason, this is generally found in the shape of a horse's head and is most elegant, though it, like the *khood maprow*, is seldom seen now.

Woodcarvers also supply other items that may become treasured possessions in more well-to-do families who live not only in villages but also in large nearby towns. Serving a decorative as well as a practical purpose, these include covered boxes in various imaginative shapes – the rabbit is popular in both the north and northeast – plumbs for use in house construction, and fitted containers to hold scales and other household objects.

Not surprisingly, bamboo forms the basis of many kitchen crafts, varying from region to region. In the northeast, where glutinous rice is preferred to the ordinary variety grown in the central plains, it is woven into a highly distinctive steamer called a *kong khao*, consisting of a wooden stand, a bulbous, double-layered body to retain heat, and a cone-shaped lid; a cord can be inserted in loops at the top of the body so the steamed rice can be slung over the shoulder and carried into the fields by the people working there. This implement comes in numerous shapes and sizes, some of the more elaborately decorated being reserved mainly for ceremonial purposes such as a ritual to pay homage to the rice goddess.

Glutinous rice is a staple in the north, too, and specialized containers for it have been developed there as well, among them the jar-like *kong khao doak*, on which strips of bamboo dyed with ebony resin are interwoven with plain ones to make geometric designs on the outer layer, and countless smaller containers for individual portions.

Other kitchen items made of bamboo include the *kra jaad*, a shallow round basket with a square bottom, used for drying foods in the sun or wind; the *kra tip*, a double-layered glutinous rice container with a curved supporting stand; the *saa*, a small northern basket used to hold fruits, vegetables and other cooking ingredients; the *fah chi*, a cone-shaped cover to protect food from flies; and a large selection of sieves and strainers.

Ladles for cooking and serving, as well as water-dippers for drinking and bathing, are more likely today to be made of metal or plastic, but traditionally they were often objects of singular beauty and can still be found in some regions. *Kra buey*, or dippers, are fashioned from coconut shells with a long wooden handle, sometimes carved, gilded or painted when used in ritual ceremonies. To produce a

particularly striking dipper in the south called a *mah jak*, nipa palm leaves are skilfully folded to form a cup with a crossed handle; a similar one in the north, where it is called a *nam tung*, has a cup of woven and lacquered bamboo strips and a crossed wooden handle.

In former days every household, rich or poor, had a set of containers and accessories used in the almost universal custom of betel-nut chewing, which required a blend of areca palm nuts, lime and the leaves of the betel pepper. A set of betel-nut requirements, including a tray or stand for holding the nuts and sometimes a spittoon, is called a *chien mak*. In royal and other high circles, *chien maks* displayed highly refined craftsmanship and were fashioned from precious metals, brass, porcelain or gilded lacquer, reflecting the rank of the owner. Surviving village equivalents are much simpler, usually of wood, baked clay, or lacquered woven bamboo, but these, too, are often decorated and gracefully shaped. Bedsides those kept in the house, there are portable betel-nut containers similar to a lady's handbag, sometimes woven in distinctive patterns to give them individuality.

One village craft that, so far at least, has successfully resisted replacement by any Western fashion is the traditional farmer's hat, or *ngob*. Described by one writer as being 'the world's best designed product', this resembles an inverted plate and consists of a mesh bamboo frame tightly layered with palm leaves, the brim braced with small wooden strips. A separate cylindrical insert, woven to permit expansion or contraction and thus affording the proper fit, is secured in place with two crossed lengths of bamboo. The result, allowing easy air circulation while working in the hot fields, is both comfortable and singularly attractive.

Also an enduring feature of village houses is the large earthenware waterjar, or *toom*, which if made of good-quality clay lasts for years and keeps the contents refreshingly cool. Every home has several of these, some for storing rainwater and others for bathing if there is no convenient river or canal. Available in a wide variety of sizes and shapes, both glazed and plain, such jars are most likely today to come from Ratchaburi, southwest of Bangkok, which sends them all over the country and even, with handsome glazes and elegant decorations, to markets abroad. Similar waterjars of lightly glazed clay in assorted shapes are also found in traditional northern homes or – a reflection of the famous regional hospitality – placed on a covered stand outside the gate for the benefit of thirsty strangers.

On the famous stone inscription of 1292, King Ramkhamhaeng is supposed to have written, 'In the fields there is rice, in the waters there are fish', thus noting not only his people's staple grain but also the primary source of protein in their diet. He might have added, 'and plenty of devices to catch them with', for it is probable that many of today's numerous fish traps and carrying baskets were also in use during his reign 700 years ago.

The range is enormous and varies from region to region, but such devices fall into

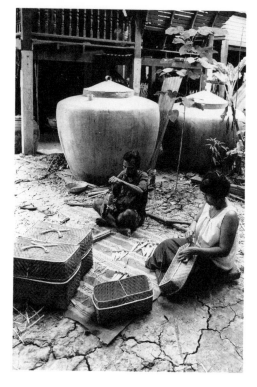

Basket-weavers outside a village house in the central plains province of Angthong; assorted storage baskets are shown in the foreground.

RIGHT *A net for snaring birds in the rice fields.*

three categories: traps which are left in place over a span of time and inspected periodically, those designed for a quick catch in ponds or streams, and containers for keeping the fish alive until they can be taken home. The basic *soom-pla* is a cone-shaped device open at both ends, made of either bamboo slats or woven strips; holding it by the smaller end, the farmer wades near the banks of canals or flooded rice fields and plunges the large end into the mud bottom when he sees a sign of fish, then removes his catch by hand from the top opening. The *toom*, found mostly in the northeast, is an upright trap of woven bamboo in the shape of a waterjar with a small opening at the bottom, placed in ponds formed by damming a stream; soft bamboo slivers inside the opening prevent the fish from escaping, so the *toom* can be left in place for some time. In moving water, such as trenches from one rice field to another, the farmer can use a long, woven, cage-like device called a *lob-non* or *lob pla-lod*, which is wedged into the channel to trap the fish as they pass through.

There is also a wide selection of *krachong*s and *khong*s, used to hold fish after they have been caught. The most attractive are tightly woven baskets in the shape of earthenware jars, with a lid or cone-shaped insert for the mouth and two loops on each side so a cord can be inserted for portability. A variation is the *khong-ped*, made in the shape of a duck, which has bamboo floats so that it can be left in the water while the farmer continues fishing.

Other bamboo traps are made especially to catch freshwater shrimp and eels, while there are special devices for spearing fish (often with finely carved wooden handles) or frogs and trapping birds and small animals. One of the latter, once common in the north, was similar in shape to a weaver-bird's nest, with a wide mouth, a narrow neck, a bulging middle and then a narrow base; it was baited and placed outside a porcupine's hole so that when the animal entered, its spines would become lodged in the mesh of woven bamboo.

In the northeast, where silk-weaving has been a local craft for centuries, special bamboo containers and trays have evolved for the storage of silkworm eggs and for holding the worms as they munch their way through vast quantities of mulberry leaves, while looms, spindles and other wooden devices are often adorned with attractive carvings that elevate them to a craft level somewhat higher than the merely utilitarian.

A very large category of village crafts derives from agricultural needs. There are specific baskets for carrying, threshing, winnowing and measuring rice, as well as

Bamboo fish traps of the type known as soom-pla, *plunged into the muddy bottom of shallow canals or rice fields.*

others for fruits and vegetables and for storing seeds, in a variety of shapes and displaying numerous complex weaving patterns. A popular kind of *kra jaad*, for instance, a carrying basket with a square base and bamboo struts which serve as feet, has a decorative edging around the top traditionally woven in one of two styles: these translate into 'the back of a mud fish', where the pattern resembles scales, and 'take the girl by the hand', meaning that the finished edge is closely interlocked and leads the eye around the rim. *Kradong*, or winnowing baskets, range from medium-sized to enormous, and are often used with a special woven fan to blow away the dust. There are baskets as well for measuring a more or less precise number of harvested coconuts and others for holding delicate or spiny fruits such as the celebrated durian.

In some parts of the country, before the introduction of modern equipment, paddy was hulled for family use in a *si-khao*, a handmill of woven bamboo with wooden fittings; while a device for extracting juice from sugar cane consisted of three huge, hand-carved wooden cylinders and was manipulated by buffaloes. Both of these are regarded as obsolete today, though the latter can sometimes be seen as a decorative object in the gardens of well-to-do homes.

A similar fate may lie in store for the *kwuen*, or animal-drawn cart, that was once a proud possession of nearly every rural home and that provided the principal means of transporting both people and produce. These are generally divided into two types: the *kwuen-naga*, drawn by oxen, and the *kwuen-kwai*, drawn by water buffaloes. The latter is more typical of the central region, where buffaloes are used in ploughing the fields, while the former is found mostly in the north.

Made of hardwood, such carts often have notably graceful lines and are sometimes decorated with carvings. Northern *kwuen*s, for instance, may have painted panels depicting an elephant, while those in the lower northeast have ornate Khmer-inspired door panels. Mae Hong Son province in the far north was once famous for its elegant *kwuen*s, which had curved tips on which to hang lanterns.

As farming methods were – and, to a large extent, still are – passed down from one generation to another, so most of these crafts were produced by village skills, inspired by specific village needs. Inevitably both have changed, especially in recent years. Tractors have replaced the family buffalo in many areas, commercial fertilizers are used instead of organic ones, rice mills (often owned by outsiders) perform the task of hulling grain. Similarly, the increasing spread of electricity and the availability of cheap plastic substitutes have affected the use of many old devices in both rural homes and fields, while objects of surviving traditional crafts are more likely to be purchased at a market than made at home by family members.

Yet in spite of these changes, it is remarkable how many of the old ways are vigorously alive. This stems partly from the conservative streak that runs so deeply through Thai culture, partly from the fact that so many of the tools continue to serve their needs better than any modern replacements.

81 RIGHT *Coconut graters, known in Thai as* khood maprow. *The user straddles the seat, often carved in the shape of an animal, and extracts the coconut flesh by scraping it against the grater at the end. Rabbits are the most common shapes, but many others were also found in the central and southern regions where coconuts are widely used in cooking. Modern devices have largely replaced them today and old ones are prized by collectors.*

82–83 BELOW AND BOTTOM *A selection of containers made of woven lacquered bamboo from northern Thailand, where the use of lacquer is more common than in other regions. These were mostly used for storing rice and other household commodities to protect them from damp and insect pests; more elaborately designed ones were often reserved for special occasions.*

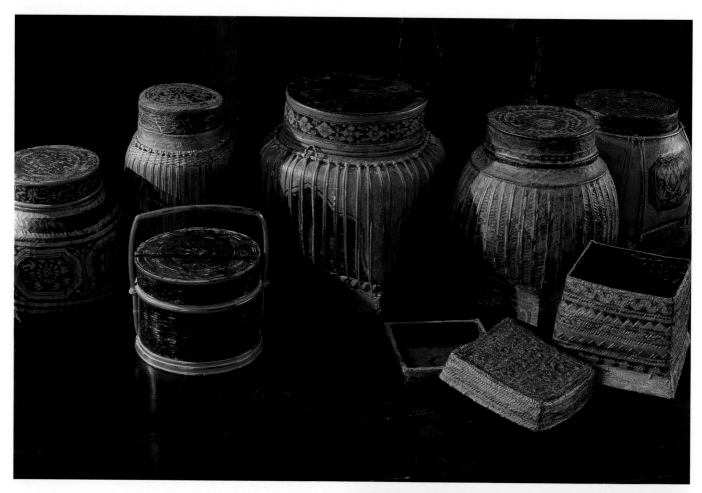

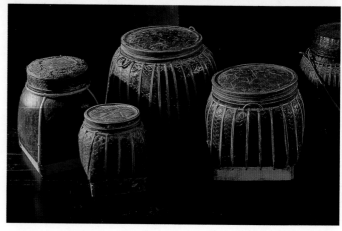

84–86 BELOW *Coconut graters in fanciful shapes.* BOTTOM LEFT *An all-in-one traditional stove, known as a* cherng kran, *made of baked clay; wood or charcoal is placed below the cooking pot.* BOTTOM RIGHT *Waterjar and simple earthenware cooking pots, along with a wooden tray for drying cooked rice. The shapes of the pots have changed little over the centuries.*

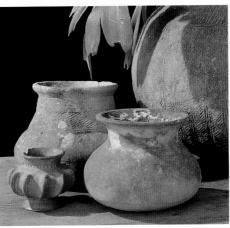

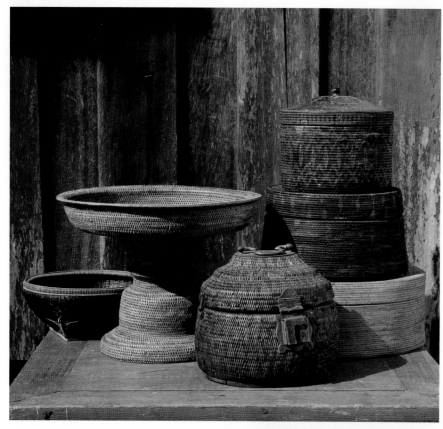

87–88 *Assorted containers made of woven bamboo and other plants, lightly lacquered to make the object more durable. Those on the left include covered storage baskets and a footed tray used to present offerings in ceremonies, while below are containers for glutinous rice, a staple food in the north and northeast.*

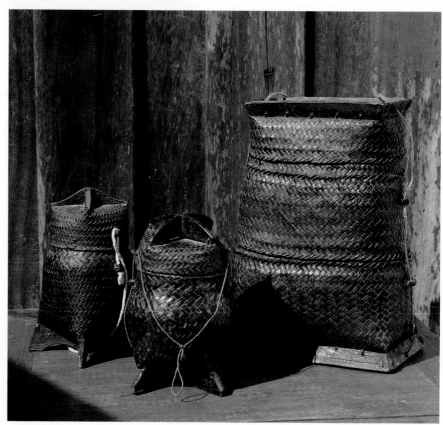

89 Northeastern glutinous rice containers, known as kong khao, *which are used both for steaming rice and for keeping it until meal times. Fitted with a cord, they can be slung over the shoulder and carried into the fields by farmers for lunch during the planting or harvest season. The shape and decorations vary considerably.*

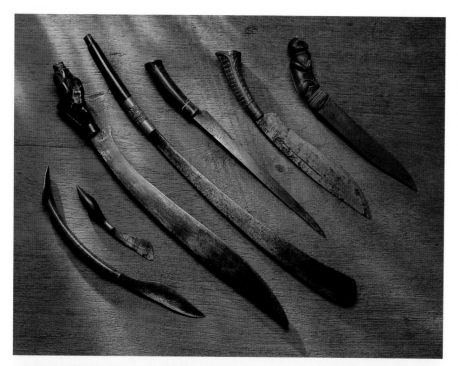

90–91 LEFT *Knives, machetes and other cutting devices with ornate handles that display the skill of the maker and indicate the status of the owner; these are passed down from one generation to another as prized family tools.* BELOW LEFT *Traditional scissors used for cutting hair and other household purposes. Such devices also figure in the coming-of-age topknot cutting ceremony, still an important rite for many village families.*

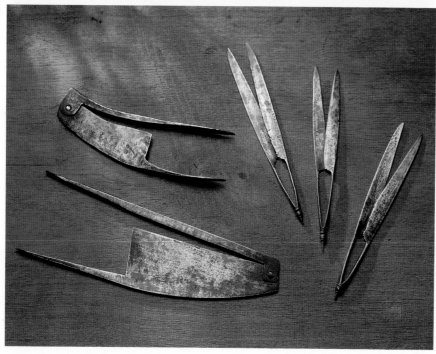

92–94 BELOW *Waterjar, traditionally placed outside village houses.* BOTTOM *Wooden trays, known as* chien mak, *to hold betel-nut accessories; these are from the northeast and decorated with inlays of deer bone.* RIGHT *Ladles made of coconut shell with wooden handles, known as* kra buey, *widely used in the south.*

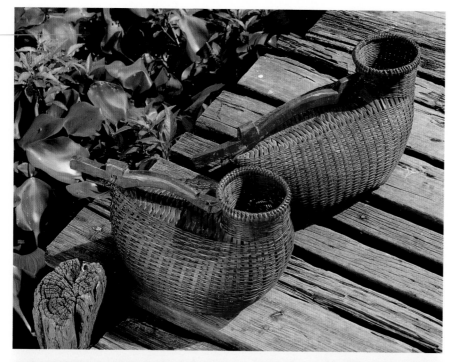

95–96 LEFT Woven bamboo containers, known as krachongs or khongs, used to hold freshly caught fish. BELOW LEFT Carrying basket for rice, vegetables and other produce, and a traditional farmer's hat which affords both protection from the sun and air circulation.

97 *Decorative wooden clappers from the northeast. These are tied around the necks of water buffaloes so that they can be easily located when they stray from the family fields. As in the case of other village crafts, they are becoming rare, as tractors and other modern implements replace the traditional methods of farming.*

98–99 RIGHT *Brushes with ornamental handles;*
these are used in the northeast to clean silk
during the weaving process. BELOW *A selection*
of decorative shaft pulleys through which silk
thread was strung on traditional looms.

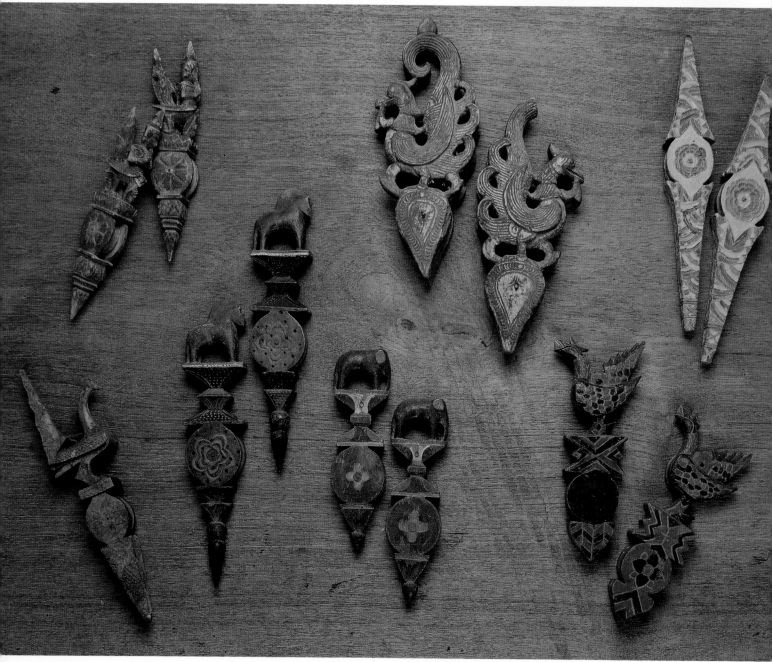

100 *Decorative pulleys for traditional looms. A pair of these was hung on each loom in the northeast; made by village craftsmen, they vary widely in form, some being fitted with wings that move up and down as the loom is operated.*

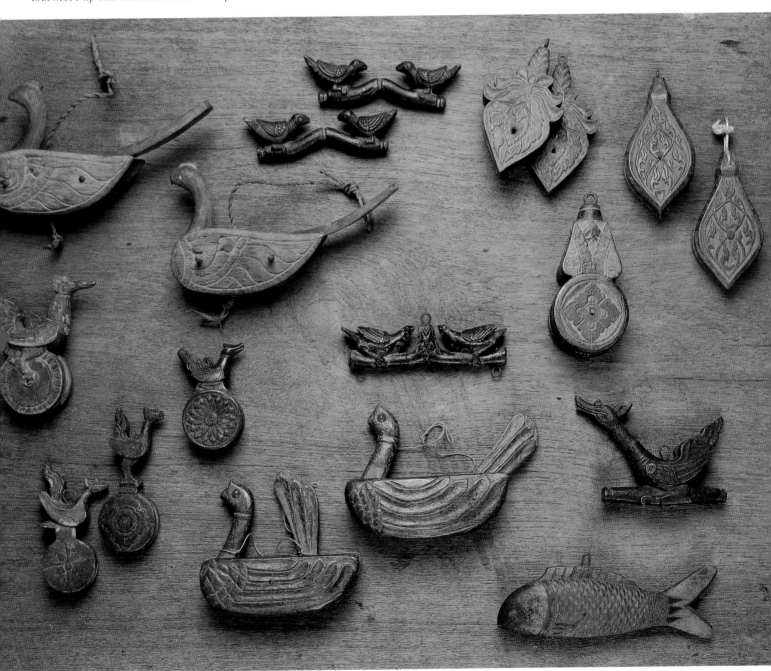

101–102 BELOW *Ornamental boxes, which serve both a practical and decorative purpose in the homes of more prosperous northeastern farmers and town residents.*

103 BOTTOM *Wood decorations on sugar cane-cutters, carved in the shape of stylized horses.*

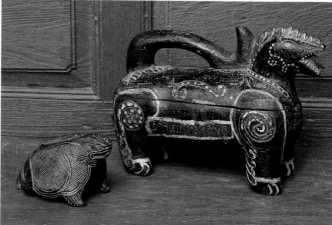

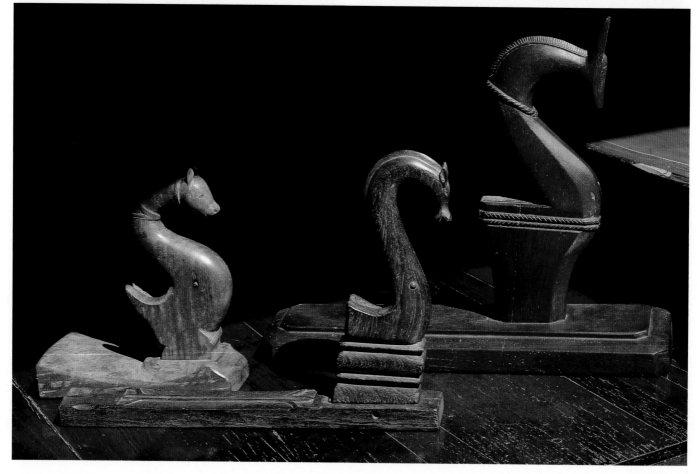

104–105 TOP *Carved wooden containers for weighing scales, used by rural merchants and pedlars.* ABOVE *Ornamental devices used by builders in construction; black powder was placed in the containers and a string passed through to mark straight lines.*

106 RIGHT *A decoratively carved reeling device, often used for reeling silk or cotton yarn before dyeing.*

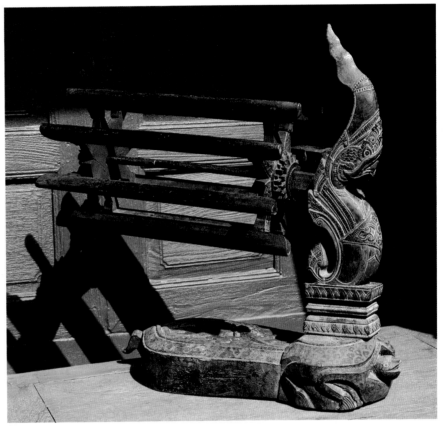

107–109 *Ornamental wooden boxes from the northeast. The making of such boxes is a specialty of the northeastern region, where they are used to store medicines, sewing tools and other small household goods. Animals of the zodiac are the most popular shapes, particularly the rabbit.*

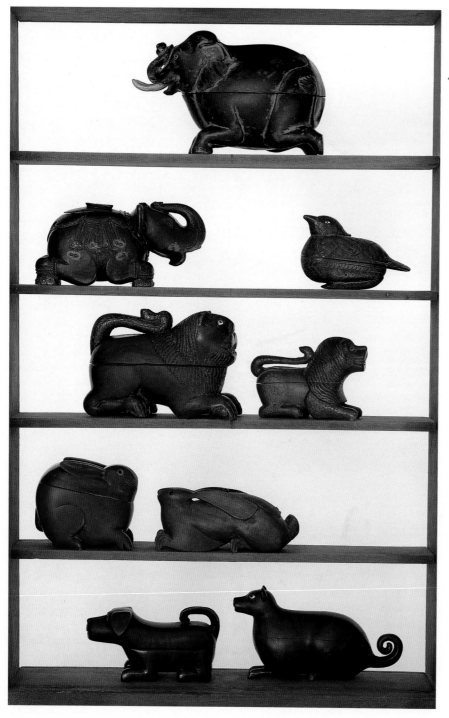

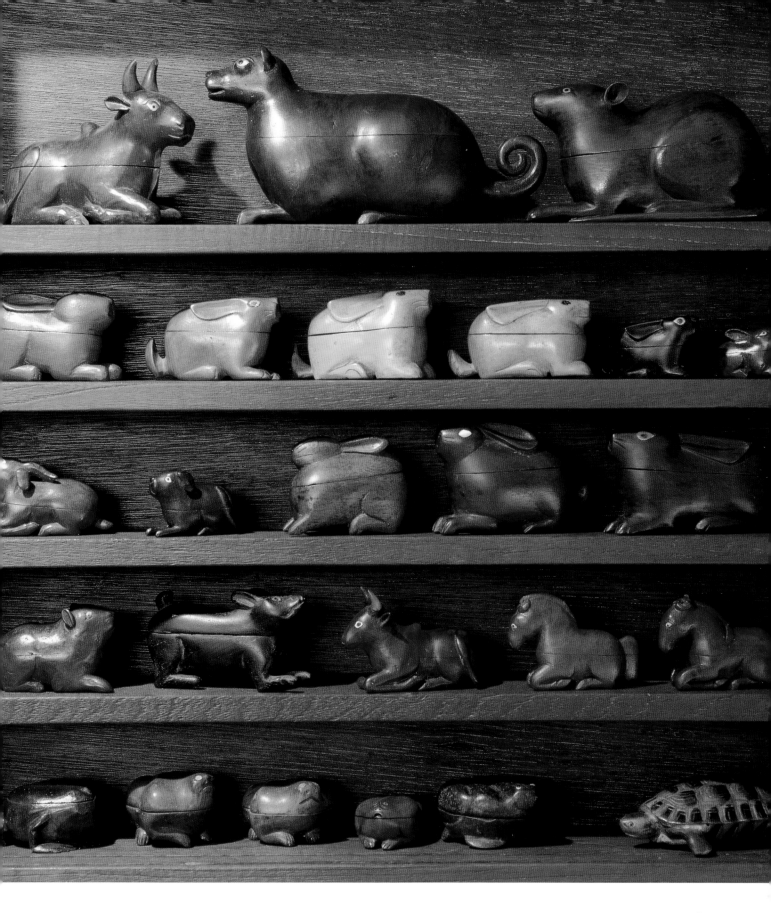

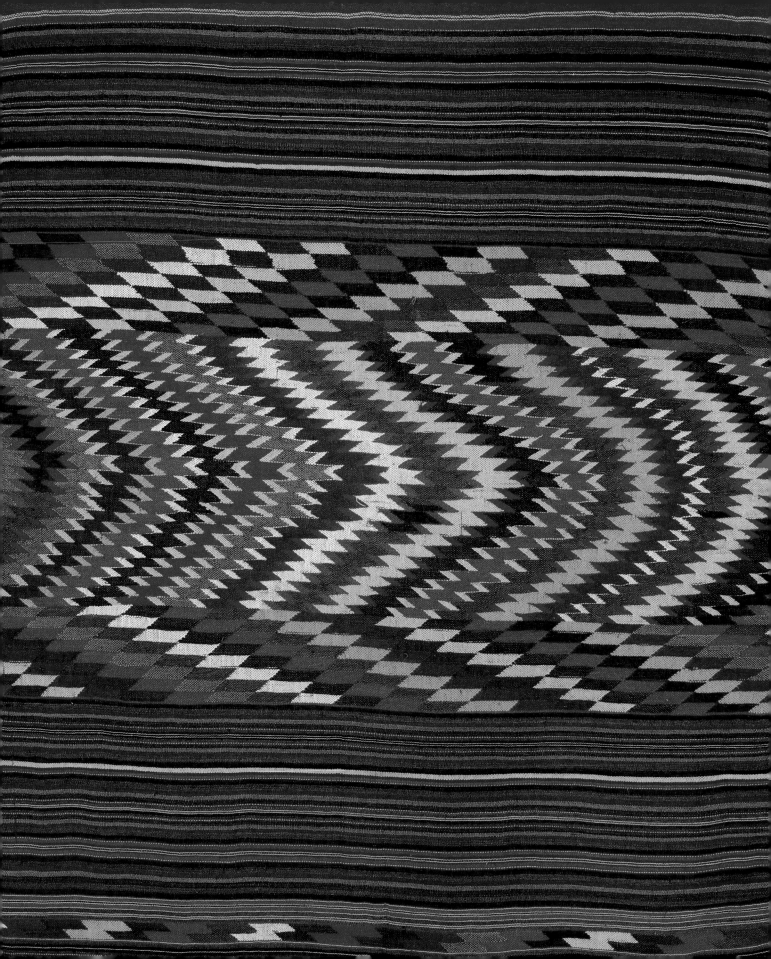

TEXTILES

IN THE EARLY 1960S, near an obscure hamlet called Ban Chiang in northeastern Thailand, an extraordinary archaeological discovery was made. Here, it became increasingly clear from a mass of material found in burial sites, a sophisticated prehistoric culture had flourished, far more advanced in its achievements than scholars of the region had previously believed possible.

In 1973, a Thai doctor and amateur archaeologist who had taken a personal interest in his country's prehistoric past, came upon a cluster of thread in one of the burial sites, lying near the right knee of a skeleton some 2.2 meters below the surface, or halfway down to the lowest level of human habitation. Microscopic tests conducted by the National Museum revealed it to be silk thread, unwoven and undyed; and tests made by a Japanese university on other artifacts found in the same grave showed them to be between three and four thousand years old.

Though it has been established that the Ban Chiang people wove textiles from local hemp – and possibly made designs on them with the aid of curious clay rollers – the evidence of sericulture remains inconclusive. On the other hand, the doctor's find suggests that it is at least within the realm of possibility and, if so, it would mean that a knowledge of the craft existed in the country a millennium before the Thais appeared on the scene, and that it existed, moreover, in an area which would later become known as the principal centre of the Thai silk industry.

Stucco sculpture and decorations from the Mon Dvaravati period (6th to 9th centuries AD) show a wide variety of garments, though whether they were made of silk or cotton (or both) is unknown. The Thais, most likely, brought weaving skills with them on their migrations down from southern China. Stone inscriptions from Sukhothai mention a kind of five-coloured cloth used for ceremonial purposes, covering the path walked along by prominent religious leaders. It is also likely that Chinese silks found their way to the first Thai capital among the goods exchanged on various trade missions, thus perhaps introducing one of the basic conundrums that confront anyone who attempts a reconstruction of the early history of textiles in Thailand: which of those mentioned elusively in chronicles or depicted in mural paintings were in fact Thai and which were foreign-made? No conclusive answer is possible, for no accurate account of such matters survives. The most probable answer is that both were to be found in Sukhothai and also at the later capital of Ayutthaya, with the finer imported silks being used by royalty and those woven locally by lesser citizens.

There is also evidence of weaving in the northern Thai principalities collectively known as Lanna, which co-existed with Sukhothai. Temple murals in Nan, Chiang Mai and Lampang provinces show costumes with designs that can still be seen on

110 LEFT *A cotton phasin, or tubular skirt, worn by rural women; this example was made in the northern province of Nan by an ethnic group known as Tai Lue, who originally came to Nan and Chiang Mai from Sipsong Panna in southern China. It is in a form called the tapestry weave, using discontinuous weft, and its bold design suggests it was probably made for a young woman.*

textiles today. The silk-weaving tradition in Chiang Mai must have been particularly strong, since it was still known in the early 19th century as a major source, though by that time most of the weavers were ethnic Lao.

The existence of non-Thai weavers within Thailand itself raises another problem of classification. In both the north and northeast, much of the population is Lao and near the Cambodian border many are Khmer. Moreover, during the early Bangkok period large numbers of Lao were more or less forcibly resettled in such provinces as Petchaburi, Ratchaburi and Nakhon Pathom, where their descendants still live today. A community of Khmer Muslim silk-weavers settled in Bangkok in the 19th century and were still practising their craft when it suddenly became world-famous shortly after the Second World War. For the purposes of this book, the textiles produced by these groups are included among the crafts of Thailand, since whatever their ethnic backgrounds they have become an integral part of the country's culture.

At the peak of its power, in the 17th century, Ayutthaya served as a major regional trade emporium, to which goods came from all over Asia as well as Europe and the Middle East. Textiles from India were particularly popular and appear frequently in murals of the period. According to one source, there were certain markets in the city that specialized in luxurious silks woven by Kaek Cham, as Khmer Moslems were known, many of whom were residents.

Evidence of local silk-weaving is, however, contradictory. In 1616, writing to the East India Company, an English trader named Richard Cods responded to a request to buy silk products for resale to Japan by stating flatly, 'I have had reports from our representatives that this would not be possible, for I can honestly say that there is no silk in Siam.' The French envoy Simon de La Loubère was equally certain, writing of his 1687 visit, 'They have not been able to raise mulberry trees, and for this reason they have no silk-worms.'

On the other hand, the Jesuit Nicholas Gervais, who spent four years in Siam (La Loubère stayed only a few months), claimed that 'they have learned from the Chinese how to make gold and silver silk brocade and, in order to avoid having to obtain silk from abroad, the king has taken pains to have a great quantity of silkworms bred in his kingdom.'

Indian textiles continued to be imported after Bangkok became the capital in the late 18th century. The most popular of these were called *pha lai-yang*, or 'designed cloth'; as with the Bencharong produced in China, the designs were provided directly by Thais, following traditional motifs, and sent to India for printing or, in some cases, painting by hand. *Pha lai-yang* had to meet the most stringent aesthetic requirements from the Thais who wore it – mostly high-ranking court officials granted the privilege by the king – and it was thus expensive and relatively rare, with many pieces rejected as being of inferior quality.

Considerably cheaper, and also less popular, was a kind known as *pha lai-nok-*

Romanticized French view of Thai upper-class dress; from an account of his journey to Ayutthaya in 1687 by Simon de La Loubère.

yang (roughly 'cloth not according to design'). On these the designs were created by Indians, and while they resembled those supplied by the Thais, there were significant differences to the practised eye. A third variety was *pha lian-yang*, 'copied design', which was somewhat more authentic, being an Indian stab at copying the Thai originals, but also plainly inferior to the *pha lai-yang*. All these categories were available not only in silk but also in cotton which came to India from English mills.

Increasingly, the markets of Bangkok filled with other imported textiles, totally un-Thai in design but fulfilling a new demand for foreign goods. This does not mean that domestic production of both silk and cotton had ceased, as some Western visitors appear to have assumed. Even in the capital, weavers were still at work, as an English visitor named P. A. Thompson discovered when he went there in 1910.

'The most beautiful silks are not displayed for sale in the markets,' he observed. 'To find them we must go through narrow passages and under low doorways, into the little houses which lie far back from the main streets, where the girls sit at their looms, and there, after we have drunk many little cups of tea, they will show us of their best.'

Both silk- and cotton-weaving were certainly cottage industries in provincial areas, where outside influences were less intrusive and, in many cases, imported materials were simply not available. The Lao who had been settled in Petchaburi, for example, were noted for their handsome brocades, including a type known as *teen jok*, in which the weft threads were slipped in and out of the warp to produce shimmering patterns; and both the north and northeast continued to produce textiles scarcely changed from those of the distant past.

Weaving in such communities was done exclusively by women, often on simple frame looms set up beneath the houses. Girls learned the techniques from an early age and a young woman was expected to produce at least two superior pieces of silk by the time she reached the age of marriage, one as part of her own wedding outfit and one to present to her future husband.

Since weaving techniques were passed down from one generation to another, in a village society that was highly conservative designs tended to remain static, with only insignificant variations. Another factor contributing to the lack of innovation was the use of natural dyes, which limited the range of possible colours and thus encouraged repetition.

Cotton was worn in everyday life or made up into such items as pillows and ceremonial banners for presentation to temples; silk, because of its scarcity and also because of its relative fragility, was saved for special occasions and then used with considerable care. For example, it was often worn over a layer of cotton cloth to protect it from perspiration, and between uses it was kept carefully folded, the design facing inwards, wrapped in another piece of thicker cloth and stored in a box or woven bamboo container; a sachet of dried flowers was often put in along with it.

Detail from an 18th-century manuscript, Pilgrimage to Sarabury, *showing pilgrims wearing checked cotton* pha khaw maa *in* chong kra ben *style. (From an early 20th-century copy in the National Library, Bangkok.)*

If cleaning became absolutely necessary, the silk was gently washed in coconut juice with no sort of detergent that might disturb the natural dyes.

Even as he and his court were adopting Western dress for most occasions, King Chulalongkorn took some tentative steps to preserve and improve local silk production. In 1901, he ordered the Ministry of Agriculture to form a silk section and hire a team of Japanese experts to survey certain provinces, mostly in the northeast, and suggest better methods of sericulture.

In 1903, the silk section became the Department of Silk Craftsmen, with one of the king's sons as its director-general. The following year a branch was set up in the northeastern city of Korat (Nakhon Ratchasima), mulberry trees were planted, and soon worms were being reared; training courses were started in several provinces, including Bangkok, with Japanese teachers who were to be replaced with Thais when a sufficient number of graduates were available.

Few of these efforts survived for long after the king's death in 1910, nor did others initiated in the 1930s, following the end of the absolute monarchy. By the Second World War, while silk-weaving remained an ingrained part of rural culture, few families regarded it as a full-time occupation and it certainly offered no competition to the famous industries of China and Japan in Asia, nor to those of France and Italy in Europe.

The man largely responsible for dramatically changing this state of affairs was not a Thai, nor did he have any weaving experience. He was an American architect named James H. W. Thompson, who came to Bangkok as a Captain with the Office of Strategic Services in 1945, a few days before the Japanese surrender. Deciding not to return to his practice in New York after leaving military service, he first chose as a career the restoration of the venerable Oriental Hotel; only when a disagreement with his partners led to his withdrawal from this project did he begin to investigate seriously the commercial possibilities of exporting Thai silk.

There were compelling arguments against such an idea. Though many rural homes still had a loom or two – in some villages there were as many as 150 – all were the simplest form of hand-looms, hardly capable of turning out silk in any great

Jim Thompson, the American who revived the Thai silk industry just after World War II.

quantity or length. Moreover, almost all the dyes in common use were vegetable-based, and while these often produced extraordinary combinations – especially in the subtly patterned weft *ikat* called *mat mii*, a speciality of the northeast – they would hardly hold up under Western cleaning methods. Finally, and perhaps most important of all, weaving was regarded as a part-time activity for female family members; it would take considerable powers of persuasion to convince even the most adventurous that a profitable export market existed far from their humble workshops.

On the other hand, the great traditional silk producers had been ravaged by the war and seemed likely to remain out of competition for some time. If a Thai substitute could be produced in sufficient quantities, it might well attract buyers in a world eager for luxury goods after years of austerity and rationing.

Thompson followed up his idea with determination. He collected all the pieces of silk he could find to build up a fairly representative sampling of what was available, and also got a descendant of the Khmer Muslim weavers who had settled in Bangkok to produce a few unusually long pieces in assorted traditional colours. In addition, he studied old silks in the National Museum and asked Thai and Lao friends about techniques; the latter were especially helpful since many had friends and relatives in the northeast who were still weaving.

Finally, in early 1947, he went to New York, where his samples created a sensation in the offices of influential *Vogue* magazine. Orders began to come in, slowly at first but then in sufficient numbers to persuade Thompson to establish a proper company, which in its early days took the silk on consignment and paid the weavers after it had been sold. Later, as demand increased, the material was bought for cash, though it was still produced largely in homes or independently owned small factories, a system that continued until some time after Thompson's death.

In retrospect, it can be seen that Thompson's most enduring contributions to Thai silk lay in two related areas: improvement of the product and the creation of a world market. Weavers had to accustom themselves to the flying shuttle rather than the old time-consuming method of passing the thread from one side of the loom to the other by hand; only by using the newer method could production be increased and standard widths supplied. Moreover, colour-fast chemical dyes had to replace the conventional vegetable ones, a delicate process that required considerable trial and error on the part of both Thompson and the weavers. When the proper colour combination was achieved, the formula had to be carefully recorded so that it could be repeated without variation in subsequent orders.

Without a market, however, all these improvements would have been pointless, and here Thompson's success was due partly to useful contacts in the worlds of fashion and interior design, partly to a flair for promotion, and partly, perhaps, to sheer luck. To the last category one might assign a decision to use Thai silk for most of the costumes in the stage musical *The King and I*, which garnered a good deal of

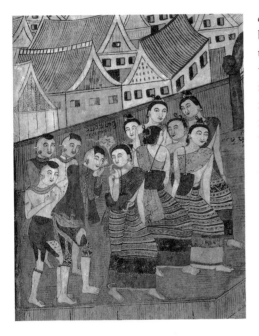

Detail from a mural painting at Wat Phumin in the northern province of Nan, showing women in traditional phasins.

LEFT *Queen Saowabha Pongsri, principal queen of King Rama V, in a court costume that blends Thai and Western styles.* ABOVE *Thai village woman wearing a sarong-like silk* phanung, *popular until the early years of the present century.*

publicity as well as business. The value of silk exported jumped from 515,386 baht in 1950 to nearly two million baht in 1952; the figure was 4.5 million in 1955 and 11 million in 1959.

In 1967, Thompson mysteriously disappeared while on a holiday in a Malaysian resort called the Cameron Highlanders; despite an intensive search, no trace of him was ever found. He left a lasting legacy, however, in a craft now being supported by numerous companies besides the one he founded, which has become almost a symbol of the country he adopted as his home.

Another important influence on silk production and use over the past few decades has been Her Majesty Queen Sirikit. During tours of the northeast early in her husband's reign, the Queen was struck by the beauty of locally woven *mat mii*, a process of resist patterning commonly known as *ikat*. A royally sponsored *mat mii* project was set up in the early 1970s to encourage commercial production; the Queen also began featuring the results prominently in her own wardrobe, thus restoring something of the status appeal the richly coloured silk enjoyed long ago in elevated social circles.

Textiles uses

In the past – and, to a large extent, today as well in rural areas – Thai textiles were mostly woven to fulfil the basic needs of clothing and merit-making offerings to monasteries. While some of the forms have changed over the years, particularly clothing worn by the upper classes, others have remained more or less the same.

Both men and women used to wear the sarong-like *phanung* pulled between their legs, a style known as *chong kra ben* and supposedly adopted from Khmer fashion. The breast-cloth worn by women was described by Dr Malcolm Smith as 'simply a scarf wrapped round the chest and kept in position by folding the edge over'; it was, he added, 'a capricious garment for it was liable at any moment to come undone.' The style continued well into the Bangkok period, though high-necked jackets replaced the shoulder cloth among upper-class men and blouses among their women as Western dress became increasingly popular; it was finally abolished at court in the reign of Rama VI, who regarded it as unmodern, and is seen today only in traditional ceremonies calling for ancient dress.

Instead of the voluminous *chong kra ben* for women, Rama IV favoured the tubular skirt called *phasin*, which more closely resembled Western fashion. This, too, was eventually abandoned in urban areas, except on such occasions as marriage (nearly every bride wears an elegant *phasin* of lavishly brocaded silk) and royal functions, though it continues to serve as basic attire at the village level.

The *phasin*s of rural women may be silk for ceremonial purposes or cotton for daily wear – sometimes a combination of the two – and, if made at home, are a highly visible statement of both her weaving proficiency and her position in society. *Phasin*s made and worn by a young girl tend to be brighter in colour and bolder in

design. As she grows older, the colours become darker and more subtle; *phasin*s of older women rarely have the large designs made by supplementary weft techniques (*khit* in Thai) or the resist patterned weft designs of *mat mii*, but instead employ plied yarns and sober hues.

A *phasin* is divided into three horizontal parts, the top (*hua sin*), the body (*tua*) and the foot (*tiin*), which may be different areas of design on a single piece of cloth or separate pieces sewn together. The *tua*, or middle section, is the largest and usually carries the major design, though the bottom – usually made of cotton – may also be elaborately decorated. Designs generally consist of intricate abstract patterns or stylized motifs from nature or mythology.

The male equivalent of the *phasin* is the *pha sarong*, which is worn wrapped around the lower body and tied in front at the waist; alternatively, it may also be used as a belt, as a carrying cloth or as a covering for the head. Silk ones are ceremonial and often come as gifts from the women who weave them, while those made of cotton are more often today bought in a market. Traditionally, the design is a chequerboard pattern in vibrant colours for a young man and darker ones for those who are older.

Another item of rural dress is the shoulder-cloth, from 33 to 45 cm. wide and from 180 cm. to several meters in length. This serves a variety of purposes for both men and women and the names differ according to use. The male version, called a *pha khaw maa*, nearly always made of cotton with bold checks, serves the same purpose as the *pha sarong* in many parts of the country.

Textiles also play an important role in Theravada Buddhism. While most of the monks' robes now presented to monasteries are factory-made, other offerings are woven locally by village women as a means of earning merit. As part of the ordination ceremony, the future monk may wear a head-covering called a *pha pok hua*, a square of white cloth surrounded by decorative designs produced on the looms of female relatives. These are nearly always cotton and the designs are parallel rows of geometric shapes.

Among the gifts to the monastery may be pillows (*maun*) in a number of shapes, ranging from simple rectangular cubes to small bolsters to wedge-shaped forms that serve as a back-rest; these are often covered with a supplementary weft patterned cotton cloth known as *khit maun* and stuffed with kapok. Such pillows are not confined to monasteries but may also be found in homes, as are decorative woven blankets.

Moreover, there are *toong*s (discussed also Chapter III), banners hung outside a temple to announce various special occasions or inside to earn merit for a deceased person; in the northeast, eight banners are flown from tall poles ritually erected in the temple compound and offerings are made to each. *Toong*s are usually made of cotton woven with colourful designs but may also consist of cotton warps interlaced with weft slats of bamboo.

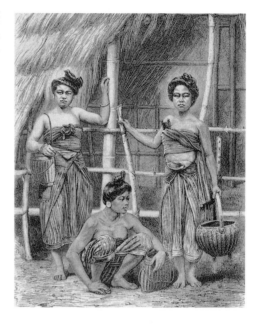

An engraving showing Laotian refugees living near the town of Petchaburi. They wear typical ikat sarongs of rough cotton, still woven in northeastern Thailand. (From the 1863 publication of the diary of Henri Mouhot, discoverer of Angkor, in the Tour du Monde.*)*

111–114 FACING PAGE TOP LEFT *Silk* phasin *from the northeast in an ikat weave, with an animal design.* BOTTOM LEFT *Silk* phasin *with a lotus motif.* TOP RIGHT *Silk* phasin *with a traditional ikat design of a serpent holding a pine tree.* BOTTOM RIGHT *Silk* phasin *from Surin province in the northeast.*

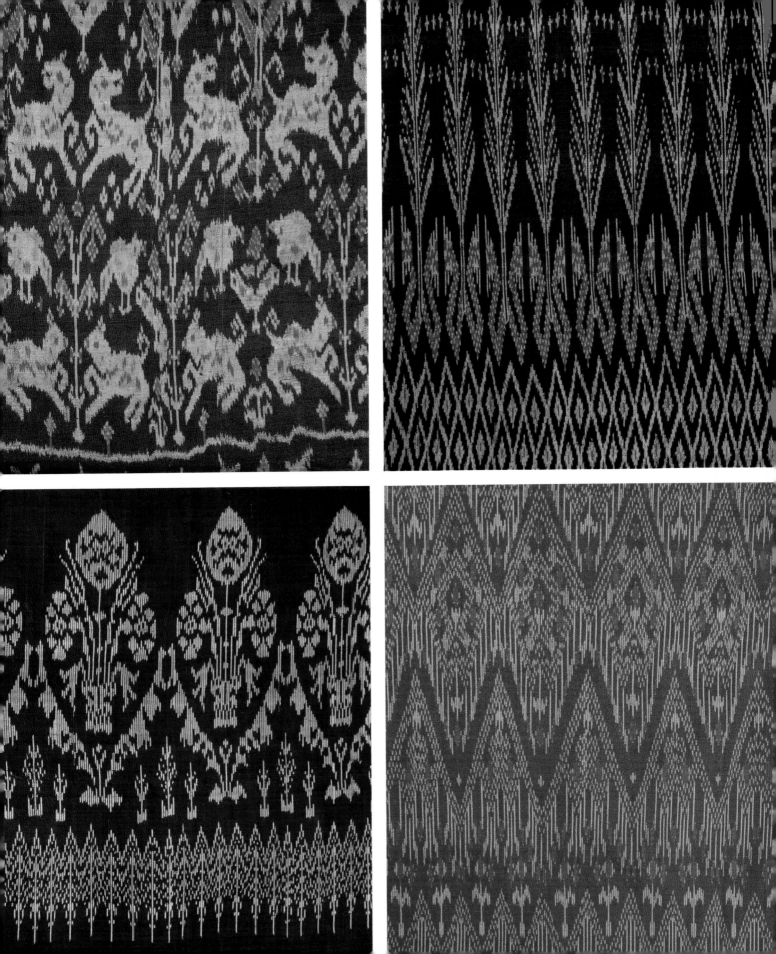

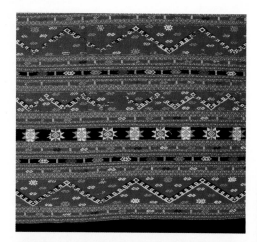

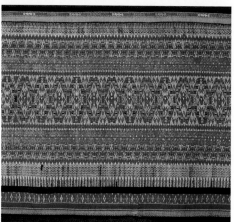

118 BELOW *Cotton* phasin *from Uttaradit province in the lower north. The middle section, or* tua, *is a supplementary warp pattern, while the bottom is a* jok *weave with stylized birds, waves and hooks. Village girls are trained in such weaving techniques from a young age.*

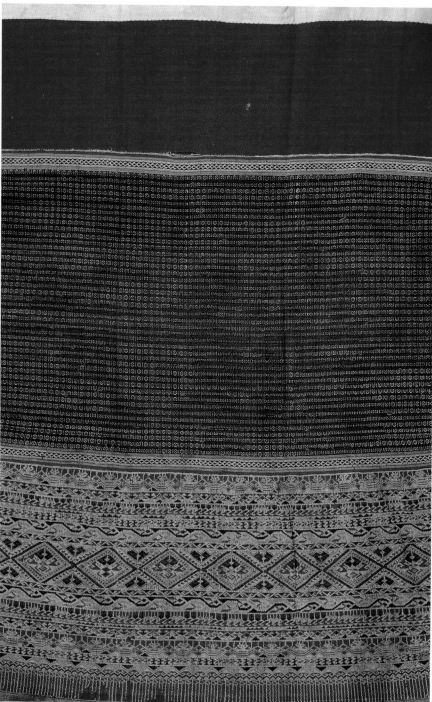

115–117 ABOVE AND BELOW *Hem bands, known as* tiin, *woven in a supplementary weft pattern called* jok. *These form the lower border of* phasins *and may be made separately from the other parts. Designs differ widely in various regions; the examples shown here are cotton and probably came from Sukhothai.*

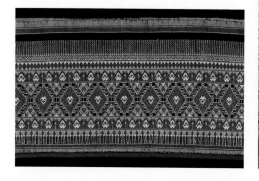

119 BELOW *Silk* phasin *from Phichit province, with serpent designs in an ikat weave. The red dye used in this example was produced by an insect which deposits a resin on the branches of the rain tree; the resin is ground into a powder which results in bright red when used on silk and pink on cotton.*

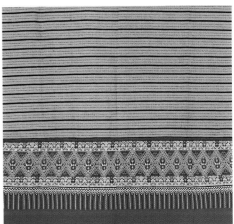

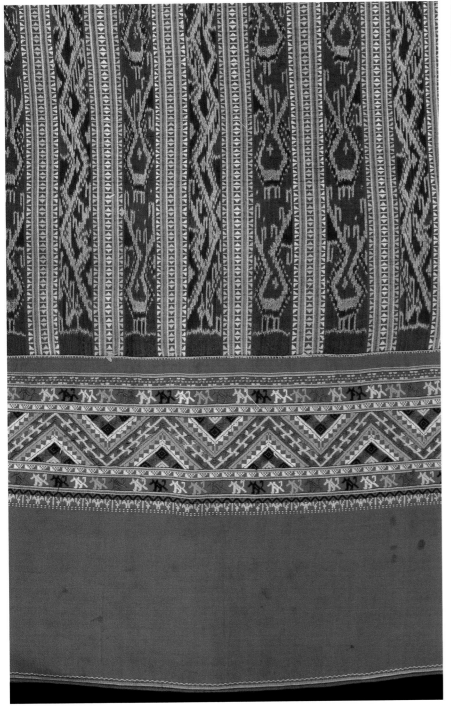

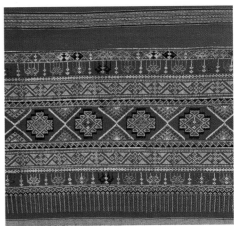

120–122 ABOVE *Three geometric designs in cotton for* tiin jok, *which form the hems of* phasins. *Such designs differ from region to region and according to the age and status of the wearer.*

123 BELOW *Cotton weft designs showing a* raja singh, *or royal lion, with a man standing on its back and trees; this was woven to be part of the covering for a pillow used in the home or presented to a monastery.*

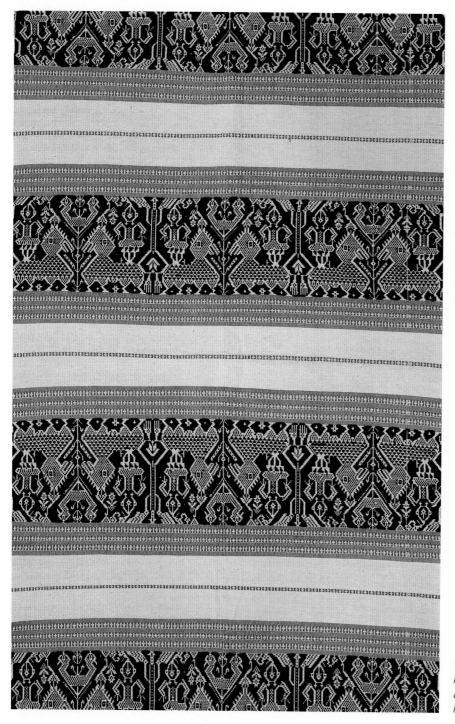

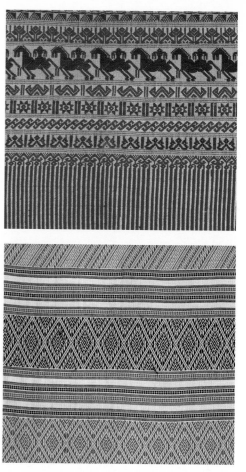

124–125 TOP *A* pha chet, *or shoulder cloth, worn by men and often presented as an offering to monks.* ABOVE *Blanket with geometrical design woven by Thai Lue people in Nan province.*

126–127 RIGHT *Northern* toong, *or banner, hung outside temples to make merit or during ceremonies.* FAR RIGHT *Colourful cotton blanket woven in Uttaradit province.*

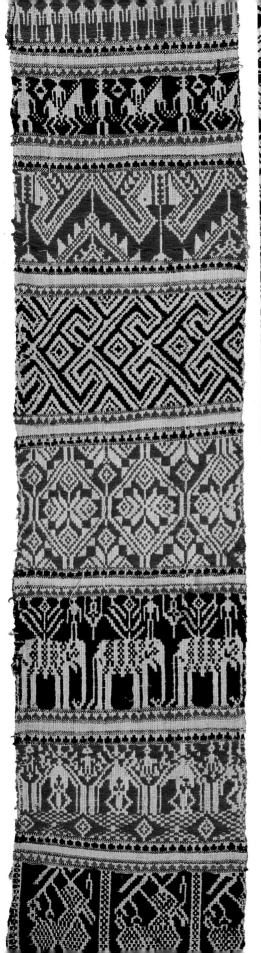

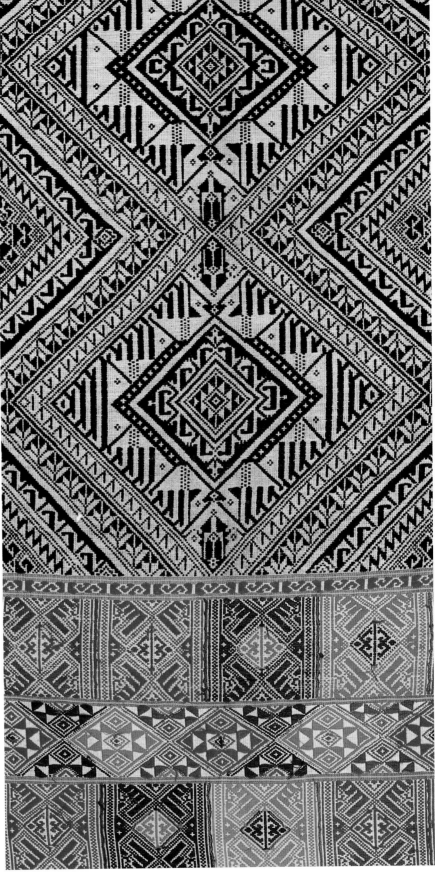

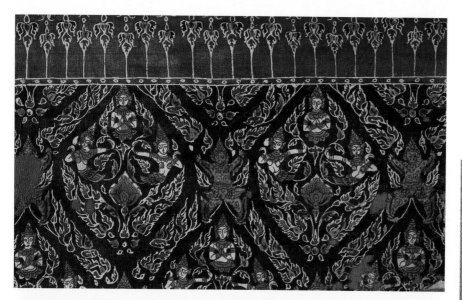

128–131 *Textiles printed in India in the late 18th century for export to the Thai market, mostly for use by royalty. For the best of these, patterns (and sometimes designers) were sent from Thailand to ensure accuracy and the desired colours. The piece shown left top shows* thepanoms, *or divinities, and the classic Thai* kanok *motif.*

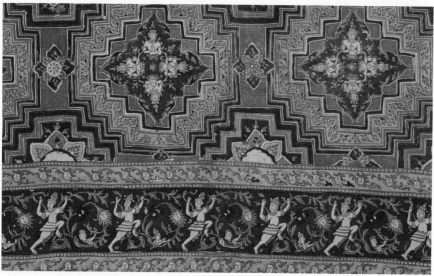

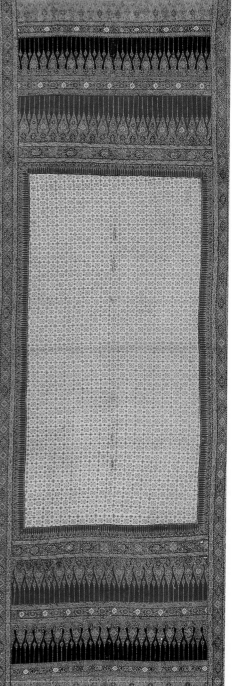

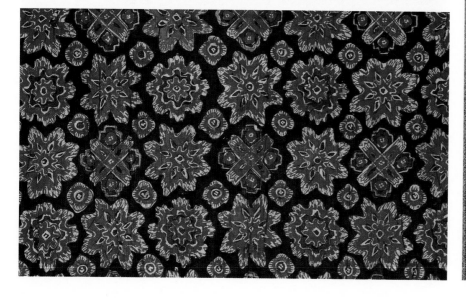

132 BELOW *Silk cloth intended for wear in the* chong kra ben *style, in which the material was wrapped around the waist and then pulled through the legs to form voluminous pantaloons. This example, which has a candelabra design at the bottom to indicate rank, was possibly woven in the early 19th century in Cambodia – then under Thai rule – for a member of the Thai royal family.*

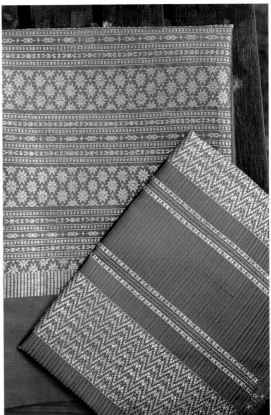

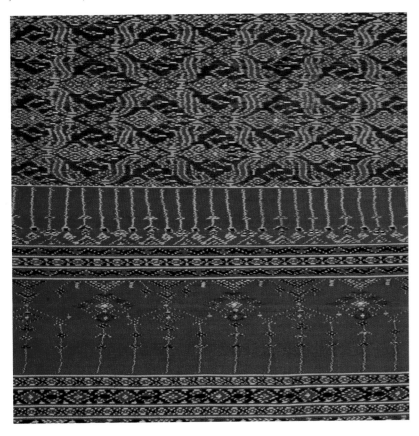

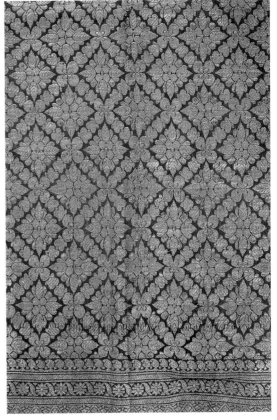

133–134 ABOVE RIGHT *Contemporary* phasins *with brocaded designs, made by the Jim Thompson Thai Silk Company.* RIGHT *Antique brocaded silk, possibly made in India for Thai royalty to wear in the* chong kra ben *style.*

ARCHITECTURAL WOODCARVING

THANKS TO THE extensive forests that once covered much of Thailand, architectural woodcarving emerged as a major craft early in the kingdom's history and became one of its most characteristic arts. Thai temples, much more spacious than their Khmer counterparts since they had to accommodate large congregations of monks, could not be built solely of stone and were therefore roofed with timber; similarly, wood was used for the increasingly elaborate decorative features that adorned religious structures. Carved wooden decorations were also used on royal palaces and, in a more modest form, on the homes of prosperous citizens of lesser status.

In the thickly forested north, a semi-autonomous kingdom until the late 19th century, the craft was widely practised and entire temples and palaces were often wooden. Carl Bock, travelling through the region in 1882, noted that 'Woodcarving is a favourite occupation, in which some technical artistic skill is displayed, and the native chiefs and the princes constantly employ a number of men to make ornaments, though I fear the remuneration is not always adequate to the skill and time occupied.... The wood-carvers have a quaint taste for inlaying their work with odd bits of coloured glass, tinsel, or other bright material: such work will not bear close inspection, but it has a remarkably striking effect when the sun shines on these glittering objects.'

These ornamental woodcarvers of the past were looked upon as an elite group of artisans. They acquired their skills through a long period of apprenticeship under recognized masters, learning the qualities of various woods, the essential tools, and the figures and patterns that were repeated over and over. Some became specialists in certain features, such as finials, while others were noted for their ability at rendering particular figures, human or mythological, and aspects of landscape. In general, woodcarvers were less restricted by conventional iconography and were thus freer to exercise their imagination than the stone carvers and bronze casters who produced Buddha images and other religious arts.

At least one ruler is credited with being proficient at the craft. Rama II, also a noted poet and musician, worked on two of the doors for Bangkok's Wat Suthat, which were supposedly inspired by the beauty of a pair of carved panels brought down from the north. Now kept at the National Museum, the royal panels display four distinct levels of carving and depict intricate scenes of plant and animal life.

The preferred material for carvers was once-plentiful teak, because of its durability and resistance to insect damage, but other hardwoods were used as well

135 LEFT *A masterpiece of Lanna Thai woodcarving, over the entrance to Wat Pan Tao in Chiang Mai; the peacock, inspired by Burmese art, is a common motif in northern temple decorations.*

for features like gables and doors. A door panel might be carved from a single slab, while for a large gable, a number of pieces had to be carefully fitted together within a triangular frame so that the joins were almost invisible. The colour of the wood used was of secondary consideration since it was customarily gilded, lacquered or adorned with glass mosaics after carving was completed.

Now as in early times, before the carving can begin, a pattern has to be prepared, sometimes by a separate designer, sometimes by a master woodcarver himself. The classic method was to draw this on paper, prick holes along the outline and transfer the design to the wood by sprinkling chalk or charcoal dust over the paper. Today, it is more usual to trace the pattern on thin paper, which is then pasted to the wood to guide the carver.

Evolving gradually over time, certain motifs and figures are traditional to Thai woodcarving. Many of them are derived from nature, though they have become so stylized and are subject to so many variations that their origins are often difficult for a layman to discern. One of the most common, for example, is the *kanok*, a vegetal motif that also resembles a flickering flame. In its basic form, this consists of three parts: the bottom one, known as the *tue ngao*, faces downwards, while the adjacent *tua prakob* leads to the uppermost part, *tue pleiw*, which tapers to a flamelike point. The *kanok* appears in many forms in architectural decorations, some of them extremely intricate and blending the prototype with other motifs in imaginative ways.

Also commonly seen are the *krachang*, based on a lotus bud, often used in border decorations and also subject to numerous variations: the *rak roi*, which resembles a flower garland and is used for decorating the borders of columns; the *dok phuttan*, a stylized version of the cotton rose flower (*Hibiscus mutabilis*); and the *karn to dok* and *karn khot*, both scroll patterns that combine various motifs joined together with stems. Still other motifs were adapted from Chinese and European sources, though usually given a distinctive Thai flavour; the *kanok khrua farang*, for example, was based on the acanthus leaf, considerably modified for local tastes.

In addition to these patterns, woodcarvings may include figures drawn from Hindu and Buddhist mythology, such as Vishnu and his mount Garuda, reflecting the concept of divine kingship; Brahma and his three-headed elephant Erawan; the *naga*, a semi-divine being usually found in the form of a serpent and regarded as a protector of Buddhism; the *singha* or lion; the god Indra and his consort; and assorted guardian demons and divinities. Some of these were incorporated into royal seals and emblems which appear on many buildings. Also popular are religious narratives, such as the moralistic Jataka tales and scenes from the life of the Buddha, and literary works like the *Ramakian*, the Thai version of the Indian *Ramayana*. Landscape scenes involving trees, flowers and animals, sometimes combined with traditional motifs, are believed to have come from China and were particularly popular in the early Bangkok period.

RIGHT *Contemporary carving from old wood of a Burmese-style divinity, one of many such items now being produced in Chiang Mai.*

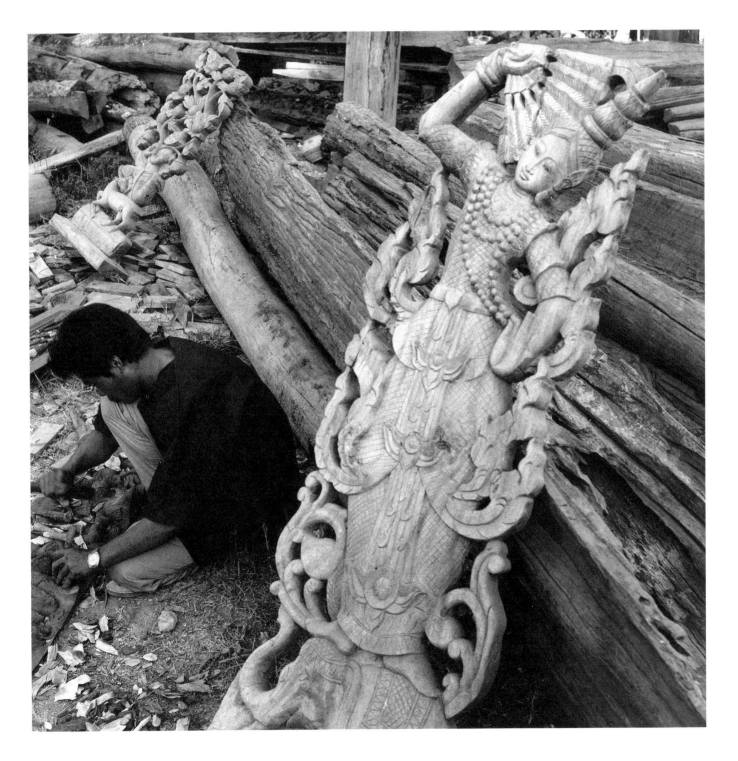

Due to the lack of early woodcarvings, it is difficult to trace the precise evolution of these features. The *kanok* motif seems not to have been used in Sukhothai but appeared around the middle of the Ayutthaya period, while the *krachang* is found in early Ayutthaya buildings. Carvings of Vishnu astride a Garuda were popular on both royal and religious Ayutthayan structures. During the reign of King Narai, when embassies were exchanged with France, European influences became more prevalent; it was at this time that the acanthus leaf motif came into favour.

Ayutthayan motifs were continued in early Bangkok, which was largely adorned by artisans who had survived the destruction of the old capital. Chinese patterns became popular in the reign of Rama III and continued through the rest of the 19th century, again frequently in combination with traditional Thai ones, though many purely Thai architectural features were retained on religious buildings.

It should be noted here that northern decorative motifs differ markedly from those of central Thailand, especially on temples built before the region came securely under the control of the central government. Burmese who arrived as labourers in the teak forests in the latter part of the 19th century were involved in the construction of many houses and temples, and incorporated elements of their own culture into the designs. The influence of Laos, also a close neighbour, was significant as well.

Although there is a good deal of overlapping between the first two, architectural woodcarvings can be divided into three categories, religious, royal and domestic, each of which deserves consideration.

Religious buildings

The earliest carvings were undoubtedly produced to adorn Buddhist temples, as a way of acquiring merit by both the artisans and the wealthy patrons who commissioned them to perform the task. They play a major role in creating the overall effect of rich fantasy that is such an important characteristic of these structures and, in the best examples, rises to the level of true art.

Of the assorted buildings in a monastery compound that are most decorated with carved features, the principal ones are the *bot*, where ordination ceremonies are held and the principal Buddha image is displayed; the *viharn*, or assembly hall, which is used for sermons; the *ho trai*, or library, often built over a pond or elevated from the ground to protect scriptures from termites and other pests; the *sala kanprien*, which usually serves as a meeting place; and various pavilions where visitors and pilgrims can rest.

All or most of these are likely to have an ornamental gable or *na ban*, a term used only for monastic and royal buildings; for domestic structures the term *chua* is used. These may be covered with traditional patterns or may display Hindu or Buddhist figures, various emblems or scenes from mythological tales. A gable from an early Ayutthayan temple, for example, shows Vishnu on his Garuda, surrounded by rows

Carved wooden decorations employing the kanok, *a basic vegetal motif subject to many variations; this form, called* kanok tai kroen, *is used on royal carriages and canopied thrones.*

of *yaksa*s, or guardian demons, while one on a temple in Petchaburi consists entirely of the *phuttan* (cotton flower) motif and animal figures, and another in the same province has the emblem of Rama V. The *viharn* of Wat Phra Chetuphon, the largest temple in Bangkok, has two gables depicting complex battle scenes from the *Ramakian* against a background of glass inlay.

In the north, it was common for some wealthy donors to a temple to identify themselves through the sign of the lunar year of their birth, which may be why a gable from that region in the collection of the Siam Society displays a cock surrounded by floral motifs; another possible explanation is that in one of the Jataka stories, particularly popular in neighbouring Burma, the Buddha-to-be is reborn as a cock.

The bargeboard surrounding the gable is topped with a graceful, elongated finial known as a *chofa* – literally 'bunch of sky' or 'sky tassel' – one of the most distinctive features of both religious and royal buildings. Opinions vary as to the precise symbolic significance of the *chofa*, which commonly appears at the tip of each of the overlapping roofs. Some authorities believe it represents a Hamsa, the celestial swan on which the god Brahma rides, others that it is derived from the Garuda, vehicle of the Hindu god Vishnu; in some regions, it may also be shaped like a bird's head, a lotus bud or, in the north, a mixture of an elephant and a peacock.

According to Nangnoi Punjabhan, who has written extensively on Thai woodcarving, 'A suggestion has been made that the structural details of the gable, or *krueng lamyong*, signify the tug-of-war between the Garuda and the *naga*. The Garuda's head forms the *chofa* while the side edges of the bargeboards (*tua lamyong*) are the wings, and one half of the *bai raka* or leaf forms are feathers, and the other half scales of the *naga*. The *hang hong* or the side finials are the *naga*'s head.'

Whatever their significance, these features contribute greatly to the sense of airy lightness, of being on the verge of soaring off into the sky above, that makes Thai temple buildings memorable expressions of religious faith.

Acting as supports for the eaves are brackets (*thuai* or *khan thuai*), commonly taking the form of a stylized *naga* though combined with the *kanok* and other motifs on some buildings. During the late Ayutthaya and early Bangkok periods, brackets became more slender and were obviously intended for ornamentation rather than for actual support. Northern brackets are usually triangular panels with a wide variety of carvings that may include human or animal figures, as well as floral patterns.

Temple doors are often beautifully carved, forming as they do the symbolic separation between the outside world and the consecrated interior. Celestial guardians, sometimes holding swords, were a frequent feature in the early Ayutthayan period and are also seen on some Bangkok temples; intricate patterns

Different forms of a lotus-bud motif called krachang, *used mainly for border decorations. These come in varied forms and are found on architecture, thrones, elephant howdahs and pulpits.*

later became more common than figures, often covering the entire surface. The doors of the *viharn* at Wat Yai Suwannaram in Petchaburi, for example, dating from the late Ayutthaya period, display the *karn khot* motif with variations. With the increase of Chinese influence in Bangkok during the early part of the present century, natural scenes of forests and animals appeared on many door panels, including those partly carved by Rama II for Wat Suthat; another pair at Wat Phra Keo (Temple of the Emerald Buddha), installed during the reign of Rama III, depict guardian figures in traditional Thai dress above Chinese-style lions with Chinese landscape carvings below.

Wooden wall carvings are seldom seen today on temple buildings, which are generally made of brick and mortar, but they may once have been more common. On Wat Kuti Bangkhem in Petchaburi, there are twenty surviving wall panels depicting scenes from the Jataka stories, supposedly carved by local craftsmen aided by monks from the temple, while Wat Kaew Phaithoon in Thonburi has panelled walls carved with floral scrolls and animals.

Another decorative feature found in religious buildings is the *dao phedan*, or 'star' ceiling. Attached to the ceiling of a *bot* or *viharn*, these are generally based on the lotus, one of the basic Buddhist emblems, in a variety of forms both naturalistic and stylized. In some grander temples such decorations cover the ceiling, whereas in others only a few carvings may be used; in later periods they were generally gilded or set with glass to reflect the flickering light of candles.

Royal buildings

During the Sukhothai period, royal palaces are believed to have been mostly plain, monochromatic wooden structures. They became increasingly splendid in Ayutthaya, when they served not merely as residences but also as symbolic representations of heavenly abodes, encrusted with suitable ornamentation. Nearly all the decorative features found on religious buildings also appear on royal structures, from the *chofas* at the roof ends to the elaborately carved door panels, with figures of Hindu gods and their associates beingparticularly prominent on gables.

The older buildings of the Grand Palace in Bangkok, though often altered and restored since their construction in the late 18th century, are undoubtedly the best surviving examples of such architecture and were intended as close approximations of those destroyed by the Burmese in Ayutthaya a few decades before. Thus the Dusit Maha Prasat, used as a throne hall by early kings, is covered with four-tiered roofs surmounted by a seven-tiered spire, each tier of which has miniature gables complete with finials, *bai raka* and *hang hong*. The bottom section represents Mount Phra Sumeru, core of the Buddhist universe, while the soaring central part suggests the various stages of concentration that led to the Buddha's enlightenment. On the main gable is a figure of Vishnu astride a Garuda, surrounded by the *karn khot* motif, and the *hang hong* are in the form of multi-headed *nagas*.

Two popular scroll motifs known as karn khot, *often seen in woodcarvings.*

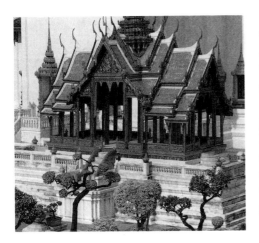

The Phra Thinang Aphonphimok, a pavilion built in the Grand Palace compound by Rama IV as a place to change robes before mounting an elephant or palanquin.

Nearby is a group of three connecting buildings known as Phra Maha Monthien, 'The Grand Residence', where the first three kings of the Chakri dynasty lived (and where it is still traditional for new rulers to spend a night after their coronation). The gables of all three structures show the god Indra above a three-spired abode, surrounded by a scroll motif.

One of the most beautiful buildings in the palace compound is a relatively small pavilion called the Phra Thinang Aphonphimok, built on the wall surrounding the Dusit Maha Prasat by Rama IV as a place in which to change robes before descending a flight of steps to mount an elephant or palanquin. Designed in the form of a modified Greek cross with the short wings on the east and west, this has double-tiered roofs that meet at a five-tiered spired top, all of carved and gilded wood. The gables show Indra standing on a platform and holding a sword, with the *kanok* motif curling like flames around the figure. The graceful pavilion has come to epitomize classic Thai architecture and for that reason has been reproduced on many occasions, among them the Brussels World Exposition of 1958.

Residences for other royal family members are called *tamnak*, which may be single buildings or a group collectively known as *wang*. These had most of the decorative features described above, on a somewhat more modest scale. A notable example is the Tamnak Daeng (Red Palace), built by Rama II for one of his queens and now in the compound of the National Museum. The structure, which has richly panelled walls and window carvings, was originally in Ayutthaya style but acquired more elements of early Bangkok decorations during the course of several moves to different sites.

Domestic houses

By custom as well as necessity, the houses of ordinary Thais were traditionally simple and unadorned. The earliest were made of bamboo and thatch, though wood was increasingly used by owners who had acquired wealth or status. Even the most prosperous owners were denied such decorative features as finials and multi-tiered roofs, which were reserved for residences of royal family members like the Tamnak Daeng, but a number of others evolved over the years to give the best examples a particular distinction.

Thai houses vary from region to region, but two classic styles have emerged, one in the north and the other in the central plains. Both are built largely of prefabricated units which are then fitted together with wooden pegs and hung on a framework of pillars, elevated a considerable distance from the ground for protection from floods and intruders, and also to provide space for the family animals. A dwelling may consist of a single unit or several arranged around an open platform, where most activities take place.

The walls of northern houses slant outwards from the floor to the lower edge of the roof, creating a solid sturdy look that some scholars have compared to a buffalo.

Both walls and pillars of central Thai houses, on the other hand, incline slightly inwards, adding to an illusion of height and graceful elegance.

Decorative features are also different in the two regions. A northern house, especially in the Chiang Mai area, is likely to have a prominent V-shaped structure known as a *kalae* at each end of the roof ridge. These originated as a mere extension of the roof supports, probably to simplify construction and increase strength (in which form they appear on many Southeast Asian homes), but on grander houses became separately carved pieces of often fine craftsmanship, suggesting flickering flames or stylized feathers. One theory as to the purpose of the *kalae*s is that they were intended to discourage crows or other birds from roosting on the roof, while another holds that they represent a pair of buffalo horns and thus reflect the family's wealth. Neither interpretation, however, has been substantially proven.

Another feature peculiar to northern houses of the past were carved wooden lintels called *ham yon*, placed over the entrance to the room where the owner and his wife slept. The motifs on these vary widely, ranging from floral patterns to complex geometric ones, and the sizes, though always rectangular, are not uniform. Kraisri Nimmanahaeminda, a noted Chiang Mai scholar, made a study of *ham yon* and found that in the old language of the north the term could be translated as 'magic testicles', leading him to the conclusion that they represented the virility of the family head and also served as a protection.

The size of the lintels, he determined, was based on the owner's foot – a small *ham yon* was three times the length, a large one four times – and before the carver set about his work a ceremony was held to invite the potent spirit to enter the piece of wood. 'Often when an old house is sold', Mr Kraisri wrote, 'the new owner, before he moves in or dismantles it, will beat the *ham yon* mercilessly in order to destroy the magic accumulated in them under the old owner for it might bode ill for him. This beating of the lintel or "testicles" is actually a symbolic "castration".'

New *ham yon* are rarely made today, since most contemporary houses tend to be in Western style; old ones turn up as collectors' items in antique shops, their owners rarely having any idea of the magical purpose they served.

Central Thai houses, apart from their inwards-leaning walls, are perhaps most memorable for their bargeboards, or *panlom*, which rise to a steep point at the peak and terminate in curving finials known as *ngao* or *hang pla*. The *ngao*, developed from Khmer art, was used on royal and religious buildings and may have been further simplified for ordinary homes; *hang pla* refers to the fact that the ornamental feature sometimes resembles a stylized fish.

Gables, or *chua*, are found in several styles, the most common being *chua luk fak*, which are panelled; *chua phra arthit*, which are decorated with small strips of wood like the rays of the sun, with openings at the top to allow air circulation; and *chua bailan*, similar to the *chua phra arthit* but without the openings. A fan-like motif is popular on some houses of the north in the Lampang area.

Various forms of kalae, *decorative features placed at each end of the roof ridge on northern houses, particularly in the Chiang Mai area; the precise symbolism of the* kalae *remains uncertain.*

136 RIGHT *Detail from a carved temple gable, inlaid with coloured metal foil; the principal motif is the flame-like* kanok, *which is subject to countless variations in Thai design.*

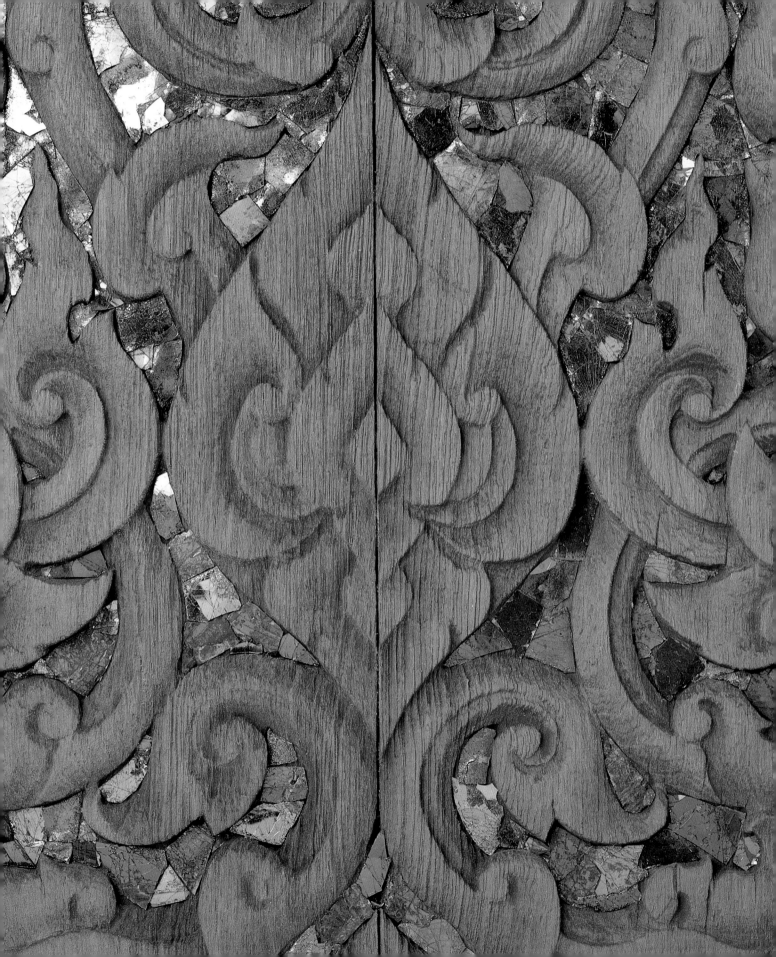

137 *Carved temple gable showing the god Brahma on his three-headed elephant Erawan. Such figures from Hindu mythology appear in the decorations on both religious and royal buildings.*

138 RIGHT *Detail from a carved gable; the Buddha is shown meditating while being protected by a Muchalinda, a multi-headed naga, or sacred serpent, who in mythology sheltered the Buddha during a violent rain storm.*

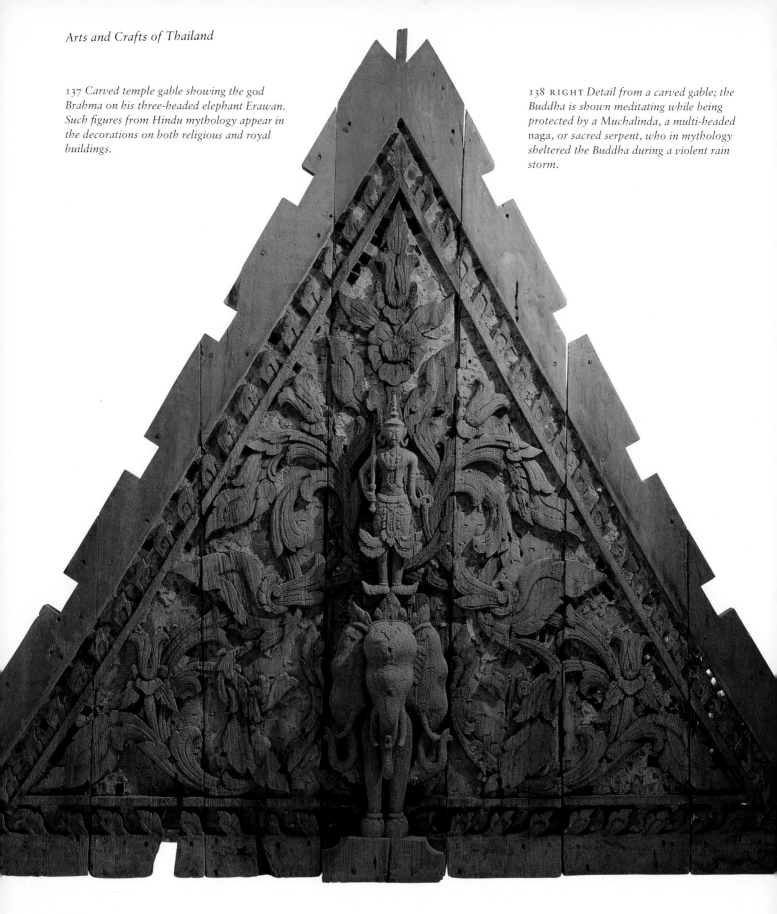

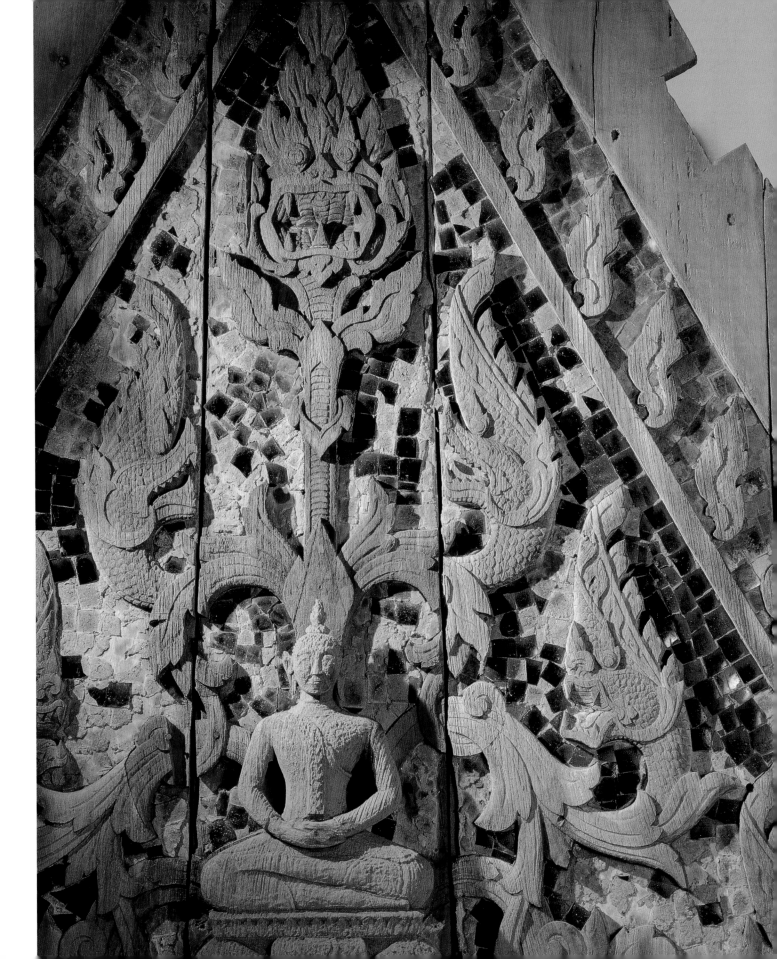

139–141 BELOW *Tiered roofs of the Dusit Maha Prasat throne hall in the Grand Palace compound; the finials are in the form of multi-headed nagas. The supporting brackets are stylized nagas combined with the kanok motif.* RIGHT *Detail of roof decorations, including a Garuda, symbol of royalty.* BELOW RIGHT *Gilded door with scroll motif on a residence that belonged to King Rama I, now at Bangkok's Wat Rakeng.*

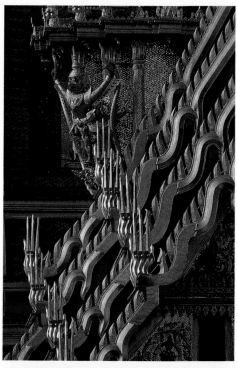

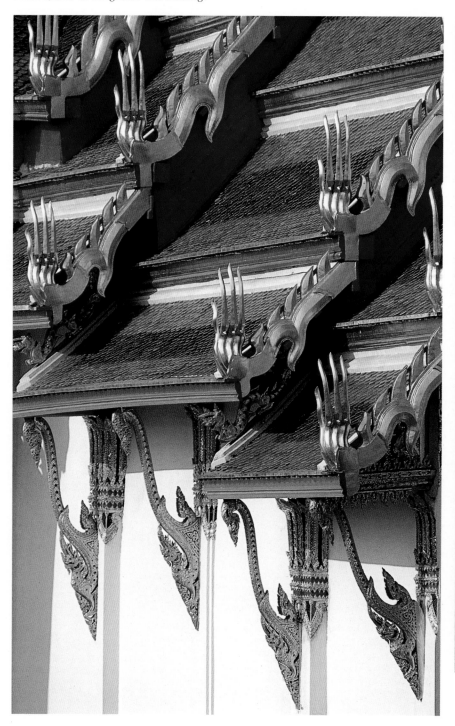

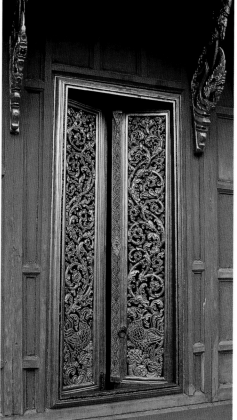

142–145 BELOW *Supporting bracket, gilded with inlaid glass.* BOTTOM LEFT *Elongated finial known as a* chofa, *which appears at the tip of each overlapping roof (see 159).* BOTTOM RIGHT *Stylized* naga *with glass mosaic.* RIGHT *Carved Ayutthaya-style window frame.*

146–147 BELOW *Gilded temple doors of Wat Na Phra Mane in Ayutthaya, with a design that incorporates various celestial beings in reverent attitudes.* RIGHT *Detail of carving on a door at Wat Wat Pratupong in Lampang, showing figures from the epic* Ramakian.

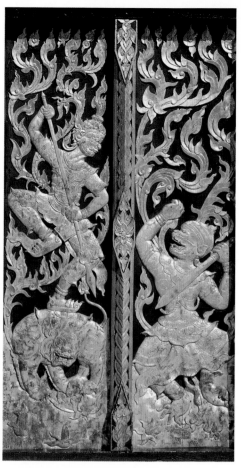

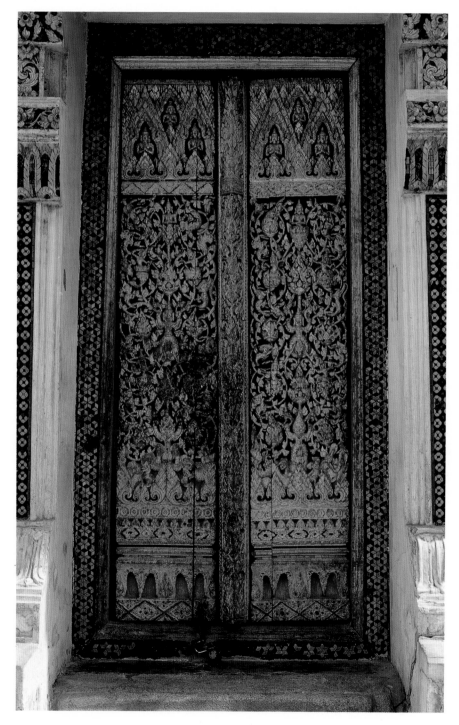

148 RIGHT *Detail from a temple door of the Ayutthaya period, showing a guardian divinity dressed in royal attire; the superbly carved door, dating from the late 15th or early 16th century, was originally at Wat Si Sam Phet and is now at the Chao Sam Phraya National Museum in Ayutthaya.*

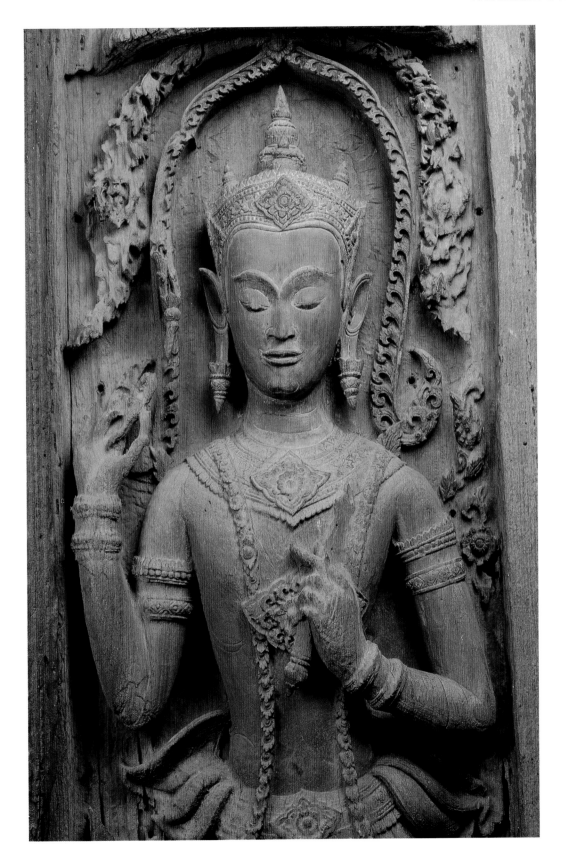

149–152 BELOW *Decorative carvings by Tai ethnic groups in Sipsong Panna, in southern China. All were parts of temple decorations.*

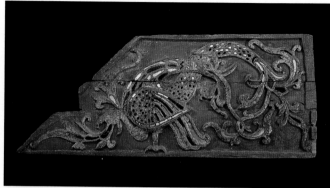

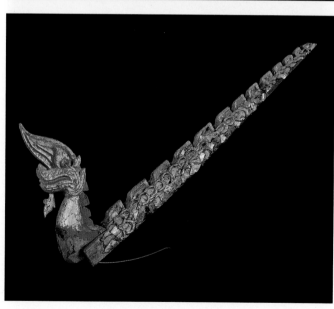

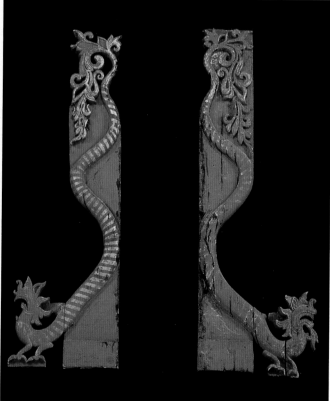

153 BELOW *Gilded ceiling decoration from a*
Sipsong Panna temple.

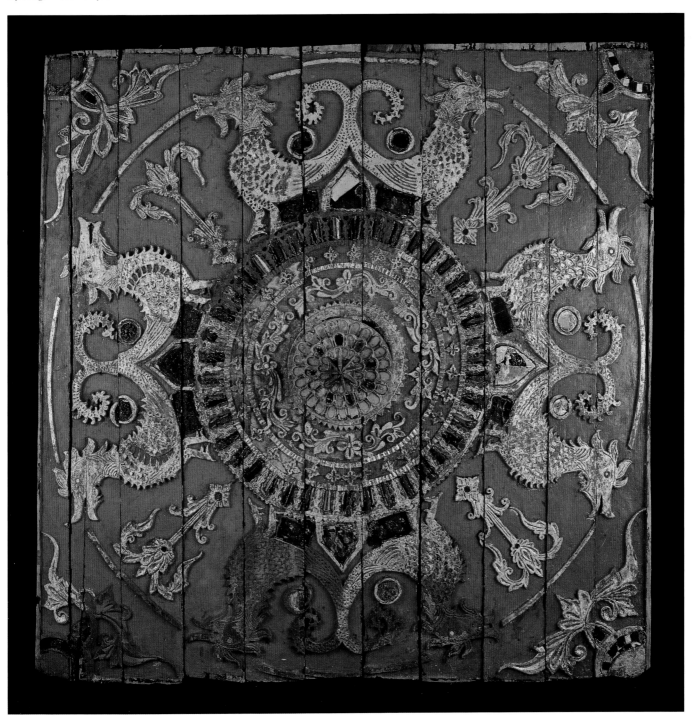

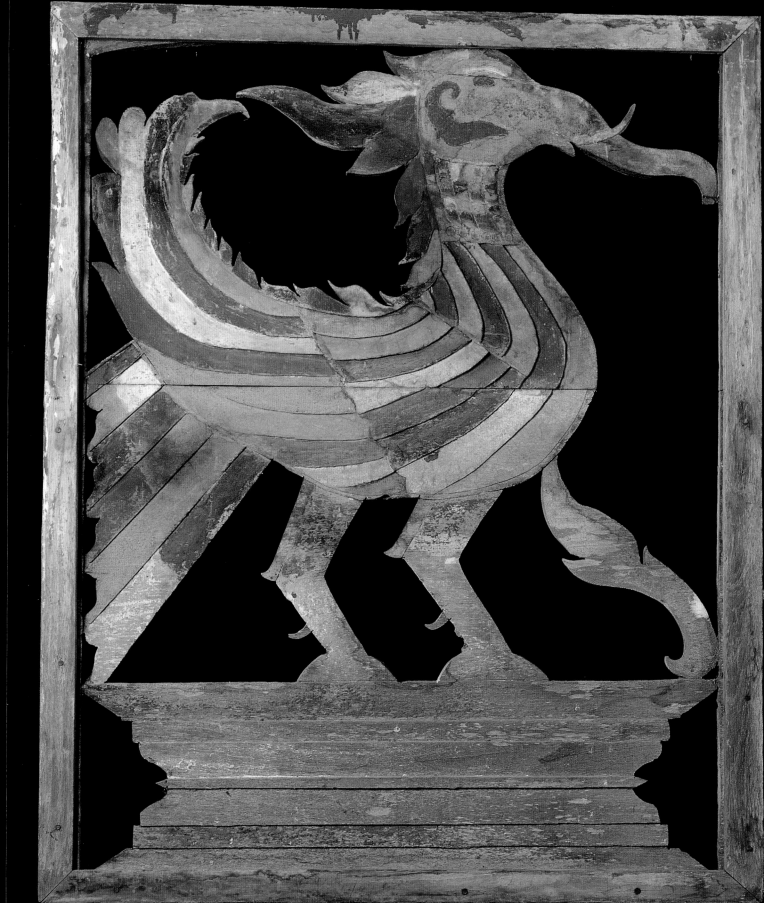

154–156 LEFT *Decorative ventilation panel from a Tai Lue temple in Nan province, showing a fabulous elephant-headed bird.* BELOW *Roof brackets from the same temple; in northern Thailand, such architectural features often depict human and animal figures.*

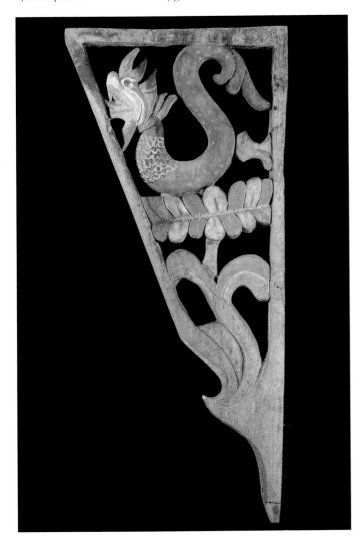

157 *Detail from the gable of Wat Phra Keo Dan Tao in Lampang province, showing a divinity standing on a guardian which represents Time eating its own body.*

158 *Elaborately carved decorations on a Lanna Thai style temple in Chiang Mai.*

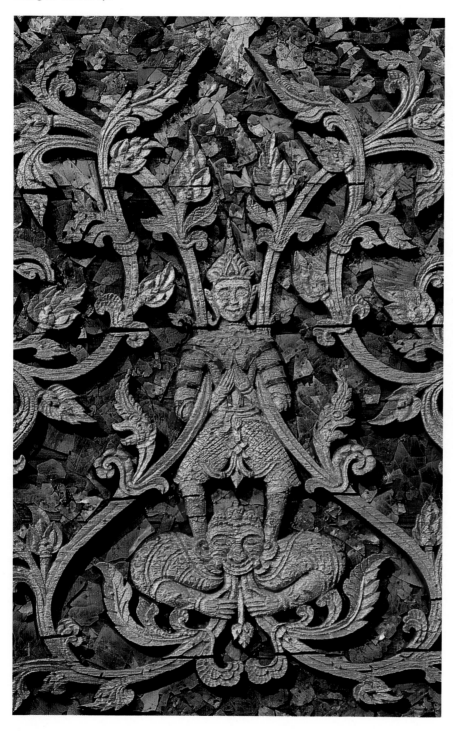

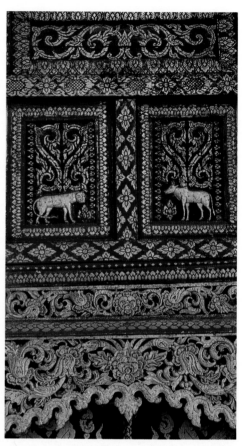

159 *Teak library in the compound of Wat Phra That Haripunchai in Lamphun, an ancient northern town.*

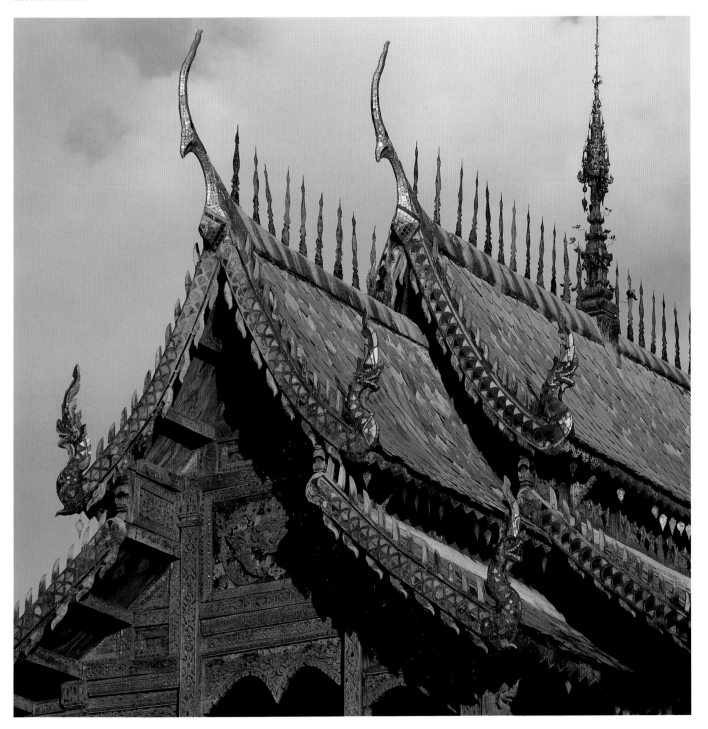

160 BELOW *Ornamental carvings at Wat Si Chum in Lampang province, suggesting the wide variety of traditional patterns.*

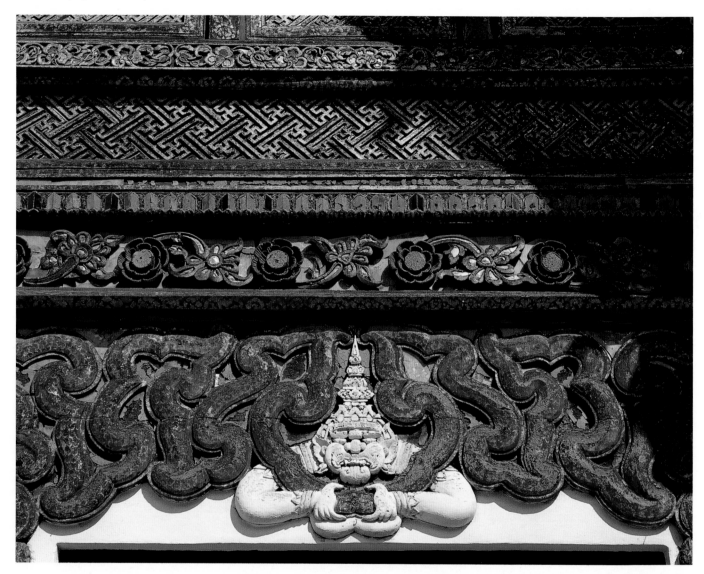

161–162 BELOW *Roof bracket depicting a masked character from the* Ramakian. BOTTOM *Classic Lanna Thai motif of the sacred bodhi tree.*

163–164 *Lintels, known as* ham yon, *from northern houses, where one was placed above the entrance to the room where the owner slept.*

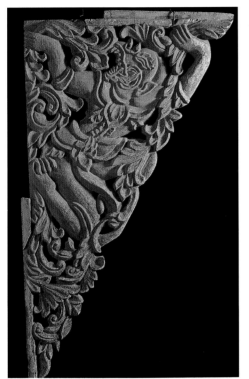

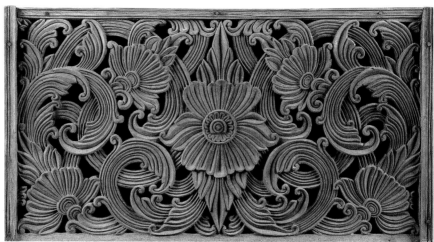

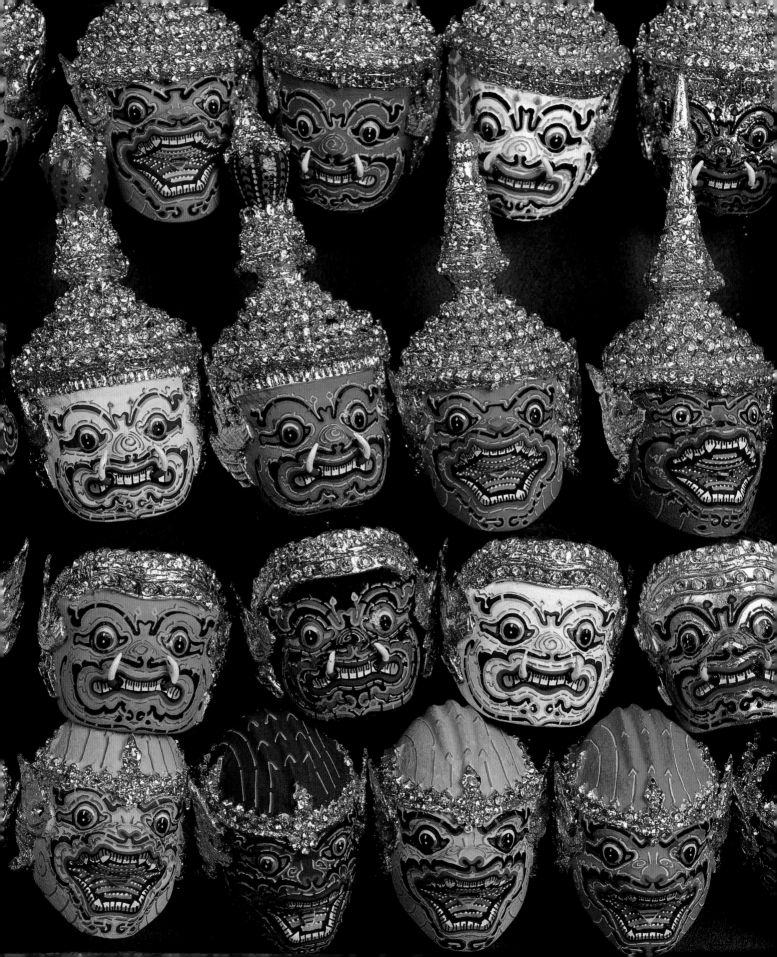

THEATRE AND OTHER DIVERSIONS

THEATRE, WHICH PLAYED an important role in Thai life of the past, gave rise to a number of crafts: mask- and costume-making for the dance drama and its variations, woodcarving and leather-cutting for puppets, together with assorted decorative techniques to embellish these, as well as musical instruments.

As with so many other aspects of Thai culture, its theatre can be divided into royal and popular, the latter for the most part having evolved from entertainments originally devised to divert and sometimes edify exalted members of the court. This was particularly true of the *khon*, or masked drama, generally regarded as the theatrical form most representative of classical traditions, even though it is seen today only on rare occasions.

The *khon* arose from the rituals and dancing of Indian temples, which spread throughout much of Southeast Asia and exerted a similar influence on the theatre of Indonesia, Malaysia and Cambodia. The story line comes from the famous Indian epic *Ramayana*; its Thai version, the *Ramakian*, is an allegory of the triumph of good over evil, which was rendered over and over not only through dance, but also in mural paintings, porcelain decorations and bas-relief carvings to adorn palaces and temples.

The development of the *khon* is believed by some scholars to have begun in the southern city of Nakhon Si Thammarat, where Indian culture made an early impact, from which it spread to both Sukhothai and Cambodia; no records of the art form survive from Sukhothai, but bas-reliefs at Angkor depict many dancers in poses similar to those still seen.

There is considerable evidence that the *khon* was a popular entertainment for royalty during the Ayutthaya period, performed by torchlight in palace halls and courtyards. Both male and female roles were played by male court retainers, since the athletic movements were regarded as too strenuous for women, a convention that continued well into the 19th century. There was little in the way of scenery. Performances relied instead on stylized postures and gestures and on dazzling, bejewelled costumes and identifying masks; narrative verses further explaining the action were recited and sung by a chorus who sat with an accompanying orchestra of woodwinds, xylophones, gongs and drums.

All written *khon* texts were lost in the destruction of Ayutthaya, but memories of the ancient story remained alive. Rama I and several of his courtiers wrote the longest of the three present versions in 1798, shortly after Bangkok became the capital, incorporating both Thai and Buddhist ceremonial elements drawn from memories of Ayutthayan rituals and traditions.

165 LEFT *Miniature heads depicting demon characters from the* Ramakian, *the Thai version of the Indian epic* Ramayana, *from which the classic Thai masked drama derives its story.*

Staged in its entirety, the *Ramakian* is an immensely complex story with 138 episodes involving 311 different characters and taking more than 720 hours of continuous performance; even the abbreviated versions presented in early Bangkok took more than 20 hours and were staged on two consecutive nights. In essence, though, it recounts a saga of which the hero is Phra Ram, a righteous king of Ayutthaya and also a reincarnation of the god Vishnu. His beloved consort, Nang Sida, is abducted by the wicked King Thotsakan of Longka (Sri Lanka), and the drama concerns the ultimately successful efforts of the king and his brother Phra Lak, assisted by the clever monkey-god Hanuman, to rescue her. There are numerous other characters, including a niece of Thotsakan who, in one often-performed episode, disguises herself as Nang Sida in an effort to deceive Phra Ram; the most popular, perhaps because he provides comic relief, is Hanuman, still regarded by actors today as the choice role because of the acrobatic opportunities it affords.

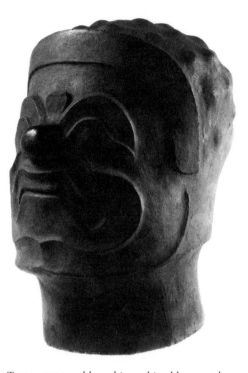

Terracotta mould used in making khon *masks; layers of papier mâché are pressed around the mould and later removed for further decoration.*

The story is told largely through movements that express both action and feeling. Such are the physical demands of mastering these movements that training begins in early childhood, with novices assigned to one of four categories – man, woman, demon, monkey – depending on personal and physical characteristics. The French sculptor Auguste Rodin, after seeing a performance by Cambodian dancers (who, incidentally, re-learned its conventions from Thais in the 19th century), is said to have remarked, 'They have found postures which I had not dreamed of, movements which were unknown to us even in ancient times.'

Of equal importance are the masks once worn by all the dancers and reflecting their personalities through colour and various features. (Today they are usually worn only by those playing demons and animal characters like Hanuman.) These are magnificent creations, made by master craftsmen following conventions recorded in illustrated manuscript books and lovingly handed down for generations by *khon* performers. The base is layered papier mâché, composed of *khoi* paper (made from the bark of a native tree) mixed with rice-flour paste, which is built up with black lacquer in layers over a mould. The mask-maker then makes a long incision down both sides, peels the papier mâché from the mould and papers over the join; a second artisan takes over at this point to paint and decorate the mask according to the character represented.

A mask for Phra Ram is always green (as is his costume), has delicate features, a faint smile to indicate his good nature, and a multi-tiered gold crown tapering to a spire, while Thotsakan has the fierce expression of a snarling demon and often additional demonic faces on his crown. Hanuman's mask is predominantly white, but may have considerable ornamentation to fit his description as having 'diamond hair and crystal fangs'; a famous Hanuman mask made in the early 19th century is covered with creamy mother-of-pearl set in a base of lacquer. His monkey helpers usually wear gold masks with bulging green-rimmed eyes and bright-red tongues.

Detail of a mural painting showing a lakhon
nok *performance, from the ordination chapel of
King Chulalongkorn at Wat Benjama Bo Pit,
Bangkok; early 20th century. Such
performances often went on through the night.*

Among the minor characters today, there are more than 30 varieties of simian masks and 100 for demons.

Perhaps because of its close associations with royalty, not to mention the intricacies of its story line, the *khon* never attracted a large popular audience. When it moved outside the court, it did so in a form known as *lakhon*. This is a less formal dance drama, and masks are worn only by the non-human characters; the stories are drawn not only from the *Ramakian* but also from the collected Buddhist morality fables called the Jatakas and other folk tales. The movements are more graceful and fluid, the hands being particularly important in the expression of emotions. The glittering costumes, heavily brocaded and sewn with a rich profusion of paste jewels, are identical to those of the *khon*.

Lakhon is subdivided into three major variations. *Lakhon nai*, which originated in the court, was performed only by women, who were renowned for their formalized grace. *Lakhon nok* was presented outside the court, in the past only by men; noted for its lively music, fast movements and often bawdy humour, it eventually developed into a popular folk theatre known as *li-ke*, still an important feature of rural festivals. A third type, *lakhon chatri*, is derived from the Manora, a southern dance drama, and is the simplest of all in presentation; *lakhon chatri* dancers can be seen at many popular shrines such as Bangkok's Lak Muang (City Pillar), where they are hired to perform as a way of showing gratitude for a wish granted by the resident spirit.

Over the years, all three forms have borrowed extensively from one another. The major difference today is that *lakhon nai* continues to be best known for romantic stories like the *Inao*, an epic poem with a Javanese background written by Rama II, and that it and *lakhon chatri* are performed mostly by women.

The *khon* was not the only form of theatre enjoyed in Ayutthaya. Far older was the *nang yai*, or shadow play, which was probably introduced to southern Thailand from the Javanese empire of Srivijaya between the 8th and 13th centuries. Early records are scant, but an account written during the reign of King Narai towards the end of the 17th century mentions that, having found a certain story appealing, 'His Majesty therefore gave orders that a poem on the subject be composed and beautiful figures cut out of hide to depict this romance on the screen.'

Nang means 'cowhide' and *yai* 'large'; thus 'a play with large cowhide figures'. The hide is soaked in salty water until it is softened, then dried in the sun and smoothed with an iron instrument. After soot is applied and the surface polished, the design – sometimes single figures from the *Ramayana*, sometimes two or more, with detailed backgrounds of trees, architectural features or traditional motifs – is drawn and the parts between the lines carefully cut out with a sharp knife. Two poles are finally attached, one on each side, to be held by the manipulator.

According to the noted Thai scholar Prince Dhani Nivat, superstition once played a considerable role in the production of certain figures. Those of Hindu gods

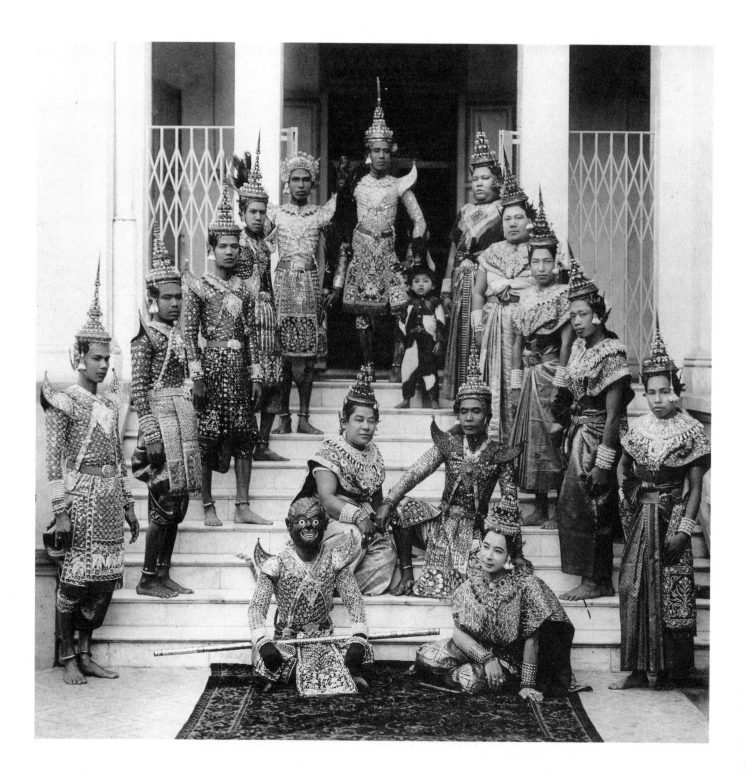

has produced an impressive collection of beautifully attired *hun* puppets and gathered a troupe to present them in occasional performances. Children are still trained in the rigorous disciplines of *khon* dancing at a school behind the National Theatre, and short episodes from the *Ramakian* are often offered in programmes on Thai culture. One former cinema in Bangkok recently staged a major *khon* performance that drew large audiences, possibly attracted less by the ancient legend than by modern laser beam displays shrewdly incorporated in the scenic effects.

Also still observed by many traditional performers is an annual ceremony held to pay homage to their teachers. The mask of a *rishi* called Pharata Muni, regarded as the first teacher of all theatrical arts, is solemnly placed on an altar, accompanied by other masks and musical instruments. Two presiding male teachers, one for dance and the other for music, conduct the rites in all-white garments. Offerings of food and flowers are laid out by those who wish to receive the *rishi*'s blessings, followed by performances by dancers and musicians.

Music is essential to all Thai theatre and, indeed, to many other diversions as well. A famous Sukhothai inscription describing processions to a monastery outside the city notes that on their way back the people 'join together in striking up the sound of musical instruments, chanting and singing'. Even now, during a traditional boxing match, a small orchestra sits just outside the ring and follows the action to stir the emotions of both fighters and spectators.

The earliest instruments, believed to have been devised even before the Thais were exposed to Indian culture, were simple affairs given names that approximated the sound they made: *kro, krong, krap, chap, ching, pi, pia, so, khong* and *klong*, for example. Later, however, the instruments became much more complex and increasingly displayed the highest degree of craftsmanship, particularly lacquer work, woodcarving, gilding and mother-of-pearl inlay. Thus several *krap*s were fitted on a stand and graded by tone to produce a kind of xylophone, while a series of small gongs was suspended on a circular frame. These were given new names such as *ranad* and *gong wong*, formed by altering or combining words.

Furthermore, new instruments from India, which had been absorbed by the Mon and Khmer cultures, were adopted by the Thais; some of these are mentioned in the *Tribhumikatha*, one of the first books written in Thai. Still other instruments appeared during the Ayutthaya period, acquired from neighbouring countries like Burma, Malaysia and Indonesia.

A typical Ayutthayan instrumental ensemble was composed of four to eight musicians. This was expanded to twelve during the Bangkok reign of Rama II, a noted patron of the arts, and later enlarged still further for certain performances. Today there are some 50 different Thai instruments, including many regional variations.

The basic ensemble is known as a *piphat*, the name being derived from a wind instrument, the *pinai*, which sounds somewhat like a Western oboe or clarinet.

or their reincarnations, as well as a holy *rishi* (hermit), were supposed to be made only from the hide of a virgin cow and various offerings were made by the maker before he started; for the *rishi* character, the hide of a bear or tiger was preferred, if available, to increase its magic power. The artist who drew the patterns of these characters was required to dress in ceremonial white and to finish his work within a single day.

In a *nang yai* performance the figures, some as tall as two meters, are held against or behind an illuminated screen (torch-lit in the past), to the accompaniment of music, choral singing and narration. 'As [each man] manipulates the figure', Prince Dhani has written, 'he is automatically bound to bend and sway, at the same time keeping time with his foot movements. In between the recitations there may be pauses for an action without words such as a march when the orchestra would strike up appropriate music and the manipulator would more or less adopt certain steps in consonance with it. He in fact practically dances, the hide-figure often doing the mere duty of identifying the role.' Some *nang yai* figures are used for daytime performances, called *nang ram*, and are painted, in contrast to the almost entirely black ones used at night.

A more popular version of the shadow play, still often seen at festivals in southern Thailand, is called *nang talung* (the latter word being an abbreviated from of the name of Pattalung province) and closely resembles the Indonesian *wayang*. The beautifully fashioned figures, also made of cowhide, are smaller than those used for *nang yai* and often have one or more moveable parts such as the chin, an arm, or a leg. Concealed from the audience, the manipulators are skilled singers and comedians, whose witty contributions probably account for the form's survival despite competition from more modern forms of entertainment.

Puppets, or *hun* – some using rods and manipulated from below with concealed strings, others more like Western marionettes – also diverted royal audiences in Ayutthaya and early Bangkok. *Hun yai*, sometimes called *hun luang* (royal puppets), were rod puppets of considerable size, with finely carved faces or masks with lacquer details and splendid dress; a complex set of strings enabled the arms, hands and fingers to be moved in an approximation of classic dance gestures. *Hun lek*, a smaller version, had fewer strings but was made with similar artistry. *Hun yai* puppets preserved at the National Museum are around 40 cm. high, while *hun lek* figures are about 25 cm.

More popular with the general public are *hun krabok* (literally 'cylindrical model'), which are similar to the hand puppets used in Punch and Judy shows and offer non-classical stories.

All classical theatrical forms – *khon, nang* and *hun* – suffered drastically from the introduction of Western-style entertainments and the decline of the old court life that had been their principal means of support. They continue to be seen, however, on a reduced scale. Chakrabhand Posayakrit, a leading contemporary Thai artist,

LEFT *A troupe of* khon *performers in bejewelled costumes but without masks except for the simian character kneeling in the front. (Photographed c. 1890 by Robert Lenz.)*
ABOVE *Detail of a mid-19th-century painting on cloth showing a* nang yai *performance. (Collection of the late Prince M.C. Piya Rangsit, Bangkok.)*

Made of seasoned rosewood, the *pinai* is about 41.5 cm. long and has a slight bulge in the middle; the tones are produced by a series of six holes in the body, manipulated by the performer's fingers.

All the other components are percussion instruments, some with a compass of differently pitched tones and therefore melodic, and the rest rhythmic drums, gongs and cymbals. The *gong wong* is a circular construction, generally of thick rattan, attached to which are gongs struck with buffalo-hide hammers; the gongs are graduated in size and treated with a mixture of scraped lead and beeswax to produce different tones. The *gong wong* comes in two sizes, the larger being about 125 cm. across and the smaller about 102 cm.

The *ranad ek*, a sort of boat-shaped xylophone on which the base acts as a resonance box, is perhaps the most beautiful of all Thai instruments in terms of shape and decoration. The body, about 121 cm. in length, is made of hardwood often richly carved and inlaid, the curving sides sometimes as tall as the seated performer; it normally has 21 resonance bars of different pitches. There are several other forms of the instrument; one, the *ranad thum*, is slightly different in shape and produces a deeper tone, while the *ranad thong ek* is shaped like a tapered box about 98 cm. long.

There are three basic types of drum. The *tapone*, made from a single block of hollowed-out wood, has one end covered with parchment made from prepared ox-hide and the other with calf's-hide. On each end is a round black lacquer mark, on which the player applies a mixture of cooked rice and burnt palm ash to modulate the tone. The *tapone* is always placed on a special carved stand, and both hands and fingers are used in the beating. A similar drum, but thinner in form, is the *song na*, held in the player's lap during a performance. The largest of the ensemble drums is the *klong thad*, which measures about 60 cm. in length and has a head about 45 cm. in diameter; though both ends are covered with hide, only one is used for playing.

The remaining instruments are cymbals known as *charp*, used in pairs; *chings*, cup-shaped, castanet-like instruments that set the pace for the whole group during a performance; and the *mong*, a gong suspended on a tripod stand which is struck with a padded stick.

Large orchestras may also have one or more stringed instruments, among them the *chakhay*, placed on a low table and usually played by a woman, and the *saw sam sai*, which consists of a triangular coconut shell, an ivory stem and three silken strings. Rama II, a noted *saw sam sai* performer, was reportedly so devoted to the instrument that he exempted from taxation all plantations that grew the triangular coconuts needed for its production.

The music produced by these instruments, largely passed down from teachers to students, is far more complex than the average outsider might suspect. The English musicologist Sir Herbert Parry writes that the Thai musical scale is so extraordinary that 'not a single note between a starting note and its octave agrees with any notes of

the European scale.... [The Thais'] sense of the right relations of the notes of the scale is so highly developed that their musicians can tell by ear directly a note which is not true to their singular theory.'

Other diversions

Less refined but still attractive crafts have developed from other traditional diversions, in particular two sports that go far back in Thai history.

One was recorded by Anna Leonowens, who came to teach some of Rama IV's children in the mid-19th century and ultimately became the heroine of a musical comedy based on her memoirs of life in then-remote Siam: 'Kite-flying, which in Europe and America is the amusement of children exclusively, is here, as in China and Burma, the pastime of both sexes, and all ages and conditions of people.'

Anna was something of a prude, or at least professed to be – recent research has more or less destroyed her carefully constructed image of a cultivated lady. Possibly, then, no one dared explain that the sport she found 'most entertaining' was actually rife with sexual symbolism. The larger of the two kites involved in a competition , the *chula*, is the 'male'; a marvel of aerodynamic craftsmanship, it is star-shaped and enormous, often measuring several meters across and requiring a team of up to twenty men to maneuvre it. The *pukpao*, or 'female', is a more conventional, diamond-shaped affair, flown by only one person.

At the start of a match, the *chula*s are sent across a boundary line into *pukpao* territory. Armed with a bamboo hook, their objective is to ensnare one of the darting *pukpao*s and bring her safely down in the male domain. The sheer size of the *chula*s might seem to make this a one-sided contest, but the *pukpao*s have the advantages of speed and greater maneuvreability; as often as not, they manage to loop their lines around a *chula* and bring it crashing to earth, thus winning a victory both symbolic and real.

Besides these serious kites, dozens of others are flown between February and April when the southwest monsoon winds blow strongly in the late afternoons. Made of bamboo and rice paper, these come in the form of butterflies and hawks, centipedes and serpents, all brightly painted and ranging from tiny to huge.

Another sport enjoyed everywhere in Thailand is *takraw*, based on a woven rattan ball of elegant construction. (One Bangkok dealer in folk crafts has had notable success selling the balls as art objects.) In the simplest form of the game, the ball is kept aloft by a circle of players who use their feet, knees, elbows and heads but not their hands, moving with balletic grace to do so.

A few would-be entrepreneurs have tried marketing *takraw* balls made of plastic or rubber. Players, however, have failed to respond; as in the case of the huge male kites – and, for that matter, *khon* masks and Thai musical instruments – tradition has proven stronger than the novelty.

Old engraving of Thai men keeping a shuttlecock aloft, a variation of the still-popular sport of takraw, *which involves a woven rattan ball.*

166 RIGHT *Layered papier mâché mask for one of the more than thirty simian characters in the* Ramakian. *Such masks are made by master craftsmen and passed down from one performer to another for generations.*

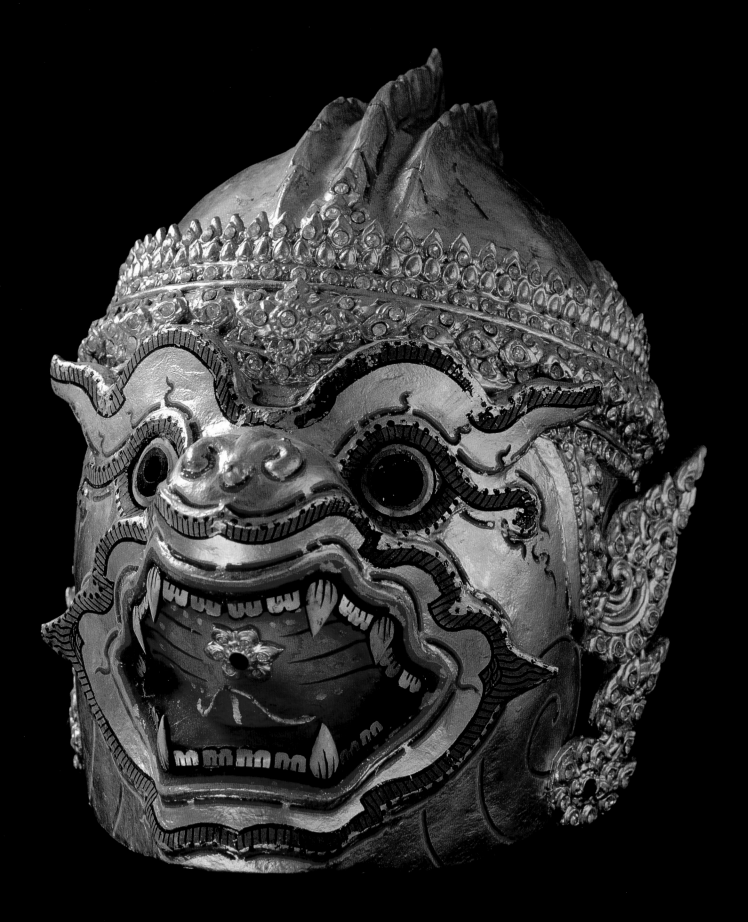

167 BELOW *Altar for annual ceremony held by theatrical performers to pay homage to respected teachers, with masks, musical instruments, and various offerings.*

168 RIGHT *A* nang yai, *or large cowhide figure, used in shadow-play performances, probably introduced through southern Thailand from Java and popular during the Ayutthaya period.*

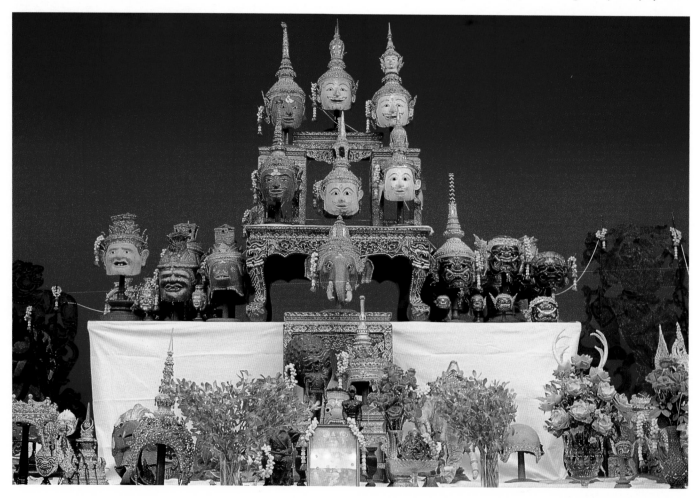

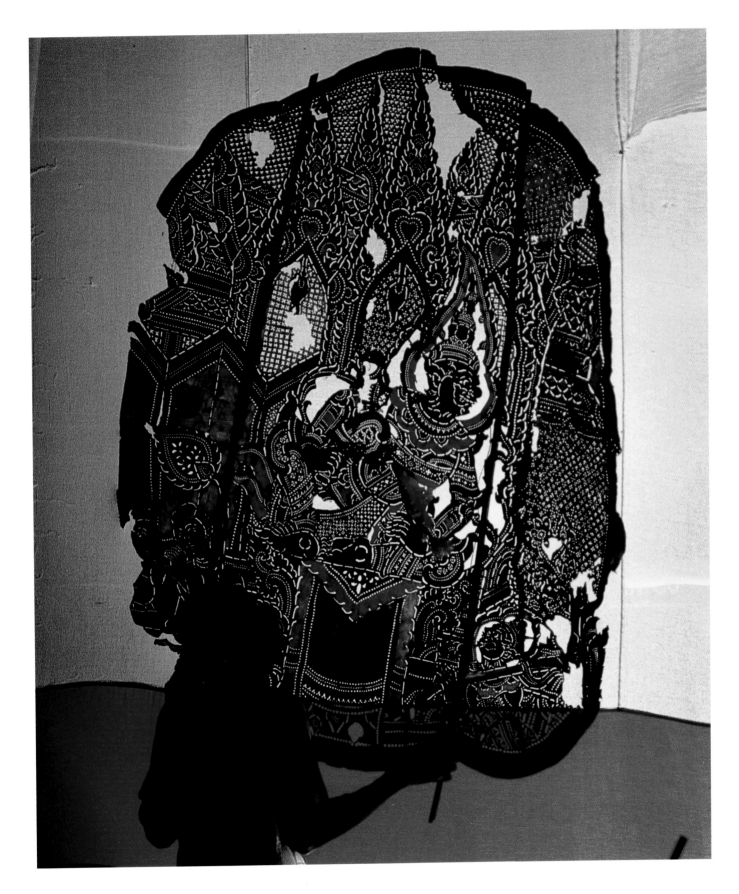

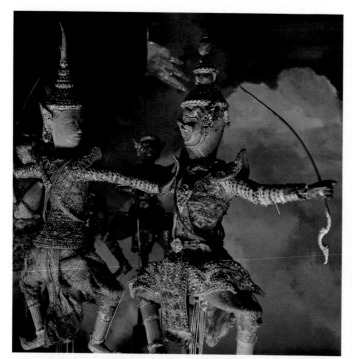

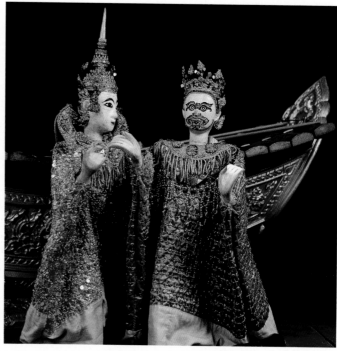

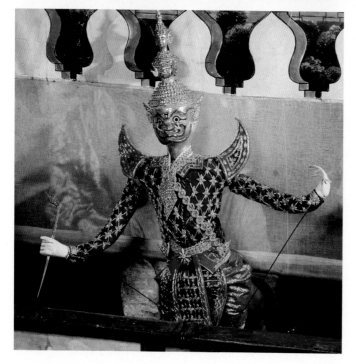

169–172 Rod puppets, operated by a sytem of concealed strings from below. Such figures, known as hun, were popular with royal audiences in Ayutthaya and early Bangkok, depicting characters from Thai legends, including the Ramakian. Performances today are rare, though a leading contemporary artist, Chakrabhand Posayakrit, has created a collection which is occasionally seen.

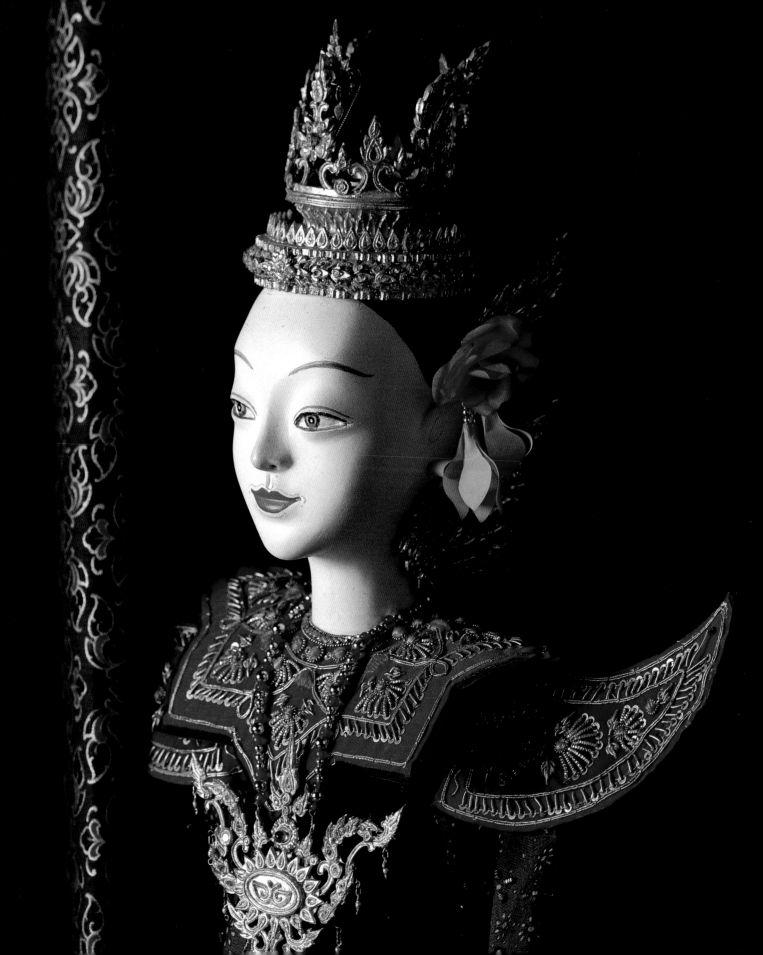

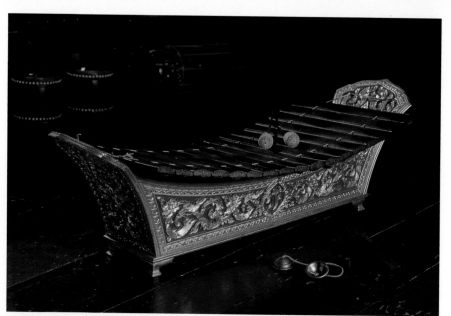

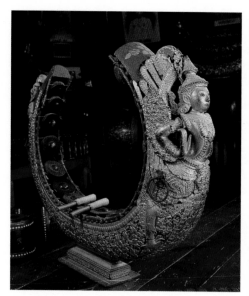

173–175 ABOVE *A magnificently carved instrument fitted with gongs known as a* song mon *and played primarily at funerals.* ABOVE RIGHT *A form of* ranad, *played like a xylophone, and a pair of cup-shaped cymbals known as* chings. RIGHT *Another* song mon, *with a Garuda carving.*

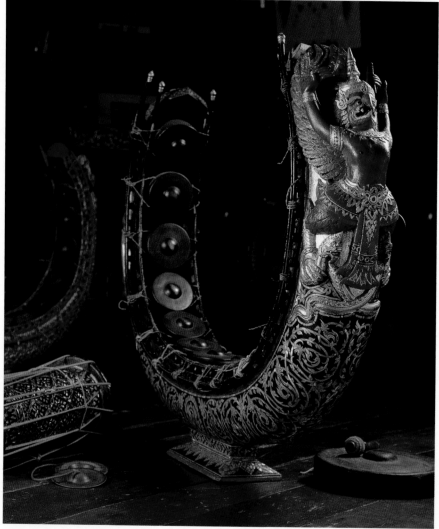

176 A collection of classical Thai musical instruments, showing both the wide variety and also the refined decoration applied by craftsmen to many of them, including intricate woodcarving and mother-of-pearl inlay.

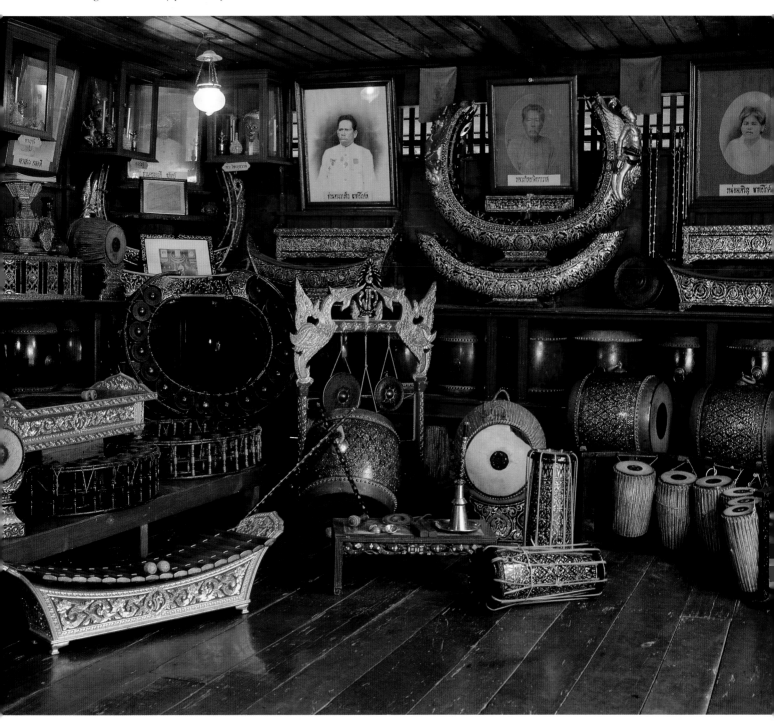

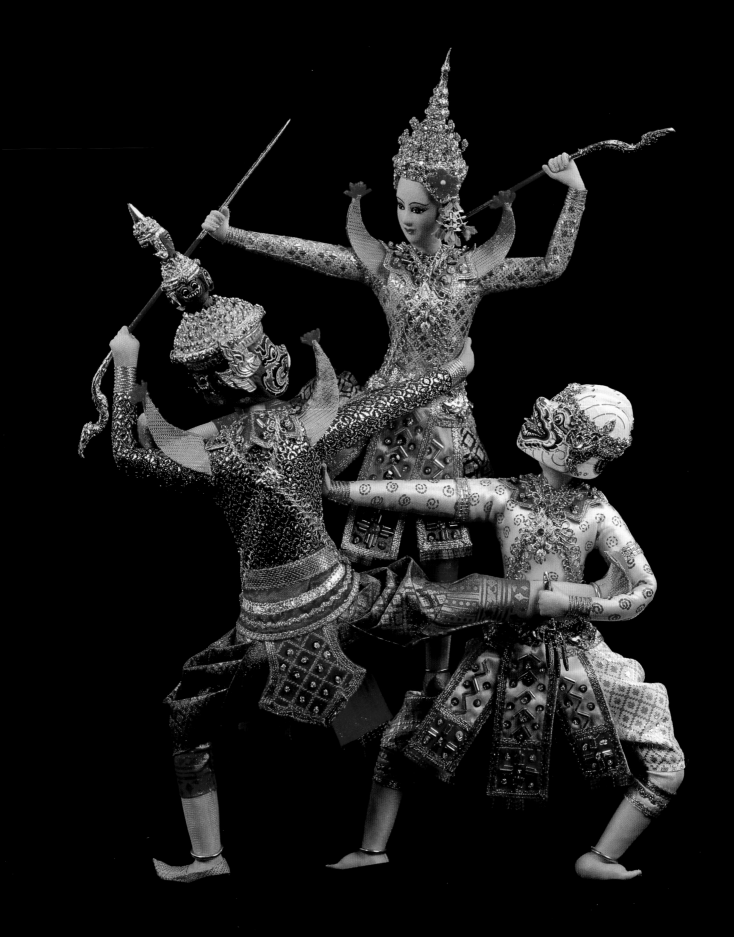

TRADITION CONTINUED: CONTEMPORARY THAI CRAFTS

IN MID-DECEMBER 1685, as their stay was nearing an end, members of the first French embassy to Ayutthaya, headed by Chevalier de Chaumont, were received in farewell audience by King Narai. 'The audience entirely consisted of civilities;' the Abbé de Choisy, aide to the Chevalier, recorded in his journal, 'all business had been concluded. The King had brought a big golden betel-nut box such as those carried only by the Oyas, the Dukes, and Peers of Siam, and gave it to the Ambassador, the greatest honour he could show him.'

By the time of King Chulalongkorn's reign, at the end of the 19th century, when the ruler wished to present a special object as a token of his esteem, even to officials of his court, it was as likely as not to be of foreign manufacture, perhaps from a Bond Street jeweler; the archives of one such firm, sold at auction a few years ago, contained hundreds of drawings of cigar cases, pill boxes, lockets and other items ordered for precisely that purpose. Though three Thai-style spires replaced the dome originally planned for the Chakri Maha Prasat throne hall, a Grand Palace addition completed in time for Bangkok's centenary in 1882, the neoclassical building had been designed by a British architect and was filled with marble statues from Italy and portraits of Thai royalty executed by European painters.

As we have seen, the impact of Western ideas and styles was particularly strong among higher-ranking Thais and led to a corresponding decline of many more refined traditional crafts for which they were the primary customers. As we have also seen, however, the skills needed to produce such crafts did not disappear. They were kept alive even in cities by the continuing requirements of ancient ceremony, religious and secular, at the village level by isolation and a deeply rooted conservatism; and thus were available when fresh demands for them arose from a variety of directions in more recent times. Following techniques developed centuries ago, often altering them in various ways, Thai craftsmen continue to create a wide range of products blending old and new in unique ways.

Echoing the royal patronage of the past, one prominent figure in this revival has been Her Majesty Queen Sirikit. The Queen's interest in local crafts arose from pioneering trips she and King Bhumibol Adulyadej began making throughout the Thai countryside soon after his coronation in 1950, and it was promoted not merely by a desire to preserve endangered skills but also by the obvious economic needs she saw in various rural areas.

Her first handicraft project, for example, was initiated in a small fishing village on the Gulf of Thailand not far from a summer palace maintained by the royal

177 LEFT *Dolls dressed as characters from the Thai classical drama; on the right is the monkey-god Hanuman, who assists the hero in his efforts to rescue his beloved consort Sida.*

family. The women of the community, she discovered, had little to do while the men were out in the boats and were badly in need of supplementary income. From the nearby province of Ratchaburi, noted for its cotton weaving, instructors were brought to set up looms in the compound of the palace itself and the women were encouraged to come for training. Lunch and daily wages were provided by the Queen, as well as a nursery for those with children.

At first the students wove *phasin*s for women and *pha khaw maa*s for men, but soon progressed to other items. The school was later moved to a permanent weaving factory, on a piece of land presented to the Queen by two wealthier inhabitants of the village, and is currently under the Department of Community Development with full-time teachers.

After this beginning, a number of other handicraft projects were launched in various parts of the country, always using skills and basic materials easily available in the area: *yan lipao* basketry in the far southern province of Narathiwat, *mat miii* silk in the northeast, miniature figures among brick-makers in the central province of Angthong. Eventually, in 1976, all the operations were brought together under a central organization called the Foundation for the Promotion of Supplementary Occupations and Related Techniques (popularly known as SUPPORT), with funds provided by the Queen and private donors. The Queen also began featuring the products prominently in her own wardrobe and accessories, and this, given the lofty role still played by the monarchy in Thai society, led to even more widespread public interest.

From headquarters in Chitrlada Palace, the royal family's Bangkok residence, SUPPORT oversees a nationwide network of regional centres that includes 59 provinces, training students and helping to market the finished products, both in Thailand and abroad. Some of the dozen or so crafts being promoted are classic ones like woodcarving, nielloware, refined basketry, textiles and items of gold and silver, only slightly modified to attract modern buyers. Others are virtually new crafts developed out of the old. In the past, for instance, bits of iridescent beetle wings sometimes embellished the more elegant shoulder-cloths worn by ladies of the royal court; these are now being used to decorate small woodcarvings and jewelry items, and also blended with *yan lipao* basketry to cover silver boxes. Artificial flowers are also popular, a reminder of the old inner palace skill at weaving real flowers into complex creations but now using cloth and other materials to produce highly realistic copies. These have now been taken up by many outside producers and constitute a major Thai export.

Other contemporary crafts have developed out of an increasing demand for unusual decorative items and individual initiative on the part of artisans and profit-minded businessmen. Having demonstrated that an international market existed for Thai silk during the 1950s, Jim Thompson, shortly before his disappearance, moved into printed silks, which had never before been produced in the country. The

RIGHT *Contemporary* yan lipao *basketry, made from the stems of a southern vine; formerly in decline, this craft has been revived by the present Queen of Thailand under her organization known as* SUPPORT *and is now enjoying a new popularity.*

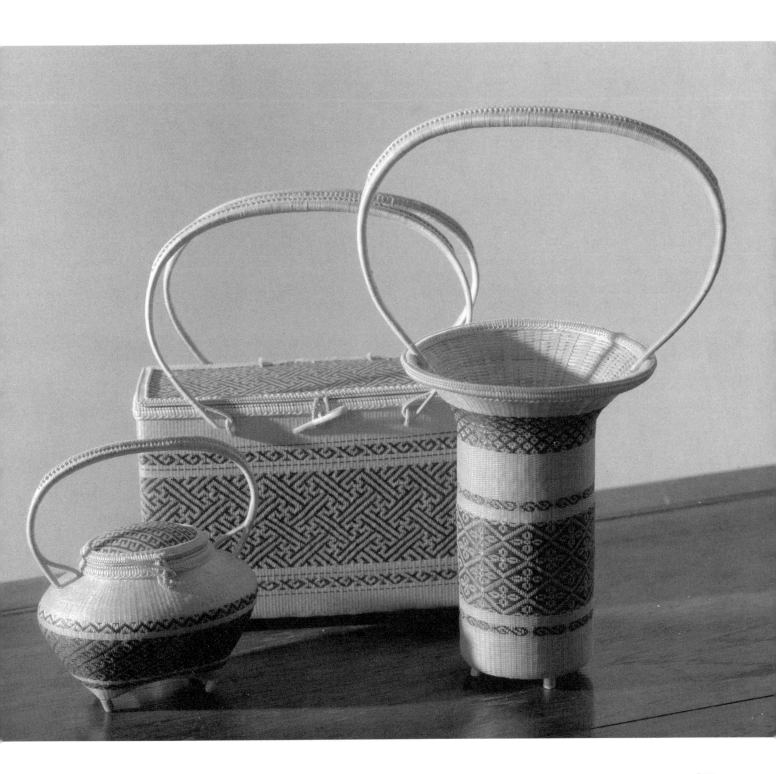

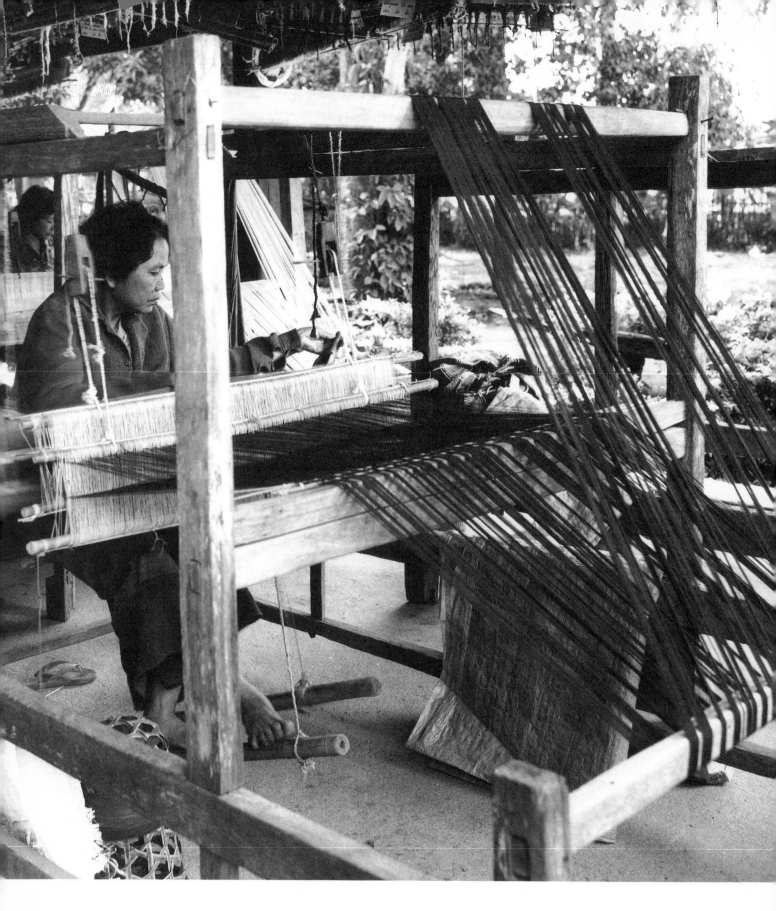

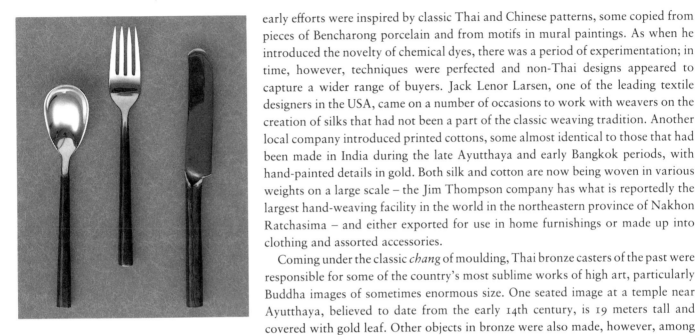

Stainless steel tableware with unpolished handles, a contemporary craft that draws on old technique to create products appealing to modern tastes.

early efforts were inspired by classic Thai and Chinese patterns, some copied from pieces of Bencharong porcelain and from motifs in mural paintings. As when he introduced the novelty of chemical dyes, there was a period of experimentation; in time, however, techniques were perfected and non-Thai designs appeared to capture a wider range of buyers. Jack Lenor Larsen, one of the leading textile designers in the USA, came on a number of occasions to work with weavers on the creation of silks that had not been a part of the classic weaving tradition. Another local company introduced printed cottons, some almost identical to those that had been made in India during the late Ayutthaya and early Bangkok periods, with hand-painted details in gold. Both silk and cotton are now being woven in various weights on a large scale – the Jim Thompson company has what is reportedly the largest hand-weaving facility in the world in the northeastern province of Nakhon Ratchasima – and either exported for use in home furnishings or made up into clothing and assorted accessories.

Coming under the classic *chang* of moulding, Thai bronze casters of the past were responsible for some of the country's most sublime works of high art, particularly Buddha images of sometimes enormous size. One seated image at a temple near Ayutthaya, believed to date from the early 14th century, is 19 meters tall and covered with gold leaf. Other objects in bronze were also made, however, among them large drums (popularly known as 'rain drums'), bells and fabulous creatures from Hindu mythology. Today craftsmen are drawing on the same techniques to produce decorative statues, some frankly copies of foreign models like Venetian lions and French garden ornaments, while others are original and often striking creations.

The popularity of bronze tableware, a relatively recent innovation, possibly led one contemporary artisan to experiment with stainless steel. Jaivid Rangthong, the owner of a shop called Thai Home Industries, began producing his cutlery about ten years ago, crafting each item from a single piece of steel and leaving the handles unpolished to give an interesting texture. The result so impressed a buyer from New York that the ware ended up on display at the Museum of Modern Art.

Other craftsmen are working closely within old traditions to produce a limited number of items that have a highly individual character. Chamnan Inluan of Petchaburi, for example, makes beautifully detailed miniature figures in lightly fired clay which are sold through only a few outlets in Bangkok, while several woodcarvers in Chiang Mai, notably Petch Viriya, have rejected the standardized designs being turned out by countless anonymous artisans and are creating works that display both skill and imagination.

One of the major success stories of modern Thai industry has been the growth of the gems and jewelry business. As already noted, whereas delicate gold-work was among the outstanding crafts of Ayutthaya, foreign visitors were generally dismissive when it came to the skills of native lapidaries and almost no Thai jewelry

LEFT Woman at work on a traditional loom in a village near Chiang Mai in the north; countless such looms throughout the country produce both silk and cotton for export and everyday use.

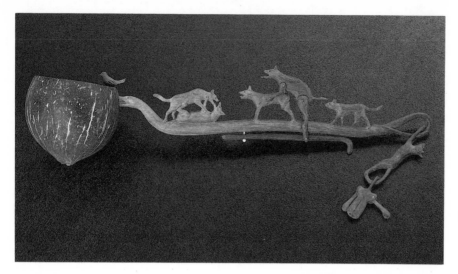

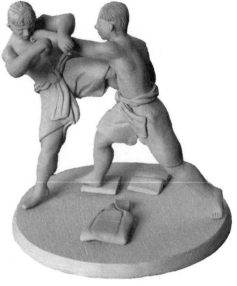

was seen abroad. This remained true for the next three centuries when, with remarkable speed, it changed dramatically.

Events in neighbouring countries were partly responsible. In 1962, General Ne Win launched what he called the 'Burmese Way to Socialism', which led to the virtual end of foreign investment and the nationalization of many industries, among them gem mining; Burmese rubies, once regarded as the world's finest, suddenly became scarce except for those smuggled across the border to Thailand. A similar shortage, this time of high-quality sapphires, resulted when the famous gem mines at Pailin, in Cambodia, ceased operation in 1975 following the takeover of the country by the Khmer Rouge.

Both rubies and sapphires had also long been mined in Thailand, mainly in Chanthaburi and Trat provinces on the Gulf of Thailand, though on a limited scale compared with Burma and Cambodia. In the late 1960s and '70s, production increased enormously to meet the new demand, to such an extent that by the end of the '70s about 80 per cent of the world's facet-quality rubies originated in Thailand. Then, in 1977, the Thai government abolished import duties on loose gemstones, which meant that stones from around the world could be brought to Bangkok for cutting and setting by a rapidly growing number of jewelry producers.

Skilled gem-cutters, whose absence had been noted so often in the past, appeared in extraordinary numbers as the industry developed. From only a few hundred in the 1950s – most of them working in small family businesses – the tally has grown to an estimated 100,000, some 7,000 of them in the previously unknown fields of diamond-cutting and -polishing. Jewelry designers and makers also increased their numbers, raising the quality of locally produced items to international levels. With the value of exports rising by some 30 percent annually – the total in 1990 was $1.4 billion – Thailand has become the second largest exporter of gems and jewelry in the world and expects to overtake Italy within the next few years.

Chiang Mai remains a leading handicraft centre, particularly in woodcarving, silverware and lacquer. Spurred by demands for novelty on the part of mass tourism and the export trade, these have branched off in new directions, sometimes at the cost of quality and originality. Woodcarvers, for instance, are copying Balinese creations and mass-producing whimsical animal figures popular with foreign buyers, while some lacquer-makers have adapted their products to satisfy Japanese

ABOVE LEFT *Ladle made of coconut shell with an elaborately carved wooden handle; this and similar items are popular in shops specializing in crafts.* ABOVE *Miniature clay model of Thai boxers; made in limited numbers by a contemporary craftsman in central Thailand.*

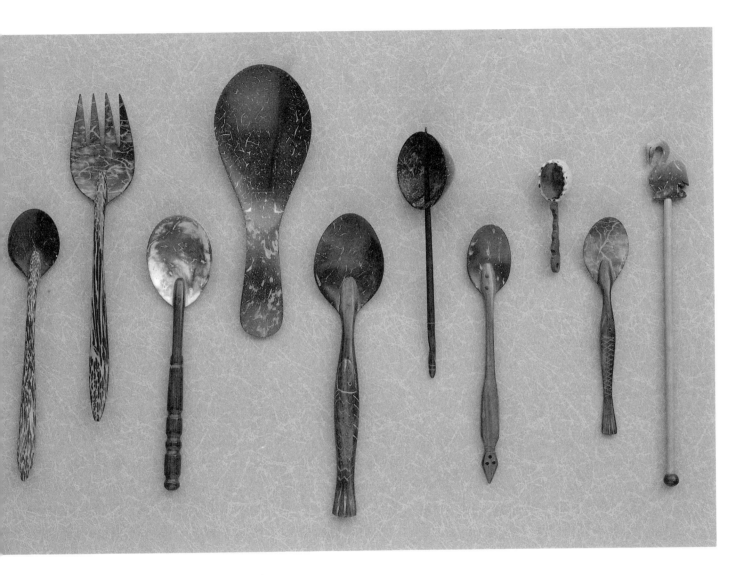

*Tableware made of carved wood and polished
coconut shell; a relatively recent creation, now
available in many different designs.*

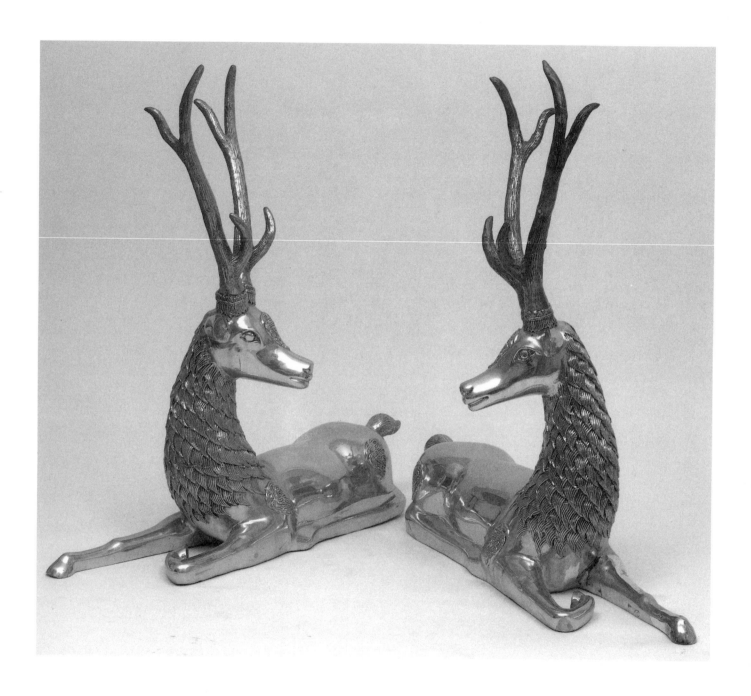

tastes. One ancient craft that has been revived with considerable success, however, is glazed stoneware similar to that made in the kilns of 14th-century Sukhothai; several pottery centres in the area now specialize in the ware, which is once more being exported on a large scale.

Contemporary pottery is also being made in Ratchaburi province, southwest of Bangkok. In addition to large waterjars which have been a speciality of the area for at least fifty years, a number of kilns are also producing handsomely glazed wares for use on terraces and patios; one, Tao-Hong-Tai, does reproductions of Chinese blue-and-white porcelain of such high quality that it was chosen to supply containers when gardens at the Grand Palace were renovated for Bangkok's bicentennial in 1982.

Collecting Thai crafts

Serious collectors of Thai crafts, old and new, will want to establish standards of excellence by studying the best examples on public display. There are a number of places where this can be done in Bangkok, the point of entry for most visitors.

A primary resource is the National Museum, one of the largest in Southeast Asia and located on the west side of the oval field near the Grand Palace. Besides numerous Buddha images from all periods of Thai history, the museum collection covers a wide range of other crafts – especially those designed for royalty and other high-ranking officials – such as jewelry, gilded lacquer cabinets, betel-nut sets, ceremonial vessels, carved funeral chariots, palanquins, elephant howdahs and similar items. There is also a display of theatrical crafts, among them *khon* masks, musical instruments, shadow-play figures and *hun* puppets. Early Bangkok furnishings are shown in the Tamnak Daeng, or Red Palace, once the residence of a queen and now located in the museum compound.

Jim Thompson's house (8 Soi Kasemsan 2, Rama I Road) consists of several old structures in central Thai style joined together, and displays the collection of the man who made Thai silk world-famous. There are some particularly fine wood-carvings, as well as Bencharong porcelain, traditional paintings, Buddhist statuary and furniture. Another semi-private museum open to the public is Wang Suan Pakkad (352 Sri Ayutthaya Road), where five old houses have been erected in the compound of a palace that once belonged to a grandson of Rama V; the collection includes some fine ceremonial vessels decorated with mother-of-pearl, carved furniture, gilded lacquer cabinets and personal items that belonged to the family.

Examples of simpler village crafts are more difficult to find, perhaps because until recently few were deemed worthy of preservation as works of art. The closest thing to an ethnological museum in Bangkok is the Kamthieng House at the Siam Society (131 Soi 21, Sukhumvit Road), an old northern-style house which was moved from its original site in Chiang Mai and which displays cooking utensils, fishing and agricultural implements, baskets and a variety of northern woodcarvings. A

LEFT AND ABOVE *Modern bronze ornaments made by the same methods used by traditional casters in the production of Buddha images, temple bells, and other objects.*

153

collection of similar items can be seen at the Ancient City, an open-air museum located an hour's drive east of the capital near the town of Samut Prakan at the mouth of the Chao Phraya river.

A less selective but also rewarding place to explore is the great Weekend Market held on Saturdays and Sundays at Chatuchak Park, on the road leading to Don Muang International Airport. Most new Thai crafts, from baskets to musical instruments, are on sale here, along with old ones such as textiles and household items regularly brought down from the countryside by dealers.

Bangkok shops specializing in crafts come and go with often bewildering speed, but the following are well established and likely to be around for a while:

Neold (149–223 Suriwong Road; branch in the Regent Hotel); old and new crafts, particularly woodcarvings, baskets, furniture and lacquer.

The Legend (3rd floor, Amarin Plaza, Ploenchitr Road; branch in Taniya Plaza, Silom Road); contemporary crafts.

Rasi Sayam (32 Soi 23, Sukhumvit Road); contemporary crafts.

Thai Home Industries (35 Oriental Lane); contemporary crafts.

Narayana Phand (127 Rajdamri Road); contemporary crafts.

Central Department Store (Chidlom branch, Ploenchitr Road); contemporary crafts.

Jim Thompson Thai Silk (8 Suriwong Road); silk, cotton, decorative crafts.

Khomapastr (52/10 Suriwong Road); printed cotton.

Celadon House (8/8 Rajadapisek Road); glazed stoneware.

Chitrlada (Grand Palace compound, Abhisek SUPPORT Museum at Vimarn-mek Palace); outlets for products of the Queen's SUPPORT Foundation.

River City Shopping Centre (next to Royal Orchid Sheraton Hotel); third and fourth floors devoted to antiques and crafts of all kinds.

Outside the capital, Chiang Mai is the leading crafts centre, with numerous shops selling woodcarvings, lacquer, silver, textiles, hand-painted umbrellas, celadon and other items of local manufacture; many of these are on sale at a Night Bazaar on Chang Klan Road. Not far from the city, San Kamphaeng is noted for its pottery, Pa Sang for textiles, Hang Dong for woodcarvings, and the smaller village of Bor Sang for umbrellas. Phrae and Nan provinces, further north, both produce homespun textiles.

Silk is a major product of the northeast, particularly Nakhon Ratchasima, Surin and Roi Et provinces; many villages in the region also specialize in baskets, while a distinctive kind of pottery is produced in the village of Kan Kwian near Nakhon Ratchasima.

Basket-weaving is a traditional industry in the central provinces of Angthong, Singh Buri and Chai Nat. Ratchaburi province is a centre for pottery production, especially large waterjars, while traditional weavers and goldsmiths are still at work in Petchaburi.

ABOVE *Lacquered wooden boxes made by artisans of the north.* RIGHT *An assortment of burlwood items from contemporary craftsmen.*

GLOSSARY

Note: Thai names are subject to a wide variety of spellings when translated into English; the following list, for the most part, is based on the versions used in the most recent reference works consulted for this book.

akat kin – literally 'space bites (in)'; term used by Thai woodcarvers to describe the illusion of great depth in carvings.

attachan – altar consisting of three steps within a wooden canopy.

bai raksa – evenly spaced leaf-form decorations at the top of the bargeboards on religious and royal buildings.

bai-sri – general term for offerings made of folded banana leaf, usually further adorned with flowers, candles and incense-sticks.

Bencharong – overglaze enamel ware with five colours, originally made in China for export to Thailand.

benja – form of altar; a low rectangular table with four posts for a canopy; on the table are placed three progressively smaller ones.

bot – monastery building where the principal Buddha image is displayed and where ordination ceremonies are held; also *ubosot*.

Brahma – one of the Hindu trinity of gods, depicted with four faces and eight arms; regarded as the creator.

Brahmanism – Indian religion out of which Buddhism and Hinduism grew.

busbok – pavilion-like structure of wood with a multi-tiered roof, used only as a seat for kings and to place objects of veneration.

chakhay – stringed instrument, placed on a low table and usually played by a woman.

chang – general term for craft or craftsman.

charp – general term for various kinds of cymbals in a musical ensemble.

chedi – spired monument which enshrines sacred relics or the ashes of important persons; also called a stupa.

cherng kran – traditional stove made in one piece of baked clay.

chien mak – set of betel-nut requirements, including tray or stand for holding them.

*ching*s – cup-shaped castanet-like instruments which set the pace for a musical ensemble.

chofa – literally 'bunch of sky'; elongated finial at the roof ends of religious and royal buildings.

chong kra ben – style of wearing sarong-like *phanung* in which the cloth is pulled between the legs and tied behind; once popular with both men and women.

chua – gable on domestic house.

chua bailan – similar to a *chua phra arthit* (see below) but without the openings.

chua luk fak – paneled gable on domestic house, especially in the central region of the country.

chua phra arthit – gable on domestic house decorated with small strips of wood like the rays of the sun, with openings at the top.

chula – large, star-shaped kite which symbolizes the male in Thai kite fighting contests.

cinnabar – red paint often applied to wooden buildings and objects as a preservative; the colour is also regarded as auspicious.

dao phedan – carved or painted ceiling motifs, generally based on the lotus.

deva – celestial divinity, often used as a decorative motif.

dok phuttan – flower of the cotton rose plant (*Hibiscus mutabilis*); also a design based on this flower and widely used as a decorative motif.

fah chi – cone-shaped cover of woven bamboo to protect food from flies.

Ganesha – elephant-headed son of Shiva and Parvati; god of arts or knowledge.

Garuda – fierce bird, sometimes part-human, who serves as Vishnu's mount; his enemy is the *naga*.

gong wong – circular musical instrument, usually made of rattan, with gongs of varying tones attached.

ham yon – carved panels above the door to the owner's room in a northern Thai house.

Hamsa – mythical swan or goose, a mount of Brahma; also *hong*.

ham hong – curving finials at the lower ends of the roof on royal and religious buildings; literally 'tail of mythical swan'.

hang pla – literally 'fish tail'; decorations at the bottom of the bargeboards of domestic houses in the central region.

Hanuman – monkey-god in the *Ramakian*, Thai version of the *Ramayana*.

ho trai – library building in a monastery compound.

hun – puppet; sub-divided into *hun yai* (large rod puppets), *hun lek* (smaller rod puppets), and *hun krabok* (hand puppets).

Indra – chief of the 33 gods who live on Mount Meru, devoted to protecting the Buddha.

jad paan – traditional Thai floral arrangement, consisting of flowers embedded in moistened earth, clay, or sawdust in a pyramidal shape; sometimes called *poom*.

Jataka – morality tales about the previous lives of the Buddha.

kachud – *Lepironia arpiculata*, water reed used to make mats in southern Thailand.

kalae – V-shaped structures at each end of the roof ridge on northern Thai houses, especially in the Chiang Mai area.

kanok – vegetal motif resembling a flickering flame composed of three parts, subject to many variations; appears in all forms of Thai decoration, especially woodcarving.

kanok khrua farang – *kanok* motif combining the acanthus leaf; adapted from European designs during the late Ayutthaya period.

karn khot – scroll pattern, often combined with other motifs.

karn to dok – scroll pattern widely used as a decorative motif.

kha singh – lion's-foot design on furniture.

khan nam – ceremonial bowl for lustral water.

khanom krok – pastry made of rice-flour and coconut milk.

khit – supplementary weft weaving technique, used for both textiles and basketry in Thailand.

khit maun – patterned cloth for pillows.

khoi paper – paper made from the bark of the *khoi* tree; used for manuscript books and for making *khon* masks.

khood maprow – device for grating coconuts, made of wood with an iron grater; also *kratai khood maprow*, similar device made in the shape of a rabbit.

khon – mask; also the classical masked dance drama which relates the *Ramakian*.

khong – woven bamboo container to hold freshly caught fish.

khong-ped – a *khong* made in the shape of a duck, which floats so that it can be left in the water.

kinaree – half-bird half-human mythological figure.

klong thad – largest of drums used in musical ensembles.

klong yao – long drum, sometimes several metres in length, used in village festivals in the north and northeast.

kong khao – steaming or carrying basket for glutinous rice.

kong khao doak – northern glutinous rice container shaped like a jar.

kra buey – water dipper, often made from coconut shell with a long handle.

kra jaad – shallow round basket with a square bottom, used for drying food in the sun or wind.

kra tip – double-layered glutinous rice container with a curved supporting stand; mainly in the north and northeast.

krachang – traditional motif based on a lotus bud, often used in border decorations.

krachong – woven bamboo container in the shape of a small jar, used to keep fish after they are caught.

kradong – woven bamboo baskets for winnowing rice.

krap – simple gong-like musical instrument.

krathong – banana leaf folded into the shape of an open lotus blossom, decorated with flowers, a candle, and incense-sticks; floated on waterways during the Lay Krathong festival to honour the water spirits.

kroen – curving decorative features on both sides of a throne or *busbok* which make the structure seem to be floating.

krok – mortar for grinding food, made of stone, wood or baked clay.

krueng lamyong – structural details of a gable on a religious or royal building.

krueng tom – nielloware, a technique of decorating silver or gold ware with black oxidized designs.

kwuen-ngua – ox-drawn wooden cart; found mostly in the north.

kwuen-kwai – buffalo-drawn wooden cart; found mostly in the central region.

lakhon – less formal form of dance drama, which became popular outside the royal court; variations include *lakhon nai*, *lakhon nok*, and *lakhon chatri*.

lai kan kod – twisting stem motif, often seen on Bencharong porcelains.

Lai Nam Thong – overglaze enamel ware to which gold has been applied, originally made in China for export to Thailand.

lai rod nam – technique of gold and black lacquer painting on a variety of surfaces, usually wood or woven bamboo.

li-ke – Thai folk theatre.

lob-non (or *lop pla-lod*) – long fish-trap of woven bamboo used in narrow channels of flowing water.

ma-ki – simplest form of altar table arrangement, consisting of a small table placed on top of a larger one, with a white canopy hung from the ceiling above.

mah jak – southern water dipper made of folded nipa palm leaves.

malai – floral garland made by threading various flowers together; used as an offering or token of respect.

mat mii – a resist patterning process, also called *ikat*, in which small bundles of yarn are tied off to prevent penetration of the dye and thus produce patterns; made in northeastern Thailand.

maun – pillow.

mong – gong suspended on a tripod in a musical ensemble.

muk fai – shell from the Gulf of Thailand used for mother-of-pearl inlay.

nam tung – northern water dipper made of woven and lacquered bamboo strips, with a crossed wooden handle.

nang ram – daytime performances of the shadow play.

nang talung – shadow play using smaller figures, often with one or more moveable parts; still popular in southern Thailand.

nag yai – shadow play; literally 'play with large cowhide figures'.

ngob – traditional farmer's hat made of layered palm leaves on a mesh bamboo frame.

nopparat – combination of nine gemstones believed to have auspicious powers.

pha khaw maa – shoulder cloth also worn as a sarong-like garment by Thai men; usually made of cotton in a bold checkered design.

pha lai-nok-yang – literally 'cloth not according to design'; textiles created by Indians with Thai-inspired designs, regarded as inferior to *pha lai-yang*.

pha lai-yang – literally 'designed cloth'; silk or cotton made in India with Thai designs supplied directly from Thailand.

pha lian-yang – literally 'copied design'; Indian-made textiles with copies of Thai designs.

pha pok hua – square of cloth with decorative designs sometimes worn by future monk during an ordination ceremony.

phanung – sarong-like garments worn by both and women, often pulled up between the legs and tied behind in a style known as *chong kra ben*.

pha sarong – skirt-like cloth worn by Thai men; may also be used as a belt, a carrying cloth or a covering for the head.

phasin – tubular skirt, divided into three horizontal sections, worn by Thai women.

pha batra – monk's alms bowl.

Phra Phum – Lord of the Land; guardian spirit of a particular piece of land.

Phra Ram – hero of the *Ramakian*.

phra thinang – hall or seat used by royalty.

phra thinang praphasthong (or *phra thinang lakho*) – elephant howdah used by royalty.

phu-yai-ban – elected headman of a village.

piphat – basic Thai musical ensemble, consisting of a wind instrument, the *pinai*, and various percussion instruments.

prang – rounded Buddhist monument with a finger-like spire, adapted from Khmer architecture.

pukpao – diamond-shaped kite which symbolizes the female in Thai kite-fighting contests.

rak – lacquer; resin of the *Melanorrhoea usitata* tree (also called *hak*).

rak roi – decorative motif resembling a flower garland, often used for decorating borders of columns.

rajasingha – royal lion from Hindu mythology.

ranad ek – boat-shaped xylophone, often elaborately decorated; variations include *ranad thum* and *ranad thong ek*.

rishi – holy hermit in the *Ramakian*, believed to have the powers of healing and protection.

saak – pestle.

sala – open pavilion.

sala kanrien – pavilion used for meetings in a monastery compound.

saw sam sai – stringed musical instrument made from a triangular coconut shell with an ivory handle and three strings.

sapakhab – elephant howdah used by ordinary people.

si-khao – handmill made of woven bamboo for hulling small quantities of rice.

Shiva – the Destroyer of the Hindu trinity of gods.

song na – medium-sized drum, similar to a *tapone*, held in the lap of the player.

soom-pla – cone-shape fish trap made of bamboo slats or woven strips.

takraw – woven rattan ball used in the sport of the same name.

talum – wide-mouthed ceremonial container with sloping sides set on a high, flaring pedestal; of possible Khmer origin.

tapone – large drum made from hollowed out wood with animal hide stretched over each end, mounted on a carved stand.

teen jok – technique of weaving in which the weft threads are slipped in and out of the warp to produce a pattern.

thammat – Buddhist pulpit.

thaamat thaen (or *tieng*) – simple pulpit consisting of a rectangular seat without a back panel, sometimes painted and gilded.

thammat tang – similar to a *thammat thaen* but larger, with arm-rests and a back support.

thammat yot – largest form of Buddhist pulpit, consisting of an elevated seat for one or more monks, sheltered by a multi-tiered spired roof.

thepanom – celestial being.

Theravada Buddhism – earliest form of Buddhism; adopted first by the Mons and then by the Thais.

Thotsakan – king of Longka (Sri Lanka); villain in the *Ramakian*.

thuai – brackets supporting the eaves on a religious or royal building; also *khan thuai*.

toom – earthenware jar used for water storage.

toom-pla – fish trap of woven bamboo in the shape of a jar.

toong – flag, usually of loosely woven cotton, hung at temples during Buddhist festivals or on holy days.

toong sor – triangular flag, attached to a bamboo pole in a monastery compound during festivals.

toong yai moom – square web-like flag, tied together in strings at a monastery in the belief that it will lead a soul to heaven.

tua lamyong – bargeboard of a royal or religious building.

viharn – assembly hall in a monastery compound.

Vishnu – one of the Hindu trinity of gods; regarded as the preserver.

wat – a Buddhist religious complex, including both buildings used for worship and the monks' living quarters.

yaksa – guardian demons.

yan lipao – southern Thai basketry made from the stem of a native vine.

BIBLIOGRAPHY

Beauvoir, Marquis of, *A Week in Siam, January 1867* (The Siam Society, Bangkok, 1986)

Bock, Carl, *Temples and Elephants* (reprint by White Lotus Press, Bangkok, 1985)

Bowring, Sir John, *The Kingdom and the People of Siam* (reprint by Oxford University Press, Kuala Lumpur, 1969)

Caddy, Mrs. Florence, *To Siam and Malaya* (Hurst and Blackett, Ltd., London, 1889)

Chou Ta-Kuan, *The Customs of Cambodia* (Siam Society, Bangkok, 1987)

Chu, Valentine, *Thailand Today* (Thomas Y. Crowell Company, New York, 1968)

Collis, Maurice, *Siamese White* (Faber and Faber, London, 1936)

Dhani Nivat, *Shadow Play* (The Fine Arts Department, Bangkok, n.d.)

Dhanit Yupho, *The Custom and Rite of Paying Homage to the Teachers* (The Fine Arts Department, Bangkok, n.d.)

– *Khon Masks* (The Fine Arts Department, Bangkok, n.d.)

Gervais, Nicholas, *The Natural and Political History of the Kingdom of Siam* (reprint by White Lotus Press, Bangkok, 1989)

Gittinger, Mattiebelle, and Lefferts, H. Leedom, Jr., *Textiles and the Thai Experience in Southeast Asia* (The Textile Museum, Washington. D. C., 1992)

Griswold, Alexander B., *King Mongkut of Siam* (The Asia Society, New York, 1961)

Hoskin, John, *A Buyer's Guide to Thai Gems and Jewellery* (Pacific Rim Press, Bangkok, 1988)

Klausner, William, *Reflections on Thai Culture* (The Siam Society, Bangkok, 1993)

Krug, Sonia, and Duboff, Shirley, *The Kamthieng House* (The Siam Society, Bangkok, 1982)

La Loubère, Simon, *A New Historical Relation of the Kingdom of Siam* (reprint by Chalermnit, Bangkok, n.d.)

Leonowens, Anna, *The English Governess at the Siamese Court* (reprint by Chalermnit, Bangkok, n.d.)

Naengnoi Punjabhan, *Silverware in Thailand* (Rerngrom Publishing Company, Bangkok, 1991)

Naengnoi Punjabhan and Somchai Na Nakhonphanom, *The Art of Thai Wood Carving* (Rerngrom Publishing Company, Bangkok, 1990)

National Identity Board, *Thailand in the 80s* (Office of the Prime Minister, Bangkok, 1984)

National Identity Board, *Treasures of Thailand* (Office of the Prime Minister, Bangkok, n.d.)

National Museums Volunteer Group, *Treasures from the National Museum* (Thai Wattana Panich Press, Bangkok, n.d.)

Phra Chen Duriyanga, *Thai Music* (The Fine Arts Department, Bangkok, n.d.)

Sangaroom Kanokpongchai, ed., *Museum of Folk Culture* (Muang Boran Publishing House, Bangkok, 1991)

Sawaddi, *A Cultural Guide to Thailand* (collection of articles published by The American Women's Club of Thailand, Bangkok, n.d.)

Silpa Bhirasri, *Thai Lacquer Works* (The Fine Arts Department, Bangkok, n.d.)

– *Thai Wood Carvings* (The Fine Arts Depatment, Bangkok, n.d.)

Smith, Malcolm, *A Physician at the Court of Siam* (Oxford University Press, Kuala Lumpur, 1982)

Stratton, Carol, and Scott, Miriam McNair, *The Art of Sukhothai* (Oxford University Press, Kuala Lumpur, 1981)

Sumet Junsai, Tongthong Chandransu, M. R. Chakrarot Chitrabongs, and Khunying Chamnongsri Rutnin, *Royal Barges: Poetry in Motion* (Office of the Prime Minister, Bangkok, n.d.)

Van Beek, Steve, and Tettoni, Luca Invernizzi, *The Arts of Thailand* (Thames and Hudson, London and New York, 1991)

Vibul Leesuwan, *Directory of Thai Folk Handicrafts* (Industrial Finance Corporation of Thailand, Bangkok, 1989)

Vimolphan Peetathawatchai, *Folk Crafts of the South* (Housewives Voluntary Foundation, Bangkok, n.d.)

Warren, William, *The Legendary American* (Houghton Mifflin Company, Boston, 1970)

Wyatt, David K., *Thailand: A Short History* (Yale University Press, New Haven, 1989)

MAP OF
THAILAND

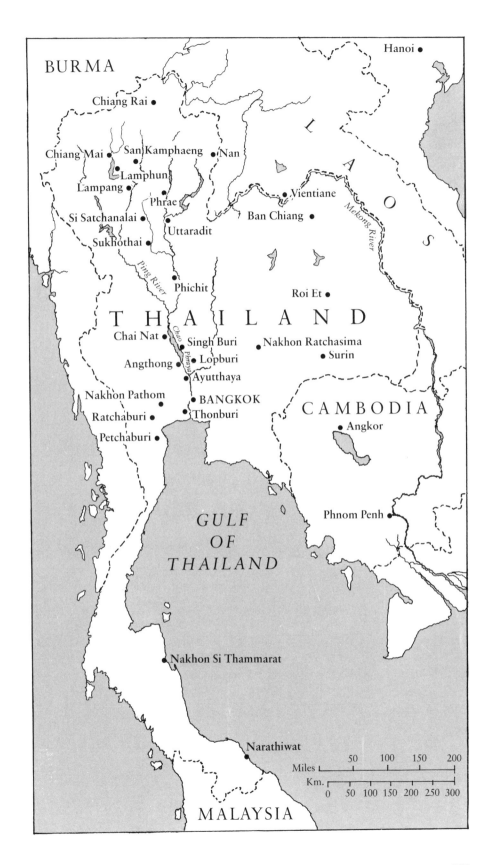

Hanoi •

BURMA

Chiang Rai •

L A O S

Chiang Mai • • San Kamphaeng • Nan
• Lamphun
Lampang • • Vientiane
• Phrae
Si Satchanalai • • Ban Chiang
• Uttaradit

Mekong River

Sukhothai •

Ping River

Phichit • • Roi Et

T H A I L A N D

Chao Phraya

Chai Nat • • Singh Buri • Nakhon Ratchasima
Angthong • • Lopburi • Surin
• Ayutthaya
Nakhon Pathom • • BANGKOK
Ratchaburi • • Thonburi

C A M B O D I A

• Angkor

Petchaburi •

GULF
OF
THAILAND

Phnom Penh •

Nakhon Si Thammarat •

Narathiwat •

| Miles | 50 | 100 | 150 | 200 |

| Km. | 50 | 100 | 150 | 200 | 250 | 300 |

MALAYSIA

INDEX